FISCHLI WEISS

—

Flowers & Questions

—

FISCHLI WEISS

—

Flowers & Questions

—

A Retrospective
—

Tate Publishing

English language edition first published 2006 by order of the Tate Trustees by Tate Publishing, a division of Tate Enterprises Ltd, Millbank, London SW1P 4RG, www.tate.org.uk/publishing

German language edition first published 2006 by Kunsthaus Zürich, Postfach, 8024 Zurich, Switzerland, in association with JRP | Ringier, Zurich, Switzerland

on the occasion of the exhibition *Peter Fischli & David Weiss / Flowers & Questions · A Retrospective* at

Tate Modern, 11 October 2006 – 14 January 2007
Kunsthaus Zürich, 8 June – 9 September 2007
Deichtorhallen Hamburg, 16 November 2007 – 3 February 2008

Exhibition organised by Tate and Kunsthaus Zürich

The presentation at Tate Modern is supported by Pro Helvetia, the Swiss Arts Council, and by the Stanley Thomas Johnson Foundation

British Library Cataloguing in Publication Data
A catalogue record for this book is available from the British Library

Editors	Bice Curiger, Peter Fischli, David Weiss
Graphic design	NORM, Dimitri Bruni & Manuel Krebs, Zurich, Switzerland
Printing	Druckerei Odermatt AG, Dallenwil, Switzerland
Binding	Buchbinderei Burkhardt AG, Mönchaltorf, Switzerland
Translations	Daniel Birnbaum (VI), Stephen Economides (XX), Fiona Elliott (VII, XXIX), Ishbel Flett (XIII, XVII, XVIII, XXX), Judith Hayward (XXVII), Catherine Schelbert (I, XV, XXIII, XXV, XXVIII, XXXI), Eileen Walliser-Schwarzbart (XXIV)
Front cover	Peter Fischli & David Weiss, *The Least Resistance*, film still, 1980–1
Paper	Luxo Samtoffset
Typeface	Times LT Std
ISBN	13: 978-1-85437-647-3
ISBN	10: 1-85437-647-0

German language edition
ISBN 13: 978-3-905770-08-7
ISBN 10: 3-905770-08-3

Distributed in the United States and Canada by Harry N. Abrams, Inc., New York

Library of Congress Cataloging in Publication Data
Library of Congress control number applied for 2006931285

CONTENTS

FOREWORD

With their video installations, sculptures and photographic works, Peter Fischli and David Weiss have developed a phenomenally varied visual and conceptual language, drawing the viewer in with their wit and enigmatic allure. These two astute observers collect objects and impressions, which they then transform in their work in order to present an altered view of reality. As if operating in a laboratory of the visible, they test and question the roles of the viewer and of the artist. No material, be it black rubber or moist clay, is safe from their hands, particularly when a loaded camera is present. To highlight just one of their contributions: in the 1980s, they liberated the art video from the reverential seriousness it initially provoked, and – through curiosity, laughter and, in later works, the clever and celebratory use of science – inspired a more widespread interest in this art form. This is no small achievement: in the contemporary art world, floating gently in shallow water and playing with hidden depths are often not very far apart. The artists have chosen the second route from the very beginning of their career, while not foregoing the possibilities offered by the former.

A striking characteristic of the artists' creative output lies in their attempt to distance themselves from reality: by doing so the artists enable a different perspective in relation to art. Watch very closely, observe, then close your eyes at the right moment and contemplate: 'where exactly are the beauty and the goodness?' The answer is that you will definitely find them here. We extend our warmest and deepest thanks to the artists for their enthusiasm and commitment to the exhibition *Flowers & Questions* and its presentation at Tate Modern, Kunsthaus Zürich and Deichtorhallen Hamburg, and for their creative input into this unique publication.

We are delighted with this successful collaboration between Tate and Kunsthaus Zürich as organising partners and wish to thank the two teams in London and Zurich who have brought the exhibition and the catalogue to life with great care and commitment. At Tate, for their support and expertise, we would like to thank Sheena Wagstaff, Chief Curator; Juliet Bingham, Assistant Curator; Stephen Mellor, Exhibitions Co-ordinator; Phil Monk, Installation Manager and Clare Simpson, Registrar. At Tate Publishing, we are grateful to Roger Thorp, Publishing Director, and Editors Rebecca Fortey and Clare Manchester for their part in realising this catalogue. At Zurich, we

would particularly like to thank Bice Curiger, Curator Kunsthaus Zürich, for her knowledgeable and sympathetic collaboration with the artists. The exhibition at Zurich has been expertly co-ordinated by Sandra Haldi, Exhibition Organiser, and Gerda Kram, Registrar, and installed by Robert Sulzer and his team. We extend our thanks to Franziska Lentzsch, Head of Exhibition Organisation, for driving the catalogue project, and are especially grateful to the many contributors to this volume for their outstanding and varied perspectives on the work of Peter Fischli and David Weiss.

We have relied on the generosity of a number of key lenders to realise this timely retrospective, for which we offer our profound gratitude.

At Tate, we are privileged to have the exhibition supported by Pro Helvetia, the Swiss Arts Council, and by the Stanley Thomas Johnson Foundation, to whom we extend our sincere gratitude for their continued support of contemporary international art of the highest calibre.

In its role as a partner for contemporary art, Swiss Re became involved with this project at Kunsthaus Zürich, and we express our heartfelt thanks to all those who have contributed, the management, and Anne Keller and her wonderful team. We celebrate with them in the successful staging of *Flowers & Questions*.

And now over to Peter Fischli and David Weiss whose grand and humble questions – 'What's waiting for us in the depths of the universe?', 'Can Truth get away with everything?', 'Am I beautiful?', 'Are People Flowers?' – continue to beguile.

Vicente Todolí
Director
Tate Modern

Christoph Becker
Director
Kunsthaus Zürich

INTRODUCTION

Ever since they began working together in 1975, Peter Fischli (*1952) and David Weiss (*1946) have cast a whimsical eye on the supposedly banal stuff of everyday life. Driven by their own inimitable brand of research, they draw us into their disarming version of the world, never ceasing to surprise us.

A tendency to seek out universals, to take an encyclopaedic approach and to do so as utterly unorthodox scientists, characterises their work in series. Their choice of medium is eclectic: photographs, moulded, carved and cast sculptures made of unusual 'ordinary' materials, slide shows, films and videos like *Der Lauf der Dinge* (*The Way Things Go* 1986–7), which has become a bestseller for young and old (–› chapters IXX, XX).

An early exhibition entitled *Plötzlich diese Übersicht* (*Suddenly this Overview* 1981) presented hundreds of little unfired clay figurines engaged in the unwritten scenes of an 'expanded history of the world', filtered through two overly zealous minds that take everything just slightly too literally (–› chapter XI). It is the same spirit that informs the films in which the artists, starring as Rat and Bear, stroll through their surroundings, making dry, understated comments on the large and small issues of life (*Der geringste Widerstand* [*The Least Resistance* 1980–1], *Der Rechte Weg* [*The Right Way* 1982–3], –› chapter XVIII).

It is as if Fischli/Weiss had set themselves the task, in the name of art, to come to terms definitively not only with truth, but also with the good and the beautiful. Hence, in recent years they have been posing countless 'questions' and producing enchanting photographs of *Blumen* (*Flowers*) and *Pilze* (*Mushrooms*), all 1997/8, whose excess of beauty represents a profound philosophical challenge (–› chapters IV and XXVII).

For the present publication, Peter Fischli and David Weiss have divided their work into thirty-one chapters, tracing the development of series and groups produced over the past twenty-eight years. Owing, most likely, to their predilection for phenomenological collecting and arraying the wonders of the world, they have chosen to challenge art criticism in this book with the same roguish zeal. To our great delight, each chapter is paired with a text, the contributors being critics, philosophers, artists, filmmakers and poets.

One soon realises, however, that Fischli/Weiss do not proceed chronologically. The order is artistically motivated in the broadest sense inasmuch as many later projects have evolved out of long-term research begun long ago. The artists' prolific *Sichtbare Welt* (*Visible World* 1987–2000, –› chapter XXVI) has led, among other things, to the well-known series of photographs *Airports* (1987–99, –› chapter II), and they've been asking their 'questions' (–› chapter IV) in a wide variety of media since 1980, including a Xeroxed brochure (*Ordnung und Reinlichkeit* [*Order* and *Cleanliness* 1981]), a large sculpture (*Fragentopf* [*Question Pot* 1985]) and projected slides (*Fragen* [*Questions* 2003]). The chapter headings are therefore not always identical to the works contained therein. A note at the end of each chapter provides information on the work groups and when they were made, as well as additional comments as necessary.

The oeuvre of Fischli/Weiss also includes a substantial number of self-contained publications, large and small books of pictures and of text alone, often linked directly to specific groups of work. The bibliography therefore lists not only the catalogues, but also the artists' books.

The decision made early on to work together instead of pursuing separate paths stems from their faith in a profoundly supra-individual approach. In their choice of cover illustration, Peter Fischli and David Weiss metaphorically define their future agenda in the world of art: costumed as Rat and Bear in 1980, they cast an expert eye on a 'modern sculpture'. An impressive rendition of the lesson they may have learned at the time is now presented in the exhibition and the publication, *Flowers & Questions*.

Bice Curiger

I–XXXI

I

—

Boris Groys

—

SIMULATED READYMADES

—

The insight that reproduction is more appropriate to human subjectivity than production is one of the oldest in the history of human thought. Nature produces; a person who still lives in and with nature also produces – the wise reproduce. Plato wanted to reproduce the eternal ideas in his soul; the true believer wants to reproduce the Passion of Christ; Freud believed in the reproduction of sexual traumas in dreams; Fischli/Weiss reproduce milk cartons, drills and saws in polyurethane. Subjectivity is something invisible, which is why it must not and cannot become visible, identifiable, objectified. Actually, the reproduction of things without an observable difference indirectly reveals subjectivity through the very absence of productive intervention.

When we first look at Fischli/Weiss's exact polyurethane copies of ordinary objects – they might best be called replicants after Ridley Scott's film *Blade Runner* – we find that they are indistinguishable from the originals. Only on close inspection will the viewer perhaps realise that they are not the 'real thing' but only artificially made replicants. It would in fact be better if the viewer knew this to begin with – from the artists themselves, from their

friends or at worst from a catalogue. Fischli/Weiss's replicants refuse to give us any insight into their inner nature and structure, which we, as products of a scientific age, automatically want to investigate. Instead, we are radically confronted with a surface that cannot be penetrated because it conceals nothing but a void. The polyurethane used by the artists is merely a physical metaphor for this void: and it is, of course, no accident that the items weigh practically nothing. Fischli/Weiss thus create a situation that obviates study and insight, a situation in which art alone has power over us. They reproduce a pre-scientific, pre-philosophical world that deals with only two things: what we see with our eyes and, as additional information, how what we see with our eyes has been created out of nothingness. It was once possible to find this information in the Bible – nowadays people look for it in exhibition catalogues.

But the greatest, most immediate effect of Fischli/Weiss's objects and installations lies in undermining certain expectations entertained by contemporary viewers. We are all familiar with the practice of the readymade, and when we see the simple things of daily life on view in a museum, we believe implicitly in their authenticity. In fact, our faith in their authenticity is even greater on seeing them in a museum than in reality. We know how hard it was for the practice of the readymade to garner acceptance; we know how long it took the artist to earn the right to put real things, and not only their representations, on display in museums. Then why should someone come up with the idea of depicting and simulating the readymade itself? One can argue that Fischli/Weiss simulate readymades rather than the objects themselves, because in real life these object-replicants would immediately be exposed for what they are, namely useless in actual practice. In a museum context, however, the readymade is not required to pass a test of authenticity or practicability thanks to a firmly established convention, which prescribes that only surfaces may be viewed, for we are not allowed to touch, take away or use the objects on display. It is this convention that has made it possible to simulate the readymade.

Our perception of readymades in a museum is, incidentally, profoundly influenced by the assumption that they are real, genuine things that could potentially be returned to reality. Fischli/Weiss's readymade replicants repudiate this assumption by demonstrating that we have been led astray by a convention that cannot give us a guarantee of reality, for readymades also

travel a one-way street from reality to art. Once the classical readymade crosses the invisible threshold that separates art and reality in our culture, the possibility of retracing its steps becomes purely theoretical. The threshold has been inscribed in the inner structure of these readymade replicants; the act of becoming art precludes their return to reality. But how does this practice enhance our understanding of art? What is the point of copying a copy or of reproducing a reproduction?

Actually the practice of the readymade is itself an act of copying, of duplication: everyday objects are duplicated by the mere fact of being placed in a museum. Duchamp's discovery consisted of demonstrating that it was no longer necessary for art to resort to painting or sculpture in order to depict reality: the context in which an object is presented suffices for us to perceive it as an artistic copy of itself. We can say that the ordinary object that escapes conscious notice, although we use it everyday, captures our attention in the context of the museum and acquires new meaning. Its once utilitarian value gives way to a new symbolic value: the object becomes mysterious, fraught with meaning, mythical. It begins to inspire darkly religious associations, to imply a ritual function – in short, it begins to carry the entire weight of our culture. It becomes erotic. It becomes pure presence. It becomes spiritual. It brings Joseph Beuys into play.

Here the threshold between art and reality is given a purely spiritual interpretation: it is defined by the individual's inner, purely mental decision to see things differently; it acquires mythical dimensions. Crossing it begins to resemble a religious conversion, an inner enlightenment that allows us to see the familiar from a new angle and to contemplate what is hidden below surfaces.

The classical practice of the readymade has the duality of a mythical experience, about which Fischli/Weiss obviously have misgivings. Their strategy evidently seeks to desecrate the distinction between art and reality. A thing made by Fischli/Weiss becomes art by virtue of the fact that it has been carved out of polyurethane. This definition replaces the old one, according to which a thing becomes art upon being seen in the light of inner enlightenment. The astonishing thing about this substitution of polyurethane for a higher spirituality is that the effect basically remains the same: divested of any practical, ordinary functionality, the thing can be used only as an object to be viewed.

By simulating readymades, that is, by reproducing a reproduction, artistic subjectivity is suppressed even more – and therefore even more subjective. In installations like *Tisch* (*Table* 1993) at the Museum of Contemporary Art in Basel, or the *Room at Hardturmstrasse* in Zurich, [a)] Fischli/ Weiss have carved items out of polyurethane that belong to the tools of their trade. In their studio, they carve replicas of their tools and utensils using these same objects. The objects manufacture themselves, carve their own self-portraits, convert themselves into art. The will of the artist no longer plays a critical role as it did in the classical practice of the readymade, where artists presided over the fate of objects by determining which ones were to be elevated to the rank of art. Instead things repeat themselves as art by producing themselves. One is reminded of Fischli/Weiss's film *Der Lauf der Dinge* (*The Way Things Go* 1986–7) [→ chap.XIX], in which things are given the appearance of having been left to their own devices as if to play out their own dynamics of inertia and motion. In more recent works, things not only move autonomously, they also seem to generate themselves in a purely physical process that eliminates anything that might be construed as spiritual, metaphysical, profound and mythical – except perhaps the greatest pre-Platonic mythos of a self-producing and self-reproducing physis. But we must not forget that the greatest, the supreme power consists of giving one's creations independence and freedom. In this sense Fischli/Weiss are divine creators, albeit with an inner irony.

Thus, their works are not without idyllic undertones. Their staged universe of tools seems to be self-contained and self-sufficient. Human beings living in the midst of this universe live in familiar, homely surroundings. An invisible human presence is tangible in all of Fischli/Weiss's installations: the things they make all show traces of use, of domesticity as part of our everyday lives. But humans do not figure as masters of these things; their activities have no external purpose to which the tools and other utensils must submit. The *Room at Hardturmstrasse*, for example, shows the unassuming atmosphere of what might be a modest little workshop. The room has not been installed in the museum but rather behind a glass door facing the street. Pedestrians chancing to glance through the door will not realise that what they see is a work of art, especially since it is not labelled as such. They will assume that the owner has locked the door and just stepped out for a moment. At most, they might wonder what the workshop is for, what sorts of things are made or repaired

there, for the owner's trade and the purpose of the establishment are not imme-
diately apparent.

Only our acquaintance with other Fischli/Weiss works, in particular
Table, will supply the answer. Here the same or at least comparable objects,
spread out on the table, are unmistakably marked as products of Fischli/
Weiss's artistic craftsmanship and not as the tools themselves. The work of the
anonymous craftsman, embodied by Fischli/Weiss, is the medium of the self-
reproduction of the instruments of the work. The only purpose of their crafts-
manship is to perpetuate itself, ceaselessly reproducing the circumstances and
instruments attendant upon their way of life. One is reminded of Wittgen-
stein's *Lebensform* (life form) or Heidegger's *Seinsweise* (manner of being).
Every activity is described as self-sufficient self-reproduction, eternally
repeated by people living in the midst of this activity and acting it out, thereby
producing a superfluity that ultimately guarantees a kind of immortality. Since
people are completely integrated in a process that does not require their deci-
sions, their personal will, or even their existence, even the radical menace of
death loses its thrust. But this menace becomes acute again as soon as the
unalloyed repetition of a way of life gives way to efforts to improve, moder-
nise, accelerate and enhance the efficacy of life. This is why both Wittgenstein
and Heidegger were so firmly opposed to the modern technological world.

Fischli/Weiss do not like modern technology either – its products do
not figure in their installations. Above all, they reject the technological
improvement – namely, the practice of the readymade – that has been so suc-
cessfully employed in the enhancement of artistic efficacy that the speed of
the fine arts today easily rivals the speed of all modern technology. And indeed,
is there anything faster than changing one's inner gaze? It is only because
such change has become the essential technology of art in our century that
modern art learned to compete in the economic arenas of our society. Fischli/
Weiss want to decelerate modern art. Their readymade replicants out of poly-
urethane do not wax ironical over the mystical pretensions underlying the
practice of the readymade, nor do they merely desecrate the distinction
between art and non-art; these objects are also products of a slow process that
revives the ethos of the artist as a working, creating craftsperson who once
again represents the things of reality.

Except: Fischli/Weiss's replicants are obviously not the original
things of this world but, as we know, mere readymades. The traditional artistic

ethos can only be reproduced today under the cover of irony: Fischli/Weiss render their things not in marble but in polyurethane. Who knows whether the reproduction of the traditional role of the artist is used by Fischli/Weiss as an ironic device or whether irony is deployed to make this role acceptable again.

[First published in English in *Parkett* no. 40/41, 1994, pp.33–7]

a) *The Room in Cham* 1991; location: Cham, 1991; Zurich, 1993–2003; fire brigade garage, La Plaiv, S'Chanf 2003–ongoing; Walter A. Bechtler Stiftung für Kunst im öffentlichen Raum.

Carved polyurethane objects, painted, life-size
1992–ongoing
Starting with *Tisch* (*Table*), exhibited at the Centre Georges Pompidou, Paris, 76 × 330 × 900 cm, objects of varying sizes
Compared to the earlier objects carved from polyurethane, these recreations of everyday objects and studio utensils show much greater detail and more realistic surface textures
Generally created in groups and specific to a particular location, for instance as: *Raum unter der Treppe* (*Room Under the Stairs*) at the Museum für Moderne Kunst, Frankfurt, 1993 [→ pp.12, 28]; *Empty Room* at the Walker Art Center, Minneapolis, 1996; *Untitled* at the Sonnabend Gallery, New York, 1994; *Untitled* at Tate Modern, London, 2000 [→ pp.22–5]; *Untitled* at the Museum Boijmans Van Beuningen, Rotterdam, 2003

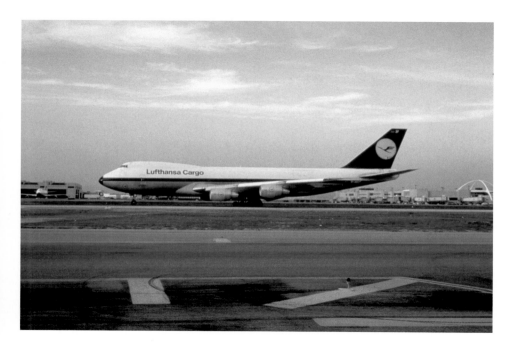

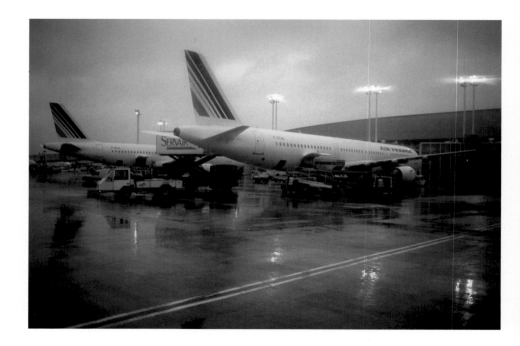

II

—

John Waters

—

—

Airports 1990, the numbing, beautiful and finally hilarious new photo book by Swiss artists, Peter Fischli and David Weiss, confused me at first. Browsing in a Zurich bookshop on an endless promotional tour, the over-sized, prominently displayed, expensive coffee-table book with that generic title invited a quick peek inside. Seeing mediocre, glossy, postcard-style photos of exteriors of nondescript airports, presented page after page in elegant binding with no text only produced a shrug as I moved on to the safer ground of the esoteric postcard rack. But I kept coming back and flipping through *Airports* again and again. 'What the hell is this?' I thought. 'Eighty dollars? For dull outtakes from an in-flight magazine? What will they think of next?' I found myself grumbling just like the dullards who panicked when they first saw paint dripping on soup cans. Then I started laughing. I was finally surprised by something. Even outraged. What an exhilarating feeling to realise that purposeful mediocrity is the only subtle way left to be new.

 Obsession soon followed. I whipped out my American Express card and gleefully signed the dotted line and my travels have never been the same

since. Every time I look out of an airplane window in boredom, frustration and exhaustion, I see a mediocre still life even duller, more stupid and less remarkable than Fischli/Weiss's. And I'm convinced that I've glimpsed a new kind of 1990s beauty, over and above the banality of Pop or the exasperation of Minimalism into a shockingly tedious, fair to middling, nothing-to-write-home-about, new kind of masterpiece.

I want to know who said *Airports* was good first. It's hard to visualise a publisher sitting at his desk debating the merits of these astoundingly inert still lifes without being familiar with the artists' past work (rubberised dog dishes, self-destructing kinetic installations on film and scarily familiar tourist sights so over-photographed – Stonehenge, Eiffel Tower, Pyramids of Giza – that they appear to be calendar pin-ups when snapped once again by these two pranksters). 'Let's see,' our editor might think, 'here's a shot possibly taken from a stalled courtesy van across the street from a static airport, too far away for any detail and framed so the foreground is filled with empty macadam marred accidentally and completely undistinguishedly by a small wad of trash.' 'Get in here,' he screams to his startled staff, 'I've seen the future of photography! We *have* to publish this book and I don't care what it costs!' The Emperor's New Clothes? Don't ask me, I never understood the moral of that story anyway. If the Emperor walked down the street naked and everybody told him how good he looked, who am I to spoil the cutting-edge of fashion? *Airports* will inspire the 'But he has nothing on!' response from the internationally humour-impaired, but I applaud these new 'Emperors', Fischli/Weiss, and salute their lethal passivity with glee.

What's really bewildering is that some of the photos are almost pretty. A rainbow shockingly appears in an oil-slick mixed with rainwater at an unidentified airport in one of the untitled, unindexed portraits. But a closer inspection reveals only the corporate airline logo on the tail of the plane reflecting back a spectrum of colour at the disappointed viewer. Twilight is a relief from the hazy daytime views of uneventful, unglamorous world travel, but detail such as a Marriott truck deadens any pleasure one could get from a beautifully photographed sky. Night shots are at least lit dramatically by airport industrial lighting, but how pretty can a catering truck be at any time of day? Foreign skylines, lush greenery, even a romantic sunset are ruined by these crazed photographers who go about their task as if hired by a postcard company that they hate with psychotic, understated fury. Looking at their

work has the appeal of being trapped in the rear of the tourist section of a stalled jet in summertime as the stewardess announces in three languages that she apologises for the air conditioner's malfunction but not to worry, 'we are number eighteen in line for take-off'.

The very worst photos are of course the wittiest but need to be surrounded by the merely second-rate to be appreciated in the proper perspective. An empty passenger jet undramatically parked in an unlit hangar is just as dull as it sounds. And a perfectly centred medium shot of a windowless Lufthansa cargo plane may force us to realise we're not much better off here than the packages inside (there's nothing to look at even if they *could* see) but it still takes a specially desensitised eye to savour this run-of-the-mill vision. The most radically ordinary images have no planes at all, just abandoned airport equipment, security vehicles rushing to nowhere, empty cargo trucks and airport personnel, never more nameless, blurred in the jet pollution, silhouetted by their uncaring cities that could be anywhere in the world.

My favourite photograph in the book is the most maddeningly mediocre. A parked Federal Express plane sits in an airport with portable debarkment steps at its door. No people. Absolutely nothing is happening. 'Next Day Delivery' never looked so unrushed. A bus used to take passengers to the gate is heavily featured as it drives by, empty except for the unseen driver. We know it can't stop, packages don't have friends to meet them at customs. It's a bad advertising shot that would be eliminated on the first editing pass from any corporate-business catalogue. There is no activity, no drama of any kind. It is impossible to see any reason ever to reproduce this photo in any form. Ultimate mediocrity has finally been achieved.

How much could it cost to purchase this picture? What could it actually be like to have it beautifully framed hanging over the fireplace in your living room? I try to imagine Fischli/Weiss's mood when they finally captured this masterwork. Were they exhausted after weeks of international travel to drab airports, or did they flippantly do this book all in one week, using every picture they took, snapping away without even bothering to look through the lens? Had they just ritualistically chanted the magic airport words, 'jetway', 'carousel number three' or 'unlikely event of a water landing', and laughed conspiratorially when they stumbled upon this utter vision of wearying tedium? Or were they giddy from experiencing the pinnacle of air travel when all the stewardesses in exact choreographed unison point their index

fingers twice, I repeat twice, at the nearest emergency exit with that incredibly embarrassed, bored, sexually humiliated expression. Is this photo worth a thousand words as they say? Hardly. A hundred? Doubtful. One? Yes. Art.

[First published in English (entitled 'Terminal Fever') in *Vogue*, London, november 1990, pp.240/1]

—

Cibachromes, 120 × 180 cm
1987–ongoing
First photographs from 35mm slides taken of airports from the evolving archive of *Sichtbare Welt* (*Visible World*) [–› chap.XXVI]

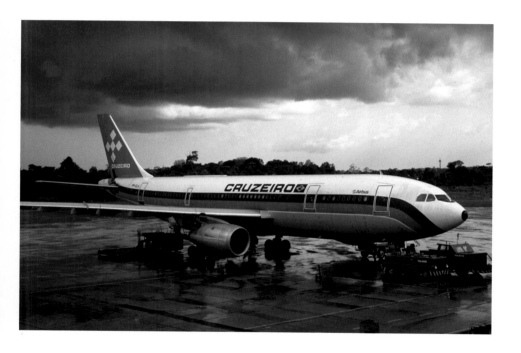

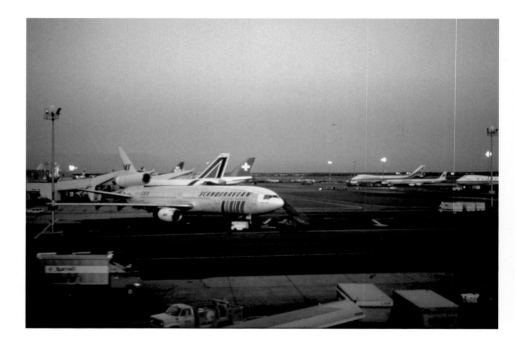

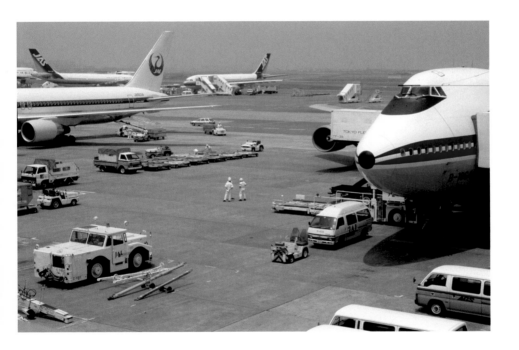

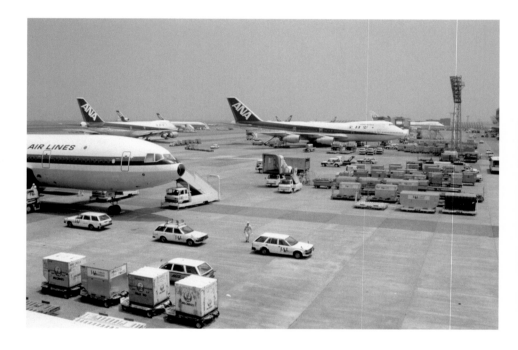

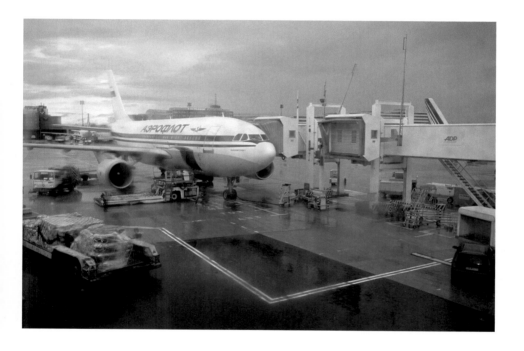

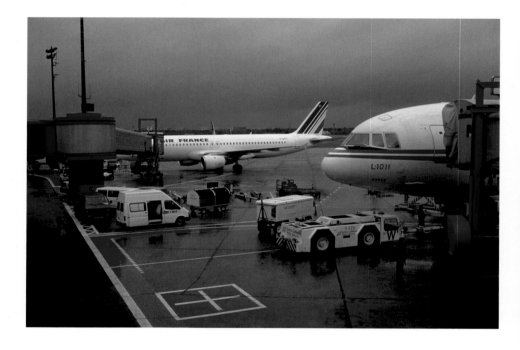

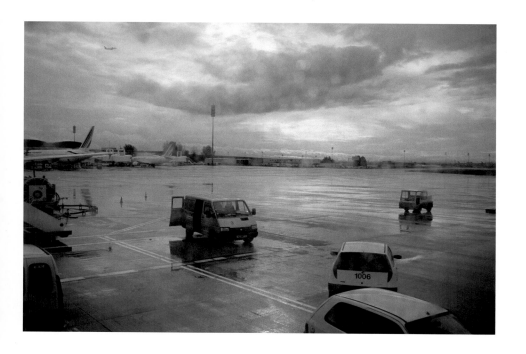

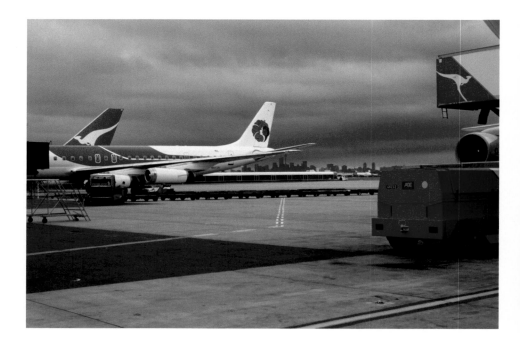

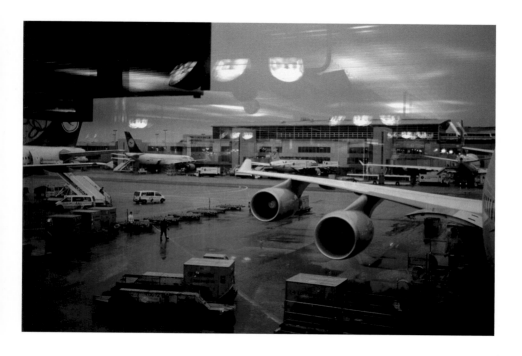

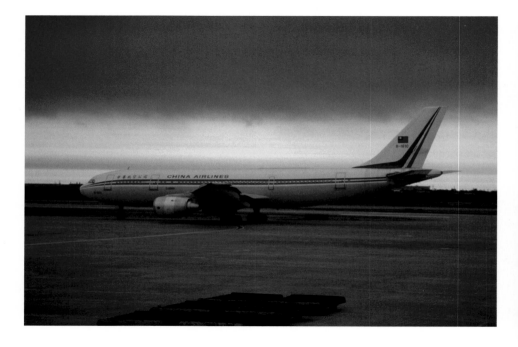

III

—

Iwona Blazwick

—

—

Picture a typical mountain scene. There are three snowy peaks dotted with chalets and spanned by a cable car; green meadows roll away from a glacial lake. This Alpine landscape is pictured in a photograph of 1979 by Fischli/Weiss [→ p.157]. Despite the quintessential flintiness of a mountainscape, the scene pictured here is somewhat squishy due to the fact that the artists have constructed it from a duvet and some snowy white pillows. The cable car is the end of a sausage and the chalets possibly corners of cheese. This delightfully de-Nietzschefied image of the sublime, this fuzzy Friedrich, presages a subsequent series of actual sculptures of landscapes the artists made in the 1980s.

Their cast concrete 'landscapes' are each approximately one metre square and, in one particular series, sit on plinths, the heights of which are roughly level with our shins. Our point of view differs radically from the conventional optical relationship on which the landscape genre depends. As literary historian John Barrel has pointed out, the origins of the word landscape – defined as 'a view or prospect of natural scenery' – reveals a relationship

with theatre. He writes, 'The word "scene", applied to a landscape, assumed also that what was being described lay opposite the observer, "en face"; and this sense came with it from its theatrical origin – the flat and square-shaped "skene" behind the orchestra in a Greek theatre, and the square frame of the proscenium arch which the English theatre had adopted since the Restoration. A "scene" then, in the description of landscape, is something opposite you and enclosed by the limits of your vision in very much the same way as a painting is enclosed within its frame.'[a] Rather than looking through a frame or window, we occupy the same space as the landscape. We do not gaze onto a perspectival rendering which draws our eyes to a horizon, and by implication to the beyond. These sculptures demand that we look down.

Fischli/Weiss have apparently taken a chunk of the earth that we stand on and elevated it. There is indeed a kind of frame provided by the smooth, flat, vertical sides of each sculpture and its horizontal base, which they variously place on plinths, props or directly on the ground. By casting a rough piece of aggregate, the artists offer a surface that appears as both a topographical imprint, and a landscape in its own right. Crucially, it is our human propensity to transform this bumpy, even abject surface into something marvellous. We just can't help imagining it as a miniature mountain.

Some of the *Betonlandschaften* (*Concrete Landscapes* 1985–ongoing) have been created for presentation in the context of a gallery. Like models, they take on an ideal, rarefied quality. Other, larger pieces, created as outdoor public sculptures, are by contrast ever changing, animated by the dynamic and the detritus of the environments and seasons surrounding them. One such sculpture is located in a park where, in dry weather, the red-brown hues of its valleys contrast with pale grey peaks to suggest a tiny desert. When the rains come, puddles form. Reflecting the surrounding trees and sky above, they attain, just momentarily, the beauty of a lake. Another *Concrete Landscape* has been sited on a bland, sprawling concrete sidewalk, flanked by a motorway flyover. The flattening and despoliation of the earth through urbanisation and traffic is briefly interrupted by a modern archaeological fragment, an intimation of what lies beneath our relentless concretisation of the planet.

The titles of these pieces also incorporate a double meaning. Concrete is both a manufactured/artificial material and a quality of the actual and the tangible – of the real. The sculptures are both representations and real landscapes.

The post-war phenomenon of so called Land art or Earth Works defied the containment of landscape within the conventions of a two-dimensional image. Yet paradoxically, the monumental scale of many of the vast interventions made in deserts, hillsides and lakes, by artist such as Michael Heizer, Walter De Maria or Dennis Oppenheim, may generate the same effect as a tiny canvas by Caspar David Friedrich. Where one privileges the eye over the body, leading the gaze into infinity, the other overwhelms through sheer immensity. Both approaches to landscape tend to position us, almost disembodied, on the dark edges of the sublime void. By contrast, the modest, Lilliputian quality of Fischli/Weiss's *Concrete Landscapes* gives us a purview that is indeed divine but also childlike. They compel us not to look away, but to concentrate on that humble piece of ground that lies here, right beneath our feet.

a) John Barrell, *The Idea of Landscape and the Sense of Place, 1730–1840,* Cambridge 1972.

Poured concrete, formed while the concrete hardened during the setting process
1985–ongoing
2 large outdoor sculptures, 25 × 360 × 240 cm
Series of smaller sculptures approx. 25 × 80–100 × 100–140 cm, varying

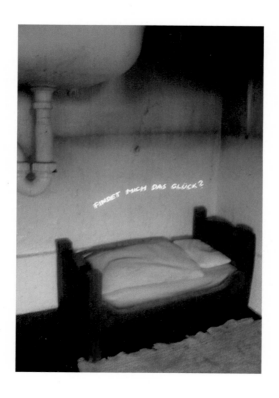

IV

—

Francesco Bonami

—

GARDENERS' QUESTION TIME: SMALL ANSWERS BIG QUESTIONS [a]

—

Mr Fischli, I assume?
Mr Weiss, I presume?

Why do I always have to write what you are saying?
Plato to Socrates

Have you finished taking notes?
Socrates to Plato

What is a Question?
Wittgenstein to his maid

Why?
Wittgenstein's maid

Descartes defines knowledge in terms of doubt, but we still don't have any real, concrete, scientific proof that Descartes was not stupid. Caught in a fire, his constant philosophical rumbling could have cost his life. 'I'm burning, therefore I am on fire.'

Is Berlusconi more intelligent than my father?

To start writing something about big questions and small questions I think it's fair to begin with a few questions myself. What do I write? Is art possible in a country that boils babies? Are boiled babies really good as fertiliser? If I kill Bin Laden will I have to go to jail?

To be serious means to take questions seriously.

Why are Big questions big and why are Small questions small? Who says so?

Because questions don't seem to be answerable in a logical way, Fischli/Weiss ask the biggest question of all: 'Is it possible to live with any doubt and still to be able to know something relevant about life?'

When you start asking things, you initiate an endless process, you open a can of worms, which is what the two artists are desperately trying to tell us.

Duchamp said that there are no solutions because there are no problems. Fischli/Weiss's book of questions is the product of a very similar conclusion. There are no answers because there are no real questions.

I will try to answer some of the artists' questions.

Will happiness find me?
Dependability is the cornerstone of a good character.

Why is everything so far away?
You can tell what sort of character people have from the company they choose.

Why does the earth turn full circle once a day?
Your reputation is what people think you are.

What does my dog think?
Every thought you release becomes a permanent part of your character.

Who's going to pay for my beer?
Some people resemble a cheap watch.

What's the name of this forest?
Trees are not stones, each one of them has a name.

Where is my bed?
Profanity is a sign of an inadequate vocabulary.

Is this brown lump edible?
Nobody can make you eat anything without your express permission.

Would it help me if I dug a hole?
Most worries are not half as serious as we first think they are.

Are animals people?

How can you judge others accurately if you haven't learned to judge yourself accurately?

Has the last bus gone?

Your mental attitude is the most dependable key to your personality.

When is the money coming?

They will pay with the loss of their most valuable possession: their reputation.

Why doesn't she call?

A real friendship is reciprocal.

Who runs the city?

Never mind what others didn't do. It's what you do that counts.

What happened 4.56 billion years ago?

A guy named Bruno killed his wife with his bare hands.

How long is the Nile?

More than a mile.

How much is 42 × 87?

3,654.4.

What good is the moon?

Going the extra mile.

Is my being filled with serenity?

If you can't manage your own mental attitude, what makes you think you can manage others'?

Should I get drunk? Another glass?

Diet is one area in which less is definitely more.

Is it okay to close your eyes and see colourful abstract images when you're listening to music?

If it was good for Ellsworth Kelly, it's also good for you.

Do I have to envision the universe as foam?

The mind grows only through use, and it atrophies through idleness.

Do we go through a wall when we fall asleep?

Yes, if you are driving.

Was I a good child?

You should have asked this question before you killed both your parents by pouring rat poison in their soup.

Is there any farmlife left in the family?

Some people invest a lot more energy in getting out of work than they would spend doing the job well.

Who's nibbling on my little house?

If you deal in malicious information, you'll rarely be trusted.

Am I too good to work?
One of the great mysteries of life is why some people, who seem to have all the advantages, never seem to amount to much.

Is the earth a mother?
No, she's an insurance tycoon.

Is my soul bedded on straw?
It is virtually impossible not to transmit your doubts and insecurities to others through body language.

Is my body a hotel?
I don't know but make sure you are a builder, not a destroyer.

Should I make myself some soup?
A common cause of food-related illness and disease is over-eating.

Will happiness find me?
I already answered this.

Was it a mistake not to run away from home?
Courage is what Ernest Hemingway described as 'grace under pressure'.

Am I a donkey?
Make it a habit to demonstrate your abilities before talking about them.

Is there a secret tunnel leading directly to the kitchen?
Ask Rem Koolhaas.

Should I marry my mother?
When you have talked yourself into what you want, stop talking and begin saying it with your actions.

Am I my car?
If you can imagine it, you can create it.

Is my brain a poorly furnished apartment?
Because worry is directed at some vague, uncertain threat, it is difficult to deal with it logically.

Why do I always fall out of bed at night?
In every aspect of your life, you may choose to be an observer or an active participant.

Do souls wander?
It depends on the kind of retirement plan they had in life.

Should I live in the woods as a robber?
Unless you manage your schedule to permit time for studying and learning, it is easy to yield to the temptation to indulge in escapist pastimes.

Does that dog bark all night?
As the Roman philosopher Pliny the Elder wrote, 'the only certainty in life is that nothing is certain'.

Is everything half as bad?

Part of maturity is the recognition that things are seldom as bad as they first appear.

Would I make a good cop?

Which type of individual do you think is most valuable to the organisation?

Is hunger an emotion?

Apparently this is the opinion of the majority of people on death row.

Am I musically homeless?

Glenn Gould never paid his rent.

Should I show more interest in the world?

Subscribe to trade magazines and professional journals.

Dove sono i bambini?

We used them as fertiliser.

Why is it so quiet all of a sudden?

Maybe you are dead.

Will insects overtake us?

You must be prepared to act soon, it could be an opportunity.

Why do we stick to the ground?

That is indeed a miracle.

Where is the galaxy heading?

I don't know, but put in a good word for America anyway.

Who owns Paris?

Berlusconi.

Is the devil a cheerful person?

He is a perennial optimist, who refuses to acknowledge that obstacles are anything other than stepping stones to success.

Does my car know me?

If you don't even know yourself how can you expect it to?

Should I slaughter my pig?

An empty mind seeks pleasure as a substitute for happiness.

Where will I end up today?

Worry is like a rocking chair. It keeps you busy but it doesn't get you anywhere.

Can music be used to calm me down?

Glenn Gould never paid his rent.

Is everything I have forgotten as big as a house?

Yes, if it's a Japanese house.

Should I make myself available for research?

Every brain is both a broadcasting station and a receiving station.

Do I know almost everything about myself?

Almost. But I know something about you I'll never tell you.

Am I frittering away my life?

Defeat is never permanent unless you allow it to be so.

Is my ignorance a roomy cave?

The secret of education lies in respecting the pupil.

How do I come across?

The life of Helen Keller is an outstanding example of the triumph of the human spirit over a physical handicap.

Do opinions come on their own?

No one is inherently lazy.

Am I loved?

I wish you well.

Why don't they leave me alone? (in peace!?)

Because you owe them a lot of money.

Is the world there when I'm not?

Yes, and it's probably celebrating.

Should I walk around in rags?

Don't delay; do it today!

Am I one of the chosen?

You may feel that you deserve better but you are wrong.

Why are there bad people?

Negative thinking always produces negative results. (Have I already told you that?)

Could I have become something else?

Make sure you are anchored to a philosophy that will sustain you.

Is freedom alive?

Self-deceit is an insidious cancer of the spirit.

Is resistance useless?

Victory is always possible for the person who refuses to stop fighting.

Am I an oddball?

Life has a funny way of evening out the score.

Are fashions plagues?

It is a curious quirk of human nature that some people can see opportunities, while others only see problems.

Is it possible to do everything wrong?

Each action is contingent upon the success of the one that preceded it.

Should I let myself go?

Without a plan for your life, it is easier to follow the course of least resistance, to go with the flow, to drift with the current with no particular destination in mind.

Why is everybody so nice all of a sudden?

It is a very basic human characteristic that we tend to respond to others in the same way they treat us.

Why does nothing never happen?

There isn't much one can do for the individual who will not try to do something for himself.

Can ghosts see me?

When you are discouraged after you've failed at something don't make things worse with stupid questions.

Have I ever been completely awake?

Unless you are willing to suspend your cynicism and disbelief, you will never be awake.

Is sleeping the only way to fight fatigue?

A good night's sleep is the best cure for cancer.

Am I caught in a web?

This is called a 'self-fulfilling prophecy'.

Is a witch riding me?

I'd rather not answer.

Should I smoke opium?

It is virtually impossible to eat more raw vegetables and ripe fruit than is good for you.

Do we see the dark side of the world on television at night?

It is important to know at that moment what your true desire is and to act to preserve your hope.

Why does it take the earth exactly one year to circle around the sun?

I think it has to do with the public school system.

Should I visit alien galaxies with my spaceship?

Yes, but be sure to be back for dinner.

Do I have to imagine death as a landscape with a house that you can walk into and there's a bed to sleep in?

Absolutely, but be sure you have made a reservation.

Should I build a hut in the woods and live there alone in poverty?

Remember, no matter where you are now, whatever you can conceive of and believe in, you can achieve. But if you take that decision, don't forget to mail some hand-made explosive parcels to your old science and mathematics teachers.

Whose fatigue do I feel?

Most probably mine, writing this shit.

Is it more important for the world or for me to be doing well?

Life is never sweet to those who are soured on the world.

What's in a dog that enjoys lying in the sun?

Fear.

Does profound peace prevail at home when I'm not there?

Everyone is occasionally tempted to take advantage of others.

Is two times two probably four?

Faith cannot be created.

Should I leave reality in peace?

How dreadfully dull it would be if we all wanted to be nuclear physicists or bakers.

Are we losing control?

Someone once said that democracy is a lot like making a sausage.

My questions again.

Are Fischli/Weiss questions Swiss questions or global questions?
Is a ringing telephone a question if we answer it?
Do people with too much money have more questions?
Why don't they pay me 100,000 dollars for this text?
Are the tonsils and the spleen useless organs?
Does Wim Wenders have a sense of humour?
Why did Fischli/Weiss stop painting landscapes?
Are Fischli/Weiss politically correct?
Are Fischli/Weiss postcolonial subjects?
Do I like Fischli/Weiss as artists, as people or as Swiss people?
Are you bored with my writing?

a) *Gardeners' Question Time* is a long-running BBC Radio 4 programme in which amateur gardeners can put questions to a panel of experts.

——————

In 1980, *Questions* first make an appearance for *Ordnung und Reinlichkeit (Order and Cleanliness* 1981) [–› pp.202–5], as drawings of –› *Ratte und Bär (Rat and Bear)* [–› chap.XVIII], *Grosse Fragen, Kleine Fragen (Big Questions, Small Questions)*
1985/6: *Fragentopf (Question Pot)* (large and small) [–› p.79], gauze-covered polyurethane, painted as –› *Graue Skulptur (Grey Sculpture)* [–› chap.VI], ø 200 cm, height 134 cm, at the exhibition at Kunsthalle Basel
2000: projection of *Questions,* small version, 3 slide projectors, Museum für Gegenwartskunst, Basel, subsequently expanded to 5 projectors, Ludwig Museum, Cologne
2002/3: projection of *Questions,* large version, 15 slide projectors, Venice Biennale, multilingual

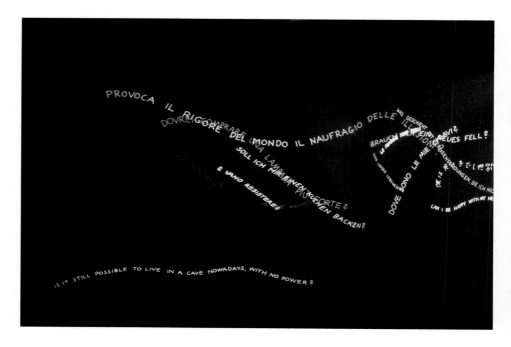

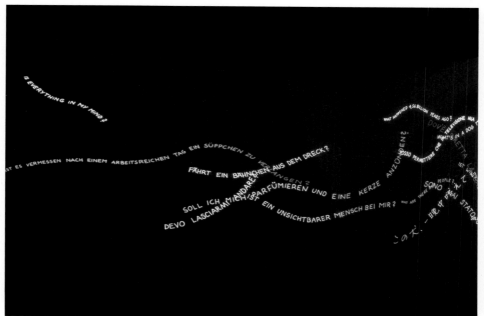

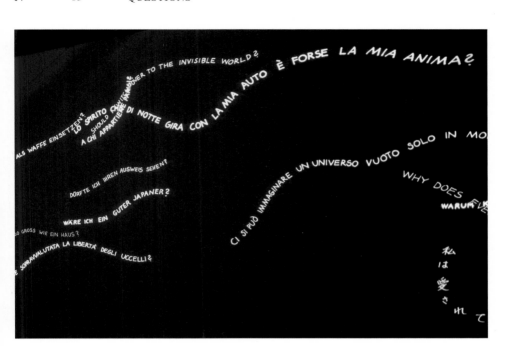

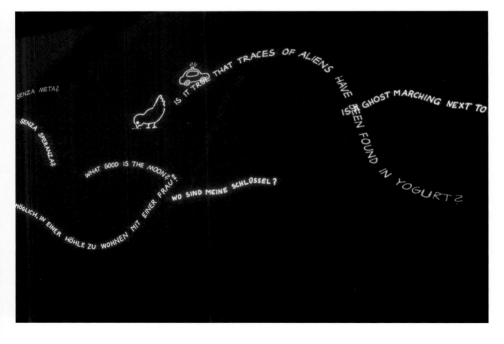

SHOULD I PAINT A PIRATE
SHIP ON MY CAR WITH AN ARMED
WOMAN ON IT HOLDING A
DECAPITATED HEAD BY
THE HAIR?
420

WHAT IS IN MY
APARTMENT WHEN
I'M NOT THERE?
260

AM I MY SOUL'S
SLEEPING BAG?
94

SHOULD I GO TO
ANOTHER CITY AND
RENT AN APARTMENT
UNDER A FALSE NAME?

DOES A GHOST DRIVE
MY CAR AT NIGHT?
12

WILL HAPPINESS
FIND ME?
162

WHY DO I ALWAYS
AGREE WITH EVERYTHING
?

WOULD ANYBODY LOOK
FOR ME IF
I DISAPPEARED?
398

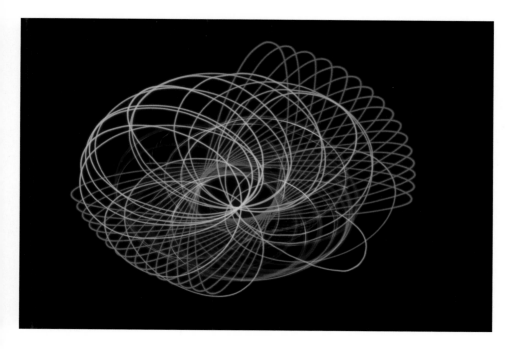

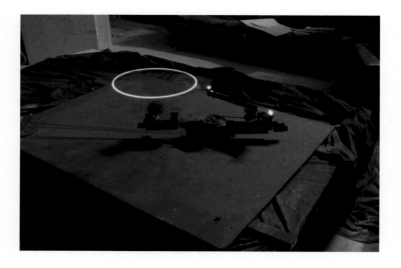

V

—

Alison M. Gingeras

—

—

In an age where a single art project's budget can soar into the millions, and an artist's enterprise might rival Hollywood standards, the working methods of the collaborative team Peter Fischli and David Weiss embody an antithetical stance. Their unpretentious production ethos might be compared to the anachronistic tradition of son et lumière theatrical productions – whose humble special effects still effectively provide a thrilling spectacle – rather than the current paradigm of technology-driven, blockbuster entertainment.

A slow-dissolve, slide show work entitled *Surrli* 1989, offers an emblematic example of their rather unique approach to art making. Appropriating the Swiss-German name for a child's spinning top, Fischli/Weiss concocted a machine with mechanical components from a store-bought toy kit, whose sole purpose was to spin or rotate a series of small coloured lights. The duo then took a series of long-exposure photographs of their machine in action, capturing the abstract imagery generated by their contraption. When projected together, the 162 slides form a progression of geometric patterns that make simultaneous allusions to high and low cultural referents. This resulting series

of coloured ellipses and interlocking whirlpools of light on black backgrounds evoke László Moholy-Nagy's Bauhaus era photograms – images made by arranging commonplace objects such as coils and mechanical wheels into geometric compositions on photosensitive paper, works Moholy-Nagy called 'paintings with light' – as much as they recall the kind of LSD-inspired visuals that fuelled the psychedelic light shows of the 1960s. With an understated wit that has become their signature, Fischli/Weiss revisit the legacy of abstraction – both in its avant-garde and pop guises – without mocking its pretension or passing a value judgment. Instead *Surrli* makes a playful attempt to overcome the trite connotations of 'pure' abstraction in order to capture some fleeting moments of beauty.

Beyond its lo-fi razzmatazz, *Surrli* demonstrates numerous formal and conceptual strategies that animate Fischli/Weiss's oeuvre. As exemplified by the clever yet simple crafting of the *Surrli* machine, Fischli/Weiss never seem to run out of inventive uses for a range of unassuming, ordinary raw materials. Whether employing unfired clay to sculpt events from the history of mankind, as in their Magnum Opus, *Plötzlich diese Übersicht* (*Suddenly this Overview* 1981) [→ chap.XI], or creating a carefully choreographed chain reaction of household props, as in their iconic film *Der Lauf der Dinge* (*The Way Things Go* 1986–7) [→ chap.XIX], Fischli/Weiss consistently gravitate towards using objects in way that mirrors a child's creativity or an amateur's resourcefulness. This precise choice of materials not only 'read' as being defiant of high art standards, the use of ordinary things in un-ordinary ways foregrounds the central role that process plays in their oeuvre. In a related work to *Surrli*, Fischli/Weiss have assembled four everyday things – a flashlight, a record player turntable, a plastic cup and tape – into a domestically scaled 'do it yourself' light show. Entitled *Son et lumière – Le rayon vert* 1990) [→ chap.IX], this work not only flaunts the artists' ingenuity, it offers a humorous metaphor for the demystification of the mechanisms of the spectacle. This charming assemblage, like its sister work *Surrli*, is less a mockery of the entertainment industry, than an earnest attempt to tap into our collective attraction to the sublime through the simplest aesthetic means. These two emblematic works are an important part of Fischli/Weiss's on-going search for beauty – a preoccupation that has led them to explore some of the most hackneyed themes ranging from flowers, to airports in their more recent work.

———

Mechanically produced 'light sculptures', using a hand-operated 'Surrli machine' made from wood, metal, lamps and batteries
1989
Photographic work in 35mm slide film with time exposure: 3 Cibachromes, 125 × 200 cm; 40 Cibachromes, 16 × 24 cm; slide projection using 2 projectors, cross-fading between 162 variants of *Surrli* pictures

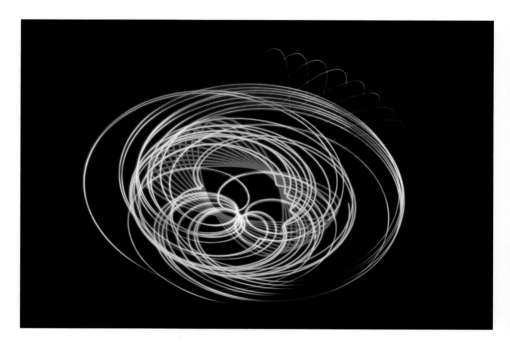

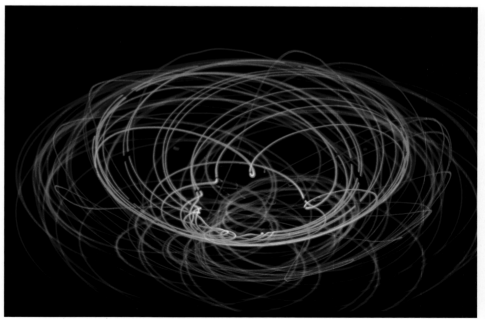

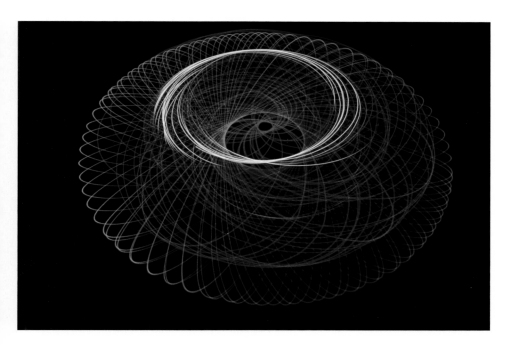

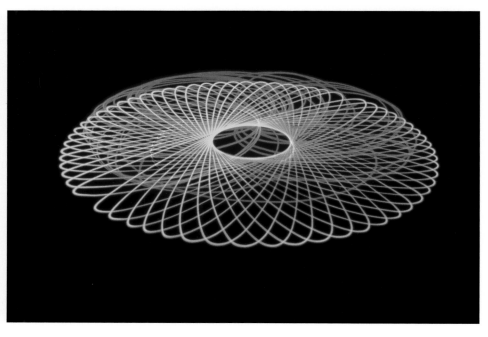

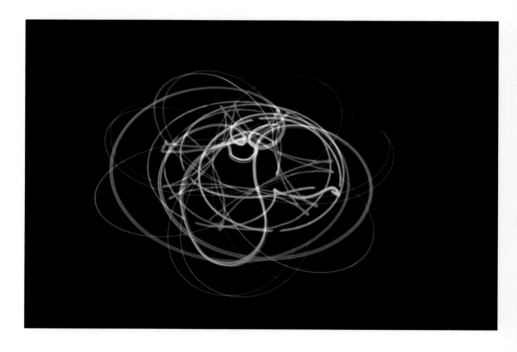

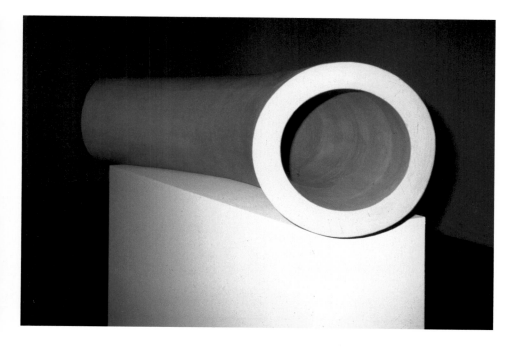

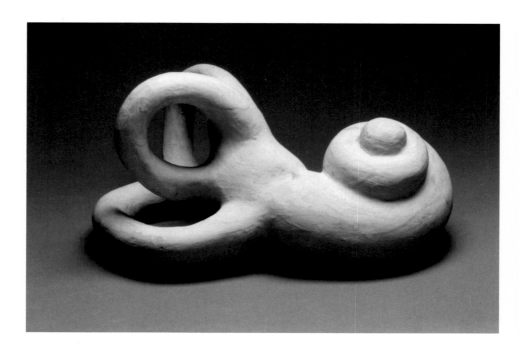

VI

—

Daniel Birnbaum

—

GREY, NOT BLUE

—

Grey sculptures by Fischli/Weiss. Grey sculptures. Grey ... I can't really remember. But I'll try.

Grey memories. Blue memories range from the sharpness of ultra-violet remembrance to the azure abundance of well-lived, if sadness-tainted, memoirs; it is a satiation in which time is caught, and discolours, like caramels in the clenched fist of a child. Grey memories, by contrast, are heaps of vacuumed dust, a hunger feeding on itself, off itself, and thus able, gnawingly, only to increase. At most, a grey mouth would exclaim 'Now, what was it ... ?' but, well, never 'O, it was ... ' or some similarly velvety variety of randomness and recollection. In the case of blue, absence is full and thriving, while here it remains as empty as a cenotaph. Instead of an intense flame releasing life's rapture and bounty, gushing delight, there is only vapour containing but dearth and missed connections.

Yet both blue and grey have a tendency to withdraw ... to disappear quietly when approached quickly ... like noon-time shadows ... which is not the case with yellow, for example, a colour which both Goethe and Kandinsky

held to be expanding in the way the sun drills its light into a silken eye filled with buoyancy (a whirling auger against which our gaze is powerless since all sight depends on light). But in blue, a person either gets lost because its dimness is so close and its attraction so great that every fall is sweet as a stroke, or because its brightness is so vast, its chill so open, that each breath expresses unconstrained freedom. To get lost here is to locate a deeper solidarity, another community, an absorption so fundamental that it may confirm an identity even behind a pronoun as hopelessly accidental as 'I'.

To be sure, we also get lost in the grey, but here everything remains uncertain – cloudy weather, cloudy memories and often simply clouds; memories that appear, mellow fields, frosty mist and still other clouds above darker fields. But where from, and how? As fog or dusk will make any distance shrink without diminishing it in the least, like a long-distance phone call, grey provides the kind of uncertainty accompanied by the feeling that something invisible is close by, yet it remains absent no matter how near it hovers. An Umbrian companion. Or the inside of a wind. For in the grey we also loose ourselves, oblivious of direction, no longer retaining any hold on life. Yet nothing is offered into which we might immerse ourselves, no embrace as secure as that of the mother's blue bosom or the warmly lined inside of a winter coat, pulled out again from the closet. It is like being the shadow cast by nobody. And therefore uncanny. And therefore uncanny, and therefore vaporous.

'Il fait gris,' Clov says to Hamm, and adds: 'Gris! GRRIS!' [a]

a) Aris Fioretos, *The Gray Book*, Palo Alto 1999.

———

Gauze-covered, painted polyurethane
Group of 11 sculptures, the smallest, approx. height 60 cm (*Gleichgewichtsorgan [Equilibrium Organ]*) [–› p.76], the largest, ø 150 cm, height 400 cm (*Turm [Tower]*)
1984–6: *Gleichgewichtsorgan (Equilibrium Organ)*, *Bohne (Bean)*, *Röhre (Tube)* [–› p.75], *Möblierte Wohnung (Furnished Apartment)* [–› p.79], *Grosser Fragentopf (Large Question Pot)*, *Kleiner Fragentopf (Small Question Pot)* [–› p.79], *Tier (Animal)* [–› p.82], *Fabrik (Factory)* [–› pp. 80/1], *Casa Metafisica* and *Turm (Tower)*
2006: *Ei (Egg)*

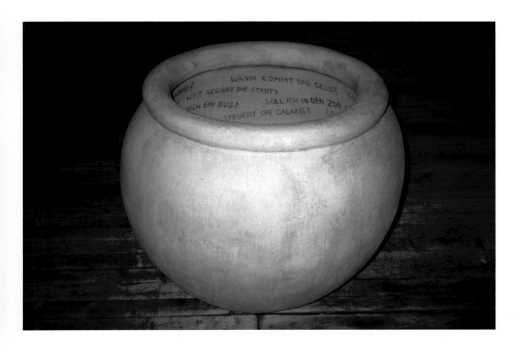

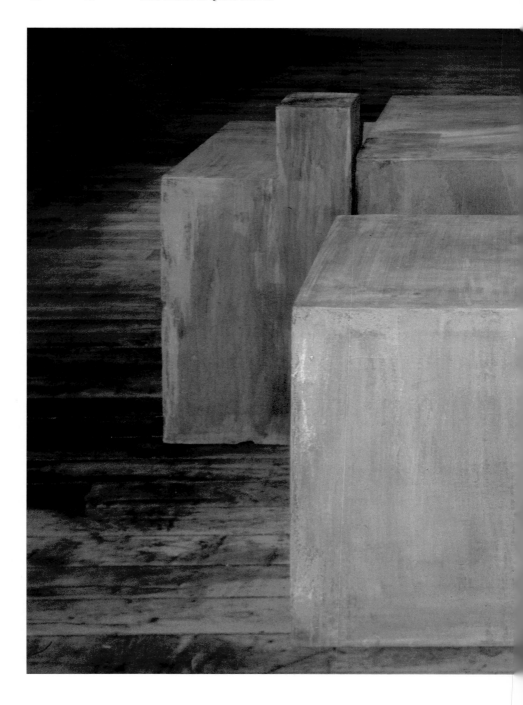

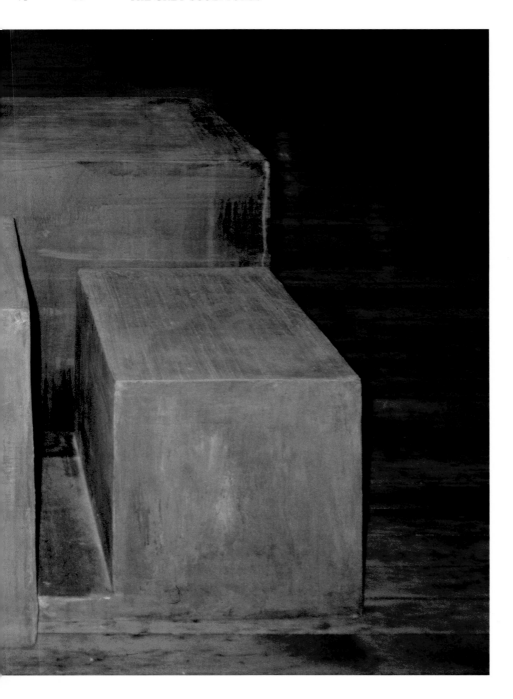

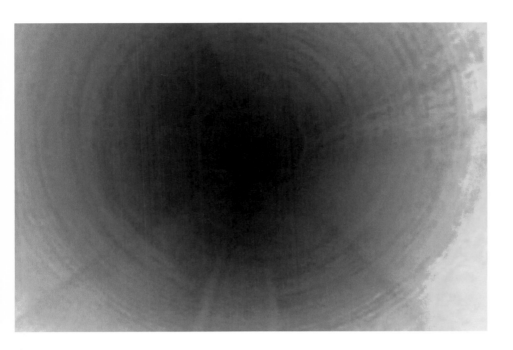

VII

—

Robert Fleck

—

—

Kanalvideo 1992 by Peter Fischli and David Weiss always reminds me of a particularly absurd situation indicative not only of the simplicity and complexity of their work but also of the countless well-meaning misunderstandings that at times colour the reception of their output. The thing is that one can develop a deep relationship with an artistic work from non-artistic factors, even from greater or lesser intellectual mishaps that may on occasion lead as unerringly to the heart of a work as the best, most coherent analysis.

In early 2004 I went to a talk in Germany on the work of Peter Fischli and David Weiss. The otherwise very competent speaker explained at least a dozen times that apart from their work, virtually nothing was known of the two artists. There were no biographical anecdotes. No one was sure where they really lived, how they went about their work and what they themselves thought of their work, because they refused to be interviewed. Furthermore,

according to the speaker, if one knew the two artists personally this 'Duch-ampesque' aspect of the art of Peter Fischli and David Weiss could be discon-certing. However, he concluded, the lack of relevant information was per-fectly understandable because they were simply very sparing when it came to that whole system of anecdotes and interviews that in the Western art world surrounds the artist to satisfy the primarily biographical curiosity on the part of the public. In a certain sense, the speaker was right when he said that Peter Fischli and David Weiss deliberately avoid the usual treadmill of the art busi-ness. However, the attempt to base a Duchamp-style interpretation of their artistic will on this was hardly convincing, not least because in reality there are numerous written and eye-witness accounts of their work that the speaker was either unaware of or had chosen to ignore.

At end of the talk, the speaker came up with a surprise. Although as good as nothing was known about the artists, he had obtained their permission to show their most recent work. This was a video piece that was to be pro-jected according to the express instructions of the artists who, he added, had only very reluctantly agreed for this new work to be shown exclusively during the course of this talk. As far as the contents of the video were concerned, the speaker assured his audience, these were shrouded in the same mystery of non-explanation as the rest of the work of Fischli/Weiss. This new work was apparently an abstract video that viewers should contemplate in a meditative manner as their gaze was drawn inexorably into a white abyss. Moreover, the video was silent, which further reinforced the meditative nature of the work.

At this point the audience was presented with *Kanalvideo,* which had already been seen nine years before this lecture by several hundred thou-sand visitors to the exhibition in the Swiss Pavilion, designed by Fischli/ Weiss, at the 1995 Venice Biennale. It is not so much the mistaken notion in the talk in 2004 that this was a new work that is of interest here, but rather the weighty, wholly earnest framework of interpretation – or rather connota-tion – that the speaker rolled out to whet the audience's appetite for the screening of the video. He told his listeners of a mysterious film, a work that was trying to achieve pure abstraction in the realms of video art, a video work that would engage the viewers' empathy and induce in them an intensely meditative state.

A few days later, during a telephone conversation, Peter Fischli and David Weiss referred to the same video by its deliberately simple, unpreten-

tious title, *Kanalvideo*. While they were working on their four-part video work for the Swiss Pavilion in Venice in 1995, they had learnt with interest that once a year the water authorities in Zurich check the city's sewer system with a video camera in order to identify any internal damage to the pipes. This then formed the basis of *Kanalvideo*, shown in summer 1995 as a second Fischli/Weiss piece in the rear section of the Swiss Pavilion.

There could hardly be a more diametric contrast between a will to art that stands out for its insistence on simplicity and wholly unpretentious approach, on one hand, and the tendency on the part of art historians and viewers, on the other hand, to impute the art with metaphysical intent (and to interpret it accordingly) than was seen in the presentation of *Kanalvideo* in that German lecture in 2004. But both moments have an objective existence. This in part explains not only the impact of Fischli/Weiss's work but also its range and its capacity to speak through a variety of media to a broad public; and although the artists accept the possibility of productive misunderstandings in the reception of the work, they never anticipate these in the work in a cynical or calculating manner. The work of Fischli/Weiss, like *Kanalvideo* for instance, is distinguished by a special simplicity in its handling of forms, a simplicity that has to do with the Bauhaus tradition, although it consciously does not also draw on the philosophy of that tradition. The philosophy of their work derives from a second element, namely their ability to deliberately side-step aesthetic and artistic notions and imaginings by means of visual propositions that are so very unpretentious that by any normal standards one would never take them for serious art. But, as I was saying, this has nothing to do with cynicism, but is a means to intentional simplicity that enables Fischli/Weiss to take a bafflingly surprising, fresh approach to a whole spectrum of very different media, from video to sculpture, photography, film, slide projections and the artist's book.

This simplicity, freshness and lack of pretension also distinguishes *Kanalvideo*. It is a found video, of sorts, in the sense that the Zurich water authorities had to make it to examine its network of underground pipes. But it is not a readymade in the sense of Marcel Duchamp, because it has nothing to do with *pars pro toto*. Rather it is a radically anti-metaphysical work that has clear echoes of the 'against interpretation' attitude of artists in the 1960s. But at the same time it is only too susceptible to all kinds of metaphysical misunderstandings, which in turn account for at least some of its poetic effect. The

public that sat gazing at this video in January 2004, mentally prepared for a 'meditative, abstract video', may well have suspected that in reality they were looking at an extremely simple, no more than ordinarily aesthetic, phenomenon. And precisely that awareness is the source of the delicate magic that frequently suffuses the art of Peter Fischli and David Weiss.

———

Video, 60 mins., silent, assembled from recordings by the water authorities made during several trips through the Zurich sewer system
1992

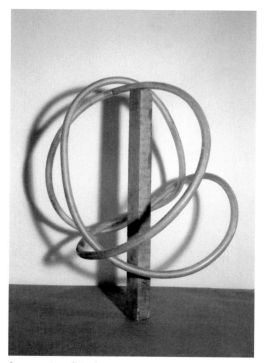

International Style

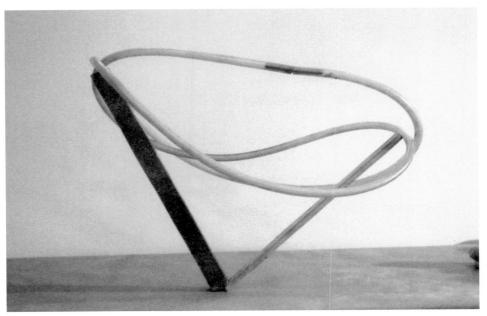

Reclining Figure

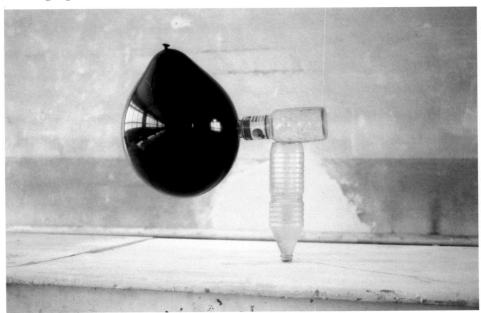

Artificial Intelligence

VIII

—

Claire Bishop

—

—

One of my favourite pieces of writing on Fischli/Weiss is by Peter Schjeldahl, because he openly refuses to make grand claims for their work. In fact, he does the exact opposite: 'As professional artists, these guys are pretty jejune. Their ideas are hybrids or retreads of precedents they don't advance or other-wise alter significantly.'[a] It's true: Fischli/Weiss don't strive to be the first or best or most spectacular. They even seem to harness mediocrity. As a result, all attempts to stake them a place in art history appear painfully strained, since every aspect of their work actively resists aggrandisement. *Stiller Nach-mittag* (*Quiet Afternoon* 1984/5) is completely typical in this respect. It com-prises a series of twenty-seven photographs of sculptures made using every-day objects precariously arranged into understated, pointless and often unmemorably complex configurations. The titles veer from daft narrative to deadpan allegory, neologisms, untitleds and the utterly inexplicable. None of the compositions bear any significant relation to any of the others in the series, which is so disparate that it fails to produce a coherent whole. There could be forty pictures or only five; it wouldn't make that much difference.

Such slack randomness has an immediately deflationary effect on art historical analysis. If anything, *Quiet Afternoon* is a send-up of traditional sculpture and the language with which we read it. Composition, matter, dynamism, weight, pictoriality: all these terms fall flat in the face of ropey materials and bathetic titling. It's hard to discuss a work as sculpture when the object of your study is a quizzical courgette tentatively gracing a stumpy carrot supported by a slim cheese grater. What follows, then, is a replacement for such potentially excruciating legitimations. It's a short compendium of art references that come to mind when perusing *Quiet Afternoon*. What comes to the fore is the recurrent theme of gravity: a split second of provisional balance before the objects come clattering to the floor. Perhaps those afternoons weren't so quiet after all.

Am Abgrund (On the Brink)/Das Experiment (The Experiment)/Die Verfeinerung (Refinement)

'Raised up, but visually unstable, these table sculptures could be smaller in scale, skeletal, and so present faster, dynamic compositions. Elegant drawings in space, they lead the eyes like swift dancers, seemingly ready to step gracefully free of the table's boundaries.'[b]

Schlummerschlinge (Slumber Loop)/Ohne Titel (Untitled)/Die Verschwörung (The Conspiracy)

'Sometimes a direct manipulation of a given material without the use of any tool is made. In these cases considerations of gravity become as important as those of space. The focus on matter and gravity as means results in forms that were not projected in advance. Considerations of ordering are necessarily casual and imprecise and unemphasised. Random piling, loose stacking, hanging, give passing form to the material.'[c]

Ohne Titel (Untitled)/Ehre Mut und Zuversicht (Honour Courage Confidence)/Die Barrikade (Barricade)/Die Gesetzlosen (Outlaws)/Ohne Titel (Untitled)

'For these sculptures are resolutely vertical, their internal dynamic securing their independence of any external "ground", be it floor or wall. And the extremely simple principle of their verticality is the heaviness of lead and its earnest response to the downward pull of gravity; for in that pull there operates the resistance that is the principle of the prop – stability achieved through the conflict and balance of forces.'[d]

Der Kreislauf (Melancholy, Longing, Strategy, Tactics, Fulfilment. A Cycle)/Masturbine/Flirt, Liebe usw. (Flirtation, Love etc.)/Die Gefahren der Nacht (Night's Danger)

'These objects, which lend themselves to a minimum of mechanical functioning, are based on phantasms and representations susceptible to being provoked by the realisation of unconscious acts. Acts of realisation from which one can hardly explain the pleasure drawn, or which render account of the erroneous theories elaborated by censorship and repression. In all the cases analysed, these acts correspond to fantasies and desires clearly characterised as erotic.'[e]

Frau Birne bringt ihrem Mann vor der Oper das frischgebügelte Hemd. Der Bub raucht (Mrs Pear Bringing her Husband a Freshly Ironed Shirt for the Opera. The Boy Smokes)/Natürliche Grazie (Natural Grace)/Hase (Hare)/Zorn Gottes (God's Wrath)/Die Seilschaft (Roped Mountaineers)

'To quote Roland Barthes, he never tired of using "different forms to represent the same thing. Does he want to paint a nose? His multitude of synonyms proposes a branch, a pear, a pumpkin, corn, flowers, fish." Interest is centered neither in the fish nor in the nose alone, but in teasing the very concept of reciprocity [...] By exploiting duplicity and reversibility, the artist makes of the canvas at once a grotesque portrait and a still life. However abstract, linear perspective accepted space as the gravitational link between man and reality. For Arcimboldo, instead, the only center of gravity was his own mind, in which eccentricity reigned supreme.'[f]

Ohne Titel (Untitled)/Die gefeierte Rübe (Triumphant Carrot)/Stiller Nachmittag (Quiet Afternoon)/Der dunkle Trieb (Dark Impulse)

'Typically involving feats of balancing, the actions that comprise *One Minute Sculptures* often suggest a bizarre type of object-assisted yoga. In the video *One Minute Sculptures* (November 1997), Wurm attempts, among other things, to do a headstand with a chair on his back; to stand on a pair of plastic polka-dot balls; to lie on his side along the length of a narrow wooden stud; and to balance a yellow bucket on his head.'[g]

Das Provisorium (Provisional Arrangement)/Reagans Modell von der bewaffneten Raumfahrt (Reagan's Model for Armed Space-Travel)/Die Gewerkschaft (Trade Union)/Die missbrauchte Zeit (Time Abused)

'The earliest performance things that were filmed were things like you sit in the studio and what do you do. Well, it turned out that I was pacing around the studio a lot ... That was an activity that I did so I filmed that, just this pacing. So I was doing really simple things like that ...'[h]

a) Peter Schieldahl, 'Childs's Play', in *Artforum International*, New York, no. 10 (1996), p.126.

b) Julius Bryant, *Anthony Caro, A Life in Sculpture*, London 2004, p.13.

c) Robert Morris, 'Anti Form', in Morris, *Continuous Project Altered Daily*, Cambridge, Massachusetts 1993, p.46.

d) Rosalind Krauss, 'Richard Serra: Sculpture', in Hal Foster (ed.), *Richard Serra*, Cambridge, Massachusetts 2000, p.108.

e) Salvador Dali, 'Objets Surréalistes', in *Le Surréalisme au service de la Révolution*, New York, no. 3 (1968), p.16.

f) Giancarlo Maiorino, *The Portrait of Eccentricity: Arcimboldo and the Mannerist Grotesque*, Pennsylvania 1991, p.34.

g) Ralph Rugoff, 'Liquid Humour', in Berin Golonu, *Erwin Wurm, I Love my Time, I Don't Like my Time*, Ostfildern 2004, p.19.

h) Bruce Nauman, in *Bruce Nauman*, Walker Art Center, Minneapolis 1994, p.73.

1984/5: 45 different photographs, colour and black-and-white, portrait and landscape
Two series: 30 × 24 cm and 40 × 30 cm
2006: Additional *Equilibres* from old negatives

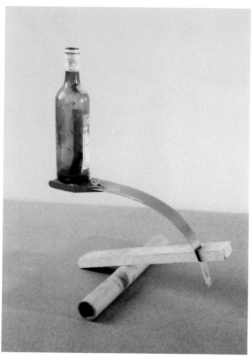

The Egoist

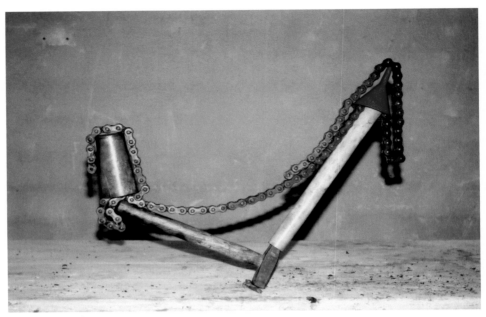

Shine and Work

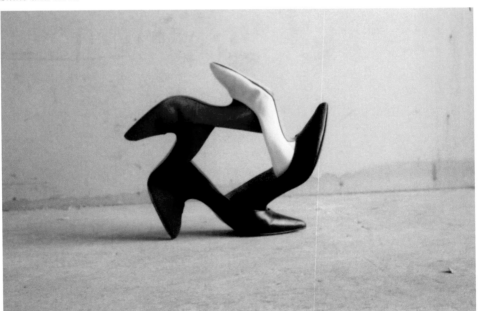

Flirtation, Love etc.

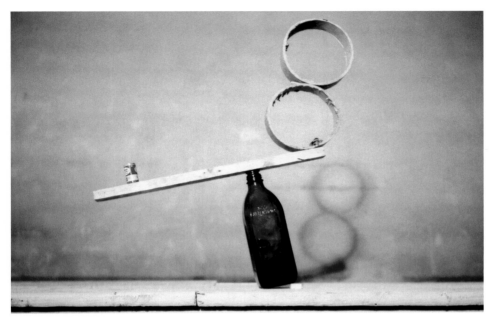

A Day's Work

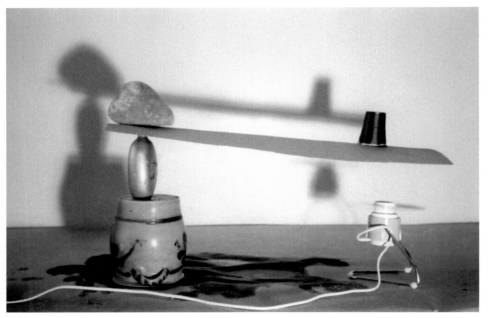

Tenderness

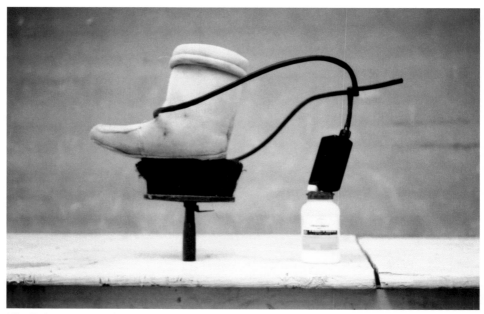

The Sedative

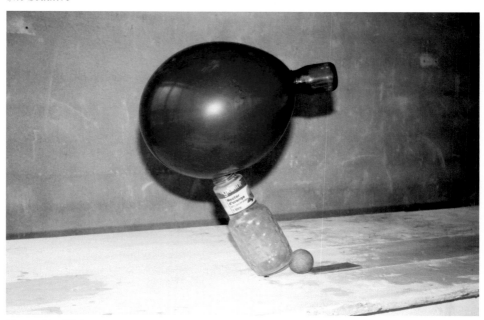

Expanding Universe

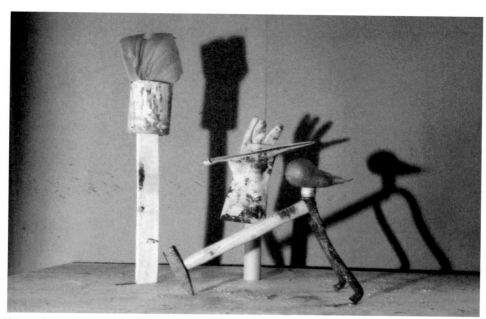

Mr and Mrs Pear with their New Dog

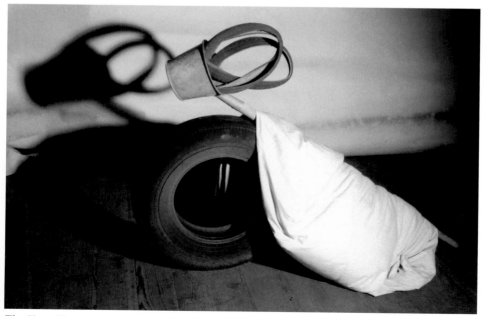

The Hare-Woman

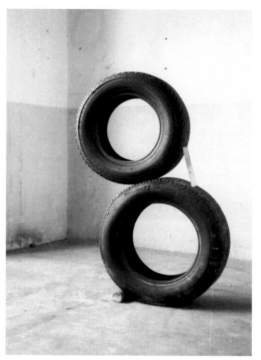

The Invention

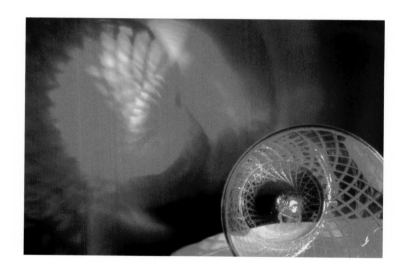

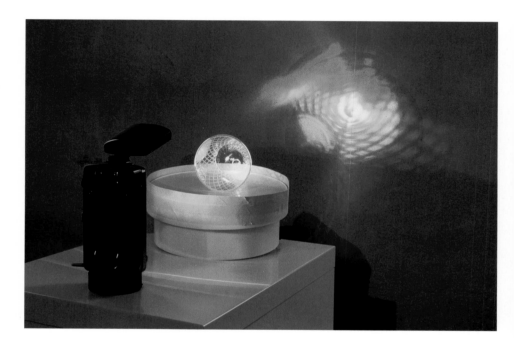

IX

Tacita Dean

—

SEND MORE CUPS

—

The *lumière* you understand immediately as you watch the spiralling red and green torchlight make patterns on the wall, but it is the *son* that surprises you: the rhythmic scratching of the plastic cup on the slightly inclined turntable, lolling, as it does, back and forth, back and forth, making sounds indescribably specific to when a plastic cup moves upon a surface. The turntable is grubby and worn where the cup has shifted, and masking tape around the edge forms a lip to prevent it rolling off. It looks homemade, *hausgemacht*, like a work of art should look sometimes but rarely does: thought up and made on the spot. Utterly simple and utterly compelling. One could have pre-imagined the light but not the sound. It is the sound that must have provided the title. Once heard, it needed equal billing: sound and light; *son et lumière*.

Only *son et lumière* normally has greater pretensions: a light show projected on the watered frontage of a castle or chateau with music amplified through temporary speakers to rows of collapsible seats put out in anticipation. It is the spectacle to crown a summer, the height of refined outdoor entertainment, but which quickly can become spectacular boredom or the

boredom that can often accompany the spectacular. But this confluence of cultural pretensions and cultural detritus is where Fischli/Weiss find their work. Nothing delights them more than deflating the majestic or elevating the quotidian, playing with our social signifiers, realigning them, redescribing them. Their material is our rubbish, our platitudes and our banalities, which they transmute like alchemists.

I have written about this work before. Then it was in the context of the green ray or *le rayon vert*, a phenomenon not easily seen, when the last ray of the setting sun flashes green briefly before disappearing beneath the horizon. It inspired Jules Verne to write his novel *Le rayon vert* which then inspired Eric Rohmer to make his film with the same title which in turn inspired Fischli/Weiss to sometimes switch their flashlight to green only and make a version of their work called *Son et lumière – Le rayon vert* 1990.

This morning I found in my files an envelope on which I had scribbled notes from a telephone conversation I had had with David two years ago. The notes read like a poem to the moment when they had the idea for *Son et lumière*. You immediately see them ambling down a road in Brazil and spotting the rotating cake stand in a shop window. And then later, in the narrative of this idea, watching people on a beach making light drawings against the night sky, and then finding that particular cross-hatched design on a plastic cup …

S. America
turntable
we bought something turning
windows
Shop
cake turntables
machine line drawings
look like computer drawings
beach Rio de Janeiro
in the dark make drawings
in the dark
geometric drawing
building same spirit

cheap thrills
by chance plastic cup drawings on it

Send more cups

Projection with kinetic objects: torch, turntable, corrugated plastic beaker, adhesive tape
Installation size variable, approx. 40 × 80 × 50 cm
1990

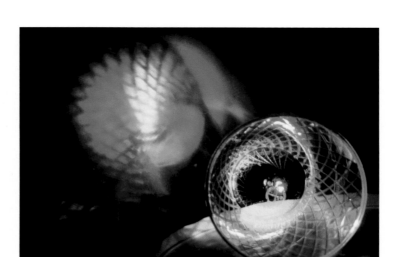

X

Dominique Gonzalez-Foerster

LIST

—

1 agglomeration
2 artists
4 seasons
8 roads
16 service stations
32 villages
64 playgrounds
128 car parks
256 bus shelters
512 pedestrian crossings
1,024 modern buildings
2,048 fir trees
4,096 lamps
8,192 road signs
16,384 motorbikes
32,768 washing lines

65,536 bushes
131,072 cars
262,144 residents
524,288 daisies
1,048,576 dead leaves

Missing from this list are windows, tons of snow, lawns, fences, flowerpots, balconies, football goals, puddles, parasols, curtains, garages, trees in bloom, garden furniture, manholes, tulips, stacks of wood and lots of other things.

———

C-prints, 16 × 24 cm
First series: approx. 45 images of settlements, from the evolving archive of *Sichtbare Welt* (*Visible World*) [–› chap.XXVI]
1993

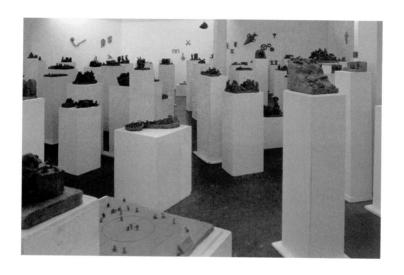

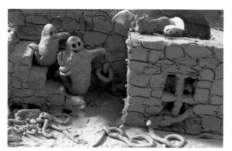

In the Cellar

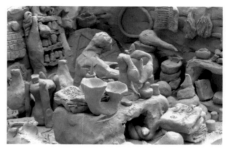

Alchemist

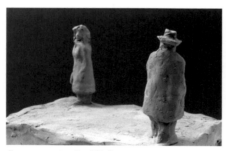

Strangers in the Night ... Full caption –› p.343

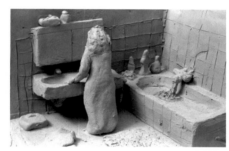

Woman in Bathroom

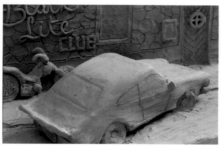

Milieu

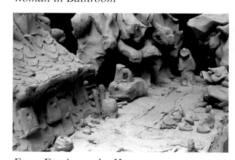

From Far Away the Hunter ... Full caption –› p.343

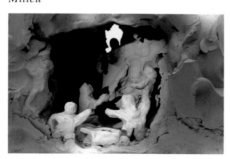

Gotthard Breakthrough

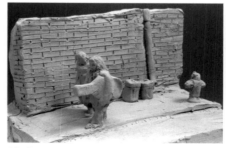

Mick Jagger and Brian ... Full caption –› p.343

XI

—

Nancy Spector

—

—

The phrase 'suddenly this overview', when uttered by the rat in Peter Fischli and David Weiss's film *Der Geringste Widerstand* (*The Least Resistance* 1980–1) [→ pp.185, 186, 197–201], describes a revelation, a moment of utmost clarity when the universe appears to cohere into predictable patterns. At least that is what the rat and his partner in crime, the bear, think at the time. Frustrated, and forlorn due to their inability to cash in on ludicrous get-rich schemes and to become the art stars they imagine themselves to be, this duo sinks into despair until realising simply that 'there is an explanation for everything'. This discovery occurs to them while watching a setting sun, moved by the sensation that there might be something greater than their petty desires. 'The sun is rising in Japan now ... A new day is beginning and people are going to work,' muses the bear. 'It's good, the way it's all arranged,' retorts the rat. This discovery catapults them into action, and the rat and the bear set out to diagram their world, to 'bring light into the darkness.' They attempt to wrest order from the chaos of their everyday reality by documenting perceived systems of growth and development, opposition, communication and

so on. Ever enterprising, these amateur philosophers produce a concise pamphlet entitled *Ordnung und Reinlichkeit (Order and Cleanliness)* [→ p.202–5] to elucidate their own rather insulated and eccentric understanding of the way things work. With product finally in hand, the rat and the bear are poised to capitalise on their new-found knowledge, and last scene in the film shows them flying off in a helicopter presumably to spread the word, like evangelists of orderliness.

Fischli/Weiss actually produced this pamphlet as an artists' book and offered it for sale at the screening of *The Least Resistance*. With its various graphs and diagrams, *Order and Cleanliness* compares contrary systems such as man versus animal or materiality versus emotion, and charts the evolution of the individual (from 'bed wetter' or 'good baby' to 'bad artists' or 'university professors' respectively), among other equally broad subjects. This little book is a deliberate farce that riffs as much on Joseph Beuys's revered, pseudo-scientific, Steiner-like chalkboard drawings as on the artists' own Swiss heritage, with its clichéd attention to precision and order. The reference to hygiene in the title certainly plays on this nationalistic stereotype and foregrounds Fischli/Weiss's own droll sense of humour (if it hadn't yet come across in their depiction of themselves as con artists in scruffy animal costumes). Created at the beginning of their career-long collaboration with one another, *Order and Cleanliness* outlines the artists' conceptual programme and indicates that their goal going forward would be to provide an 'overview' of their world, no matter how contrived or banal it might be.

In the same year as *The Least Resistance* and its accompanying publication, the two co-conspirators created a sculptural analogue to their systematic reading of the universe. Aptly titled *Plötzlich diese Übersicht (Suddenly this Overview)*, the work comprises 250 small, hand-crafted sculptures that collectively map the history of time as we know it, from *Der erste Fisch beschliesst an Land zu gehen (The First Fish Decides to go Ashore)* to *Moderne Siedlung (Modern Development)*. Crudely rendered in unfired clay, the sculptures convey a kind of call-and-response interaction between the artists, like an improvisation in jazz music. One can just imagine the scenario:

FISCHLI

'How about the life of Albert Einstein? That's certainly momentous.'

WEISS

'Great idea, I'll get right to it, but let's show only the moment after his conception when Mr. and Mrs. Einstein are already asleep.'

FISCHLI

'OK, now what about the Buddha? I know, let's show him sewing!'

WEISS

'Let's also think about popular culture; what on Earth should we include?'

FISCHLI

'Hmm, that's tough – there's the Beatles, Hendrix, Joplin, Clapton, Dylan … '

WEISS

'Yes, Dylan!!!!! Let's show him first arriving in New York, a veritable nobody getting off the bus.'

FISCHLI

'I think this topic deserves more attention. I'm going to make Mick Jagger and Brian Jones going home satisfied after composing "I Can't Get No Satisfaction".'

WEISS

'Before we get carried away here (but then again, why not?), we have to also deal with the entire history of Judeo-Christian thought.'

FISCHLI

'I have some ideas for that but not until I make the invention of the miniskirt. OK, let's see, we have Adam asleep in paradise, before there were women … '

WEISS

'I know, I know, how about Cain and Abel, the parting of the Red Sea, Christ on the Cross, some monks, St. Francis preaching about the purity of the heart … '

FISCHLI

'OK, OK, enough. We still have to think about fairytales – you know, Snow White, Rose Red, Little Red Riding Hood, Rumpelstiltskin and Puss in Boots – and evolution, too.'

WEISS

'That's easy, there's cell division, the last dinosaur, the invention of fire … But where do we stop?'

FISCHLI

'I don't know – when we run out of clay? We have all the time in the world, nothing much else to do, and no dearth of ideas.'

WEISS

'That's either our curse or our blessing.'

In addition to the perceived milestones of civilisation – which also include the construction of the first pyramid, Gutenberg inventing the printing press and Anna O dreaming her first dream for Sigmund Freud – Fischli/Weiss depicted a selection of mundane objects in their 'overview' as if to ground their grandiose cultural allusions in banal, everyday things. Hence, *Suddenly this Overview* also contains sculptures of a loaf of bread, an anchor, a pot, a plate of peanuts, a tea set, a backpack and some bones among other sundry items, all rendered with the same child-like technique. There is a third category to this obsessive catalogue as well, which harks directly back to *Order and Cleanliness* in its focus on common dualisms. Dubbed by the artists *Beliebte Gegensätze* (*Popular Opposites*), a number of the sculptures give physical form to contrary states, but blur the distinction between them in the process, suggesting that difference is not innate, but lies, rather, in perception. For instance, the comparison between small and big is typically demonstrated by a mouse and an elephant, but here each animal is the same size, showing that dimension is always relative (i.e. a mouse would seem huge to a flea). And similarly, for the representation of good and evil – manifest by Fischli/Weiss as roughly hewn figures engaged in battle – the physical differences between them are indiscernible. The distinction between high and low – presumably a reference to the cultural strata so dear to keepers of the aesthetic integrity of the fine arts – is illustrated by the figures of two dachshunds, one standing on its hind legs, the other on all four. For Fischli/Weiss, whose work emulates the low (which is different than merely depicting it), the division between that and some lofty, rarefied realm is artificial and arbitrary.

As part of their interrogation into the validity of binary structures, the artists also lampoon the distinction between outer and inner by presenting a staid, normal-looking person and his wildly uncontrollable id. In this sculpture they are taking on the fundamental suppositions of Psychology 101 – that

man is inherently divided into his outer, socially determined persona and his inner, more primal self. While not explicitly denying the existence of different realms of being, Fischli/Weiss question the kind of dualistic thinking that isolates and evaluates seemingly separate entities or ontological states that, in reality, can blur into one another in provocative and meaningful ways. But Western culture has long forbidden the intermingling of perceived opposites (as well as the union of the same, but that is a different story entirely). The artists play with this notion in the *Popular Opposites* sculpture devoted to man versus animal, which shows a person on all fours wearing the costume of a horse. Man *is* an animal, after all. But in our culture, this reality is entirely sublimated, pitting man *against* beast (in areas of sport, labour and agriculture). In the end, however, the artists are really challenging the privileging of theory over practice, in which pompous postulating too often obfuscates, or entirely replaces, the act of doing. The sculpture from the *Popular Opposites* series that subverts this duality combines a wheelbarrow laden with material and a man holding the feet of another who is walking on his hands. While the men can demonstrate the physical mechanics of the wheelbarrow in this child-like posture, they cannot approximate its weight-bearing capacity. With this nimble juxtaposition, the artists reveal the hazards inherent to favouring concept over function if one wants to get anything done.

Fischli/Weiss's anti-theoretical stance would have been particularly pointed in 1981, when the art world – or at least the critical writing associated with it – was suffused with 'theory', deconstructive, post-Structuralist, postmodern thought that influenced the production and interpretation of an entire genre of visual art. It is not that the artists are patently against theory – they have simply refused to jump on any defining bandwagon, resisting, for instance, both the visceral *Sturm und Drang* of 1980s Neo-Expressionism and the machinations of French thought. Fischli/Weiss have fashioned themselves as anti-heroes who create a deceptively simple, low-brow art form that probes some of the more profound aspects of daily life with subtle humour. The wilful absurdity of *Suddenly this Overview*, with its pretensions to chronicle the history of the world and explicate its thought systems, links the two artists to infamous literary pairs with wholly idealistic aspirations like Cervantes' Don Quixote and Sancho Panza; Beckett's Vladimir and Estragon; and Flaubert's

Bouvard and Pécuchet. It is the latter duo, a nineteenth-century 'odd couple' that Fischli/Weiss most closely approximate, particularly in their playful attempts to represent the entire world.

Bouvard and Pécuchet 1881, Flaubert's last, unfinished novel, tells the tale of two Parisian copy clerks who retire together to the country when one of them comes into an inheritance. Craving the kind of direct engagement with real life denied to them by their desk-bound profession, the men set out to cultivate their new land despite utter ignorance about the process. After consulting various agricultural journals and applying their newly gained knowledge (often in direct opposition to advice offered by more experienced neighbours), Bouvard and Pécuchet fail at every turn. Convinced they only need to study the disciplines they wish to pursue, they are never able to reconcile the theoretical with practical applications, thus losing themselves in internal contradictions and faulty reasoning. Impervious to their unrelenting failures, the two work their way through the entirety of the human sciences: arboriculture, landscape design, palaeontology, medicine, chemistry, anatomy, physiology, geology, archaeology, religion, metaphysics and so on. No matter how earnestly they try, the men are unable to master any of their subjects. They assemble an encyclopaedia of world knowledge, but its content remains ineffable; their efforts at totalisation result in its opposite – fragmentation, incompleteness and a sense of overriding randomness. The pair finally concedes the bankruptcy of their endeavours, and it is with great relief that they revert in the end to their original profession as copyists, spending the rest of their days duplicating everything and anything that comes their way. While Flaubert did not complete the novel, he left copious notes towards its ending, from which the following passage is derived: 'Then they feel the need for a taxonomy. They make tables, antithetical oppositions such as "crimes of the kings and crimes of the people" – blessings of religion, crimes of religion. Beauties of history, etc.; sometimes, however, they have real problems putting each thing in its proper place and suffer great anxieties about it.

 Onward! Enough speculation! Keep on copying! The page must be filled. Everything is equal, the good and the evil. The farcical and the sublime – the beautiful and the ugly – the insignificant and the typical, they all become an exaltation of the statistical.'[a]

Flaubert planned a second volume to *Bouvard and Pécuchet*, which would presumably have been filled with what the characters obsessively copy and diagram – their own map of the world, as it were. It is tempting to imagine that with *Suddenly this Overview* Fischli/Weiss have completed that volume for him.

a) Eugenio Donato, 'The Museum's Furnace: Notes Toward a Contextual Reading of *Bouvard and Pécuchet*', in *Textual Strategies: Perspectives in Post-Structuralist Criticism*, ed. Josué V. Harari, Ithaca/New York 1979, p.214.

———

250 unfired clay sculptures
Smallest object: 6 × 7 × 5 cm, largest: 5 × 53 × 82 cm
Shown for the first time at Galerie Pablo Stähli, Zurich, in 1981

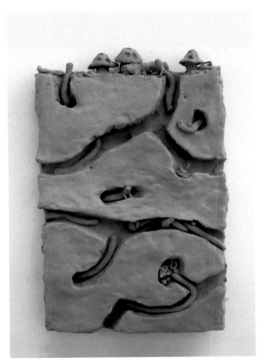

Under the Ground

Popular Opposites: Sweet and Sour

Popular Opposites: Funny and Silly

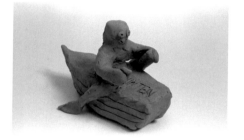

Popular Opposites: Front and Back

Popular Opposites: Man and Beast

Popular Opposites: Small and Big

Popular Opposites: Theory and Practice

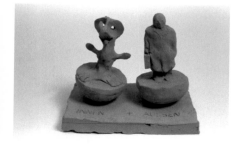

Popular Opposites: Inside and Outside

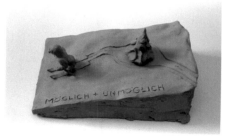

Popular Opposites: Possible and Impossible

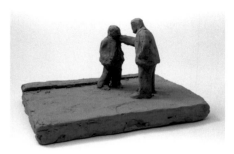

Lex Barker Hits Marcello ... <small>Full caption –› p.343</small>

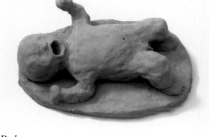

Baby

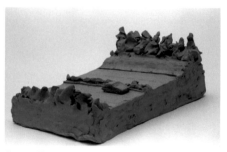

Bread

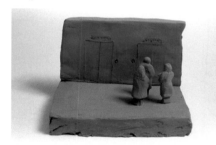

Waiting for the Elevator

Swiss Freeway

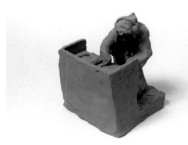

Disc Jockey

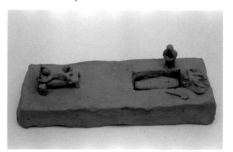

Birth and Death

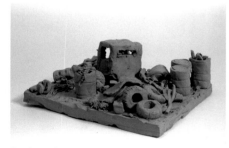

Junkyard

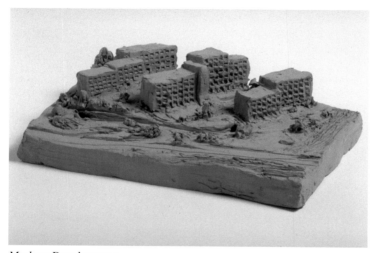

Modern Development

Mausi's Pissed

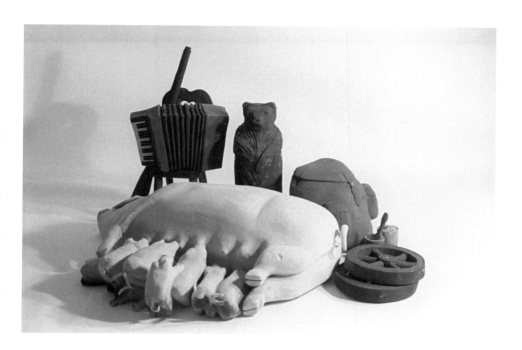

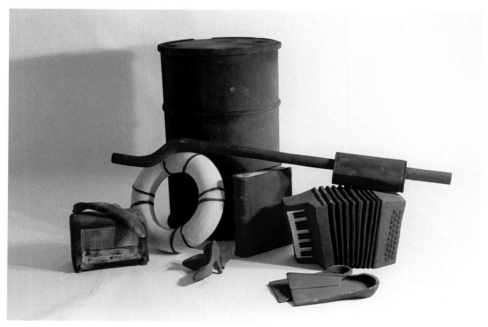

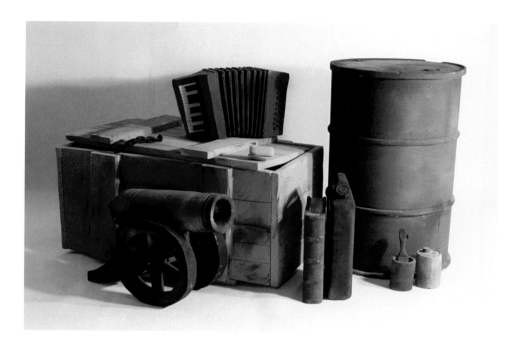

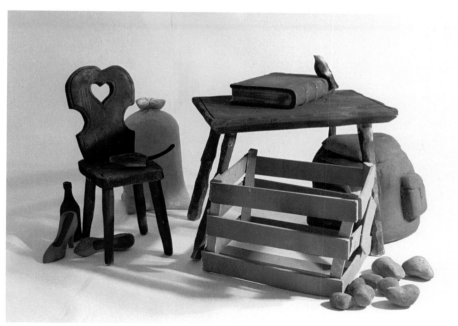

XII

—

Christy Lange

—

—

If all goes well, the first man to sail around the world on a raft will most likely be Poppa Neutrino. The 73-year-old American has built nine rafts in all, including one made entirely of scraps (and which sailed him across the Atlantic Ocean), though Neutrino swears that the secret to his new raft is its floatation device, made of polyurethane foam. Neutrino's raft looks like a childhood fantasy unfurled – a ragged dinghy clad in plywood and tarpaulin, with makeshift masts supporting old sheets for sails, and large blue water jugs strapped to its side. Before setting sail, Poppa Neutrino (the name is self-proclaimed) lived with his family aboard the raft in a New York City harbour, prompting the neighbours to call the raft an eyesore, and raising the Coast Guard's concern about the seaworthiness of the craft. Indeed, some see his adventure on the raft as a foolish attempt to defy nature, but for Neutrino, it's an alternative to an everyday home, and an everyday life. In the tradition of the Kon-Tiki or *The Raft of the Medusa*, the raft always totters between a symbol of self-made liberation and a basic life-saving device.

In Fischli/Weiss's installation *Floss* (*Raft* 1982), six wooden planks support a jumble of worldly goods: a treasure chest, a plump upholstered car seat, a teddy bear without legs, a sturdy table topped with a bottle of wine and a simple soap dish. Amounting to over seventy items in all, this could be the last stuff afloat in a flooded world, left at sea on a hastily cobbled-together lifeboat. Though the owner of the raft is nowhere to be found, and the only trace of life is a content pig nursing her six suckling piglets. Some of the remaining belongings on the raft look like useful tools for survival at sea: a bottle of milk, a rifle and a life preserver. Others, like the large anvil and the oil drum, might have been better off jettisoned long ago. But now the items have reached the end of the narrative: in the installation, sculpted crocodiles and hippos surround the raft, like scavengers waiting to feast. The tale is a sad one, but it's an animated version of sadness. After all, the objects are carved from foam that would float even without a raft, their supposed predators are hollowed-out halves of animals, and they're not actually stranded at sea, but on a museum carpet.

The *Raft* was Fischli/Weiss's first large group of polyurethane figures. Unlike the convincingly illusionistic installations that followed, this tableau suggests a cautionary tale about the folly of materialism in the face of survival – a kind of reversal of *The Raft of the Medusa* (save the stuff, jettison the people). It took the artists about six weeks to sculpt the objects for the raft, and in order to document its varied contents, they arranged the sculptures in different constellations on a neutral backdrop, playfully stringing together possible narratives to create the photographic series *Still Lifes: Objects from the Raft* 1982–3. Like actors being cast in a play, the sculptures look a little stiff on stage, posing for their portraits. But, then again, you would be stiff too, if you were carved of rigid polyurethane foam. The objects from the *Raft* are all carved of this same Ur-material – possibly the most un-unique substance on the planet, used in everything from surgical tubes to grain chute linings. The material makes the articles look deceptively sturdy, almost like stone, though in reality they are light enough to blow away and brittle enough to be crushed with a hand.

Fischli/Weiss have resurrected these items from their roles as old-fashioned, 'authentic' goods, and fashioned imitations of them using the ultimate in synthetic material, turning them into fragile stage scenery or portable Hollywood props. The sculptures are caught in a comical conflict between

artificial simulation and authentic handicraft, like traditional Eskimo totem poles carved with a chainsaw, or 'genuine' Swiss cuckoo clocks made in China. In contrast to sculptures the artists made for later installations like the *Cupboard*, these likenesses couldn't be mistaken for the objects they are imitating. There is something whimsical or merry, maybe even a bit too cute, about the objects from the raft. You can see this quality in the harmless cannon, the overstuffed piglets, or the crooked wagon wheels. The discarded pair of high heels looks like Minnie Mouse's shoes, and the perfectly triangular wedge of Swiss cheese could belong to Tom and Jerry, or could be something made to fool them. It is as if the artists rendered the objects from fairy tale caricatures or from loose memories in their heads.

If the *Raft* evokes a fable of its absent, ill-fated owner, then the photographs in *Still Lifes: Objects from the Raft* have more in common with classical painted still lifes – conglomerations of things arranged deliberately by the artist, just to see how they would look if they were painted. Historically, such arrays featured fish flesh dripping like honey from the carcass, wildly fanned feathers of freshly killed fowl, flush bursting grapes spilling over table edges, and maybe a skull subtly placed at the bottom for extra effect. Through the artist's rendering, each became a relic frozen in time, suspended between preservation and decay. In Fischli/Weiss's still lifes, too, things are eternally rotting but never rotten, eternally old, but never disappeared – like items kicked out of the house but too large to be removed from the curb. In the photographs, an exaggeratedly round cup adorns the ruddy farmer's furniture – the vision of rural mountain kitsch, as crudely whittled as we imagine it would be in the original wood. A fish flops over a chair or a motor. A car tyre, looking more like an edible black donut, is propped against a wooden crate, while paint spills carefully over the lip of a paint can. Suspiciously tame, a colourful bird perches on a greasy engine, and a portentous skull rests underneath the table, its hollow eye sockets gazing at a roll of toilet paper. These could be items at an Alpine rummage sale – not leftovers or rubbish, necessarily, but rather the kinds of things that just won't go away. After all, how do you recycle an old motor, an oil drum or a small cannon? How to dispose of a chandelier made of candles on a wagon wheel, or a perfectly functional accordion? And what does a nostalgic do with his beloved carved bear, or his large clay vessel, perhaps purchased at a thrift store and destined for the same shelf?

These sculpted likenesses appear to quote the nostalgic past of the found object – from the ancient artefact to the modern readymade. But their sentimental value, use value, anthropological value, or any other kind of value has been carved up, shaved off and hollowed out by their new status as art objects and as replicas of their former selves (if they ever really existed). Now, as dispossessed possessions, scavenged by the artists, their meanings are adrift. Like looted pirate booty, they've been repossessed and re-evaluated. Useful objects are useless here. Instead, they have shifting, multiple lives: as things and as carved things, as objects and art objects, as original sculptures and as replicas or simulations of things. A sculpture of a real pig is also a perfect replica of a carved pig. In being transformed into models, and then into photographs, these items, at last, are, as Fischli/Weiss would put it, 'freed from the slavery of their utility'. In the still lifes, they will still lead lives liberated from their owners and their everyday functions. Even if it reads like a melancholic story, you can almost see the objects chuckling at their newfound obsolescence, and delighting in their own survival.

———

Roughly carved, painted objects in polyurethane, approx. life-size. *Raft*: 300 × 500 × 350 cm
1982
First indoor installation with objects at St. Galerie, St. Gallen. Subsequently all objects including the *Raft* at the Klapperhof, Cologne
Photographs of still lifes with the objects from the *Raft*

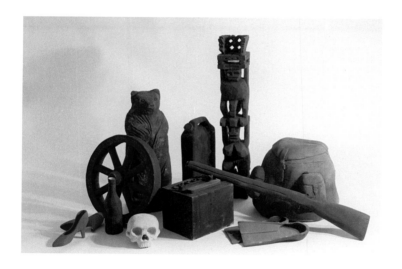

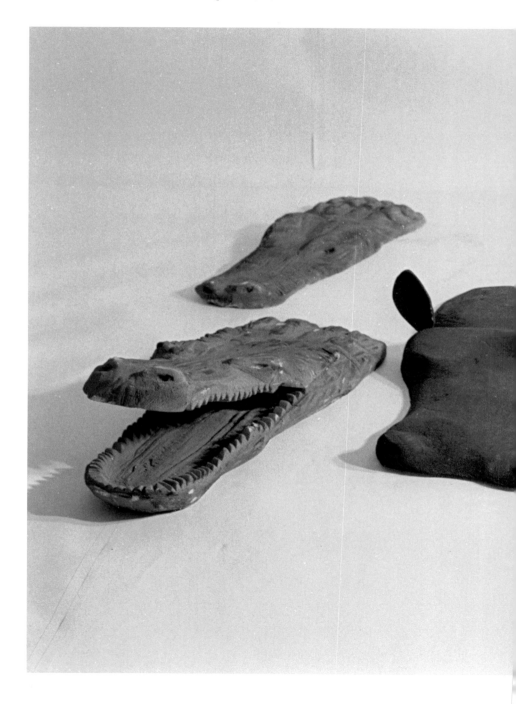

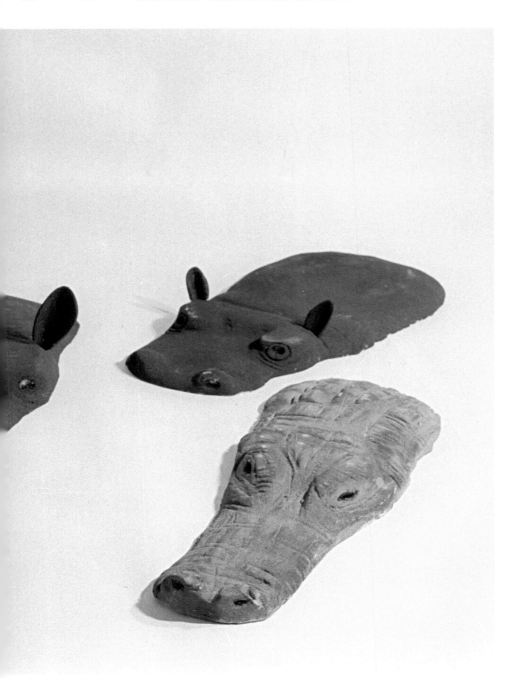

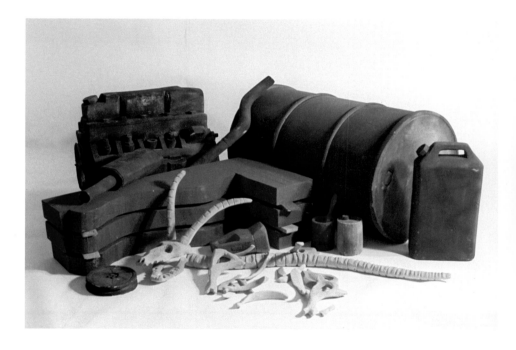

XIII

—

Max Küng

—

—

[1] Learning Curve, Part 1

Things are not always what they seem. As I was about to find out. When I moved from the country to my first city flat, I moved into a house that no longer exists. It was demolished. I was wakened one night by a loud bang that threw me out of bed and destroyed part of the building. That taught me a lesson. It was a cheap, one-bedroom, second-floor flat in the Gundelinger district of Basel. The only problem with it was that I had to keep trying to avoid my next-door neighbour – a blue-rinsed old lady who would pounce on you at the door and tell you the story of her life for hours on end. Or longer. It was usually the same story.

A young woman lived in the flat above mine. She was good-looking, but she had this really heavy way of walking. I would hear her stomping around in her flat. Maybe she wore clogs instead of slippers. Or maybe she wore those comfy shoes that massage your feet. At any rate, she would stomp from room to room. And I would hear her all the time. She sounded like a

pirate with two wooden legs. Not that it bothered me. Sometimes I would hear other sounds, too. A kind of whimper or groan. Quiet, but clear. I would often hear it in the morning when I was lying in bed by the open window, nursing a hangover on a fine summer morning.

I was young, a new kid on the block, lonely and lusting for life. By comparison, she was grown-up. She had a boyfriend (who was crazy and insanely jealous, as it turned out – but that's another story). She was probably lying in bed with him, doing those things I knew so little about at the time. I liked that idea. I would imagine them. Those quiet groans. At 10:30 in the morning.

But then I started to notice that my neighbour did an awful lot of groaning. I noticed that she always groaned when my bedroom window was open. I noticed that she groaned in the afternoon as well. I noticed that she groaned when she was stomping around in her flat. And then I realised that she kept on groaning even after I had already seen her leave the house.

That was when I realised that it wasn't my neighbour who was groaning at all. It was just the pigeons on the balcony. I felt miserable. I felt betrayed. I would never trust my own ears again.

[2] Learning Curve, Part 2

Not long after that, I went to London. I was still young and lonely and lusting for life. And I was quite interested in art (my godmother and her husband were ambitious art collectors, and that did have some influence on me – but not much). Anyway, I went to an exhibition at the Hayward Gallery. It was called *Doubletake: Collective Memory and Current Art*. I didn't know much about art at the time and I wandered around shaking my head a lot. But the huge installation by a certain Ms Hamilton had quite an impact on this farmer's boy from a little village in the northwest of Switzerland. Ms Hamilton had covered a big room in pork fat. In the room, an actor sat washing his hands at a huge block of soap all day long. There was a lot of froth.

I vaguely recall that the exhibition also included a work by Peter Fischli and David Weiss. It was an installation. You could see it through a window in a poorly lit, long and narrow room with all sorts of stuff in it. There seemed to be some kind of renovation going on. Who knows what was going on in there. I looked into the room and saw a chair, a bucket and a power drill.

And I thought, those are the things that are there. The room is this room. Quite honestly, I thought the artists were still at work. I thought this was the gallery's storeroom. I remember thinking it wasn't as untidy as my own place. I didn't think deeply about it, but I did think about it a lot.

[3] What really is (more real than reality)

Music cassettes (four), one stove, one wooden chair with a heart cut into the back, one plastic chair (orange), one office desk, one radio cassette player, one power-drill (red, with no bits), one coffee maker with a red top, two six-packs of beer (one complete six-pack of Pils in bottles, one opened six-pack of a product with yellow labels), one wooden pallet, one leather armchair (black), one fridge, one calculator, one toothbrush, some aspirin, a sculpture (souvenir of Africa?), a razor (Gillette), an accordion, a dog's lead, a dog bowl (with food in it), a dozen turnips, a dozen potatoes, various planks and lathes, a skateboard, a plastic spoon, a fake-fur jacket, various tools in a box, a dozen pieces of metal (rusty), an exhaust pipe, a rubber carnival mask, a hub-cap, a cot, rubber boots, a manhole cover, a plastic bucket, a leather file, a rubber pipe, a Bunsen burner, shoes, a wooden stool, a cup, a saucer, a file (containing tax returns?), a box, a pair of scissors with ergonomic plastic handle, a chain, a neon tube with fittings, a crate (wood), a glove, a phone (type Elm), a thermos flask, beer cans (two, of Pils), tyre tubes, an empty plastic beaker (probably custard), a hammer, a paint pot (red, open, with stirrer), a blue container, pincers, sticky tape (yellow), rags, beakers, a milk carton, a towel, a washbasin, a soap-dish with soap, a sponge (green), a hot water bottle, various plastic bottles (presumably cleaning products; some open, some closed), canisters (two, closed), a plastic bowl with natural sponge, a chain, window-cleaner, a piece of piping.

[4] Conclusion

And now? Now we know what there really is in this room. Now we can start wondering about it.

[5] Postscript

My favourite work of art is half a peanut shell. It is an entire world.

———

Installation, which can only be seen through the window of a free-standing garage; roughly carved, painted objects in polyurethane, approx. life-size
1991
Created on the occasion of the exhibition of the *Chamer Räume* (*Rooms in Cham*) in Cham, near Zug (Switzerland)
Subsequent adapted versions, such as 1992 in *Doubletake*, Hayward Gallery, London, and as a long-term installation at Hardturmstrasse and in the Löwenbräuareal, Zurich

XIV

Lynne Cooke

HOME ALONE ...

Raiding the icebox, chain smoking, killing time: when home alone, thoughts turn dark, dreams curdle, fantasies sour. Boredom and frustration attend domestic confinement: although play seems to offer a way out, visions of escape too often get derailed.

Assuming monstrous shapes, bedclothes morph into mountainous peaks behind which a glowering sun hovers; across a barren landscape made from a dreary brown carpet, a single-lane highway beckons. Far more unsettling than the car crash, however, are the spooky witnesses, a phalanx of cigarette butts solemnly surrounding the scene of disaster. Nearby, fire breaks out in one of the tacky high-rises, threatening to spread to its near neighbours. Elsewhere, the Titanic meets its doom again, this time in the bathtub; a meagre campfire warms the gloomy oven; a deserted space station occupies the fridge, and the freezer is reduced to an arctic wasteland. Even those places which offer potential pleasure – whether the lure of shopping or the glamour of fashion – are riddled with malaise; the motley salami and sausage rugs are arrayed for sale across a grimy floor; the crowded catwalk is perched on a bilious-pink bathroom shelf backed by a spotted mirror.

The first collaboration in Fischli/Weiss's extensive oeuvre, the *Wurstserie* (*Sausage Photographs* 1979) presages much that has followed. Impish inquiry, disarming understatement, dexterous improvisation and make-shift materials again and again serve as the means by which big questions are writ small, as the miniature becomes the vehicle for the metaphysical. Our initial delight, triggered here by their resourceful playfulness when trapped indoors in a shabby apartment, is, as so often in their work, soon undermined. For a mordant wit infiltrates even the most beguiling of their seemingly inane pranks, captured in these modestly scaled documentary-styled prints.

Earlier that same decade, late at night, brooding on a cigar, a solitary Philip Guston had limned sardonic scenes from the mundane stuff that littered his studio. Even in self-imposed seclusion we rarely escape the gnawing suspicion that we're going to hell in a hand-basket.

———

Series of 10 photographs in three different sizes: approx. 24 × 36 cm (small series), 50 × 70 cm and 70 × 100 cm (large series)
1979
Peter Fischli and David Weiss's first collaborative work

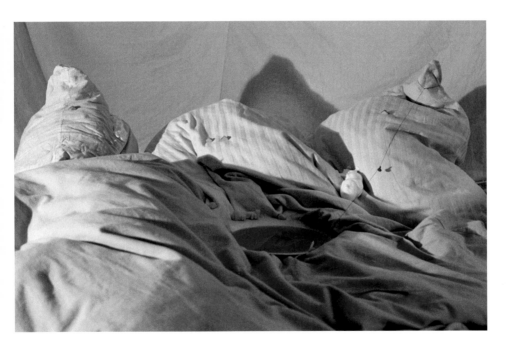

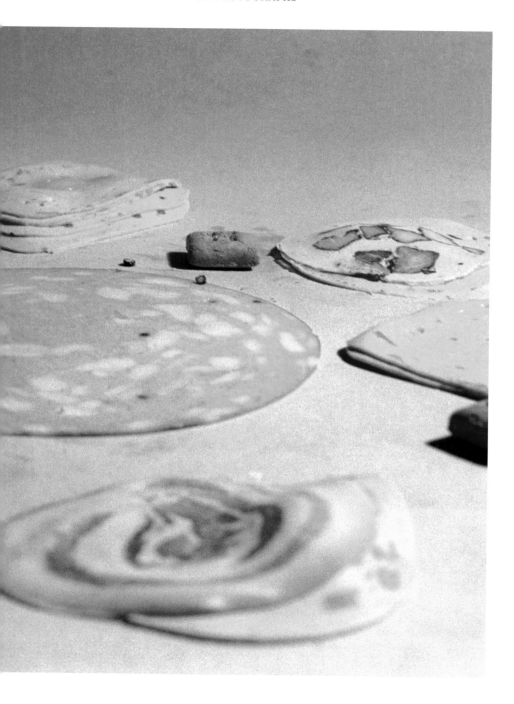

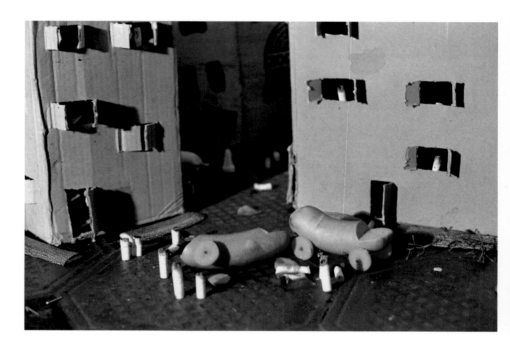

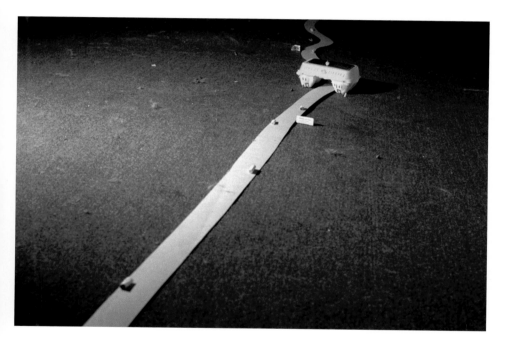

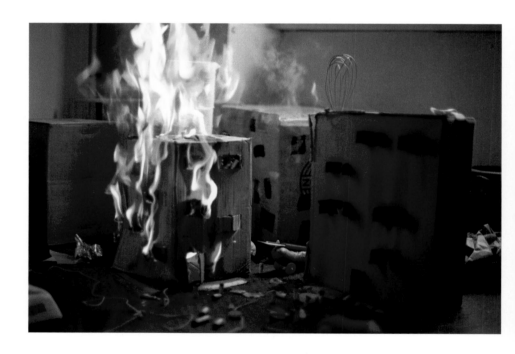

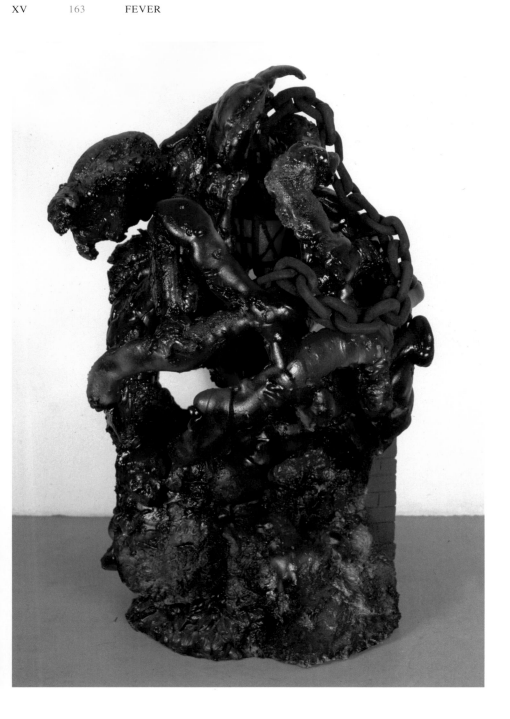

XV

—

Renate Goldmann

—

FEVERISH GLOBAL ENIGMAS

—

The 'dirty studio' that Peter Fischli and David Weiss moved into at the beginning of their shared career is partitioned off behind temporary walls in a large warehouse. Colossal chunks of polyurethane foam block the entrance. They have to be moved aside in order to enter the alchemist chamber – feverish traces of the 'last loosening'.[a]

Having finished the miniature clay sculptures for *Plötzlich diese Übersicht* (*Suddenly this Overview* 1981) [–› chap.XI], Fischli/Weiss shift from undersized to oversized. They experiment with various materials, before settling on the use of lightweight and easily carvable polyurethane foam. The ways in which the material can be crafted appeals to them: it can be painted, disguised and cut. They produce the series *Fieber* (*Fever* 1983/4) and *Metaphysische Skulpturen* (*Metaphysical Sculptures* 1985/6) as well as important single works like *Floss* (*Raft* 1982), *Kleines Bett* (*Small Bed* 1983) and *Haus* (*House* 1985) – in response to contemporary conditions.

Around 1980, the art scene freely vents its feelings. After the motto of 'anything goes', a mood of spectacle emerges in the wake of punk, student

unrest and visionary scenarios of the future. This spirit informs the choice of title for their first polyurethane sculpture: it is named after *Mad Max* by the Australian filmmaker George Miller. *Mad Max* is later enlarged and renamed *Raft*. b) Objects of everyday use and a variety of other offbeat items, spread out on the *Raft*, reappear in later years as assemblages in single sculptures. The *Raft*, a humorous commentary on the gloomy subculture of the 1980s, reverberates in the sculptures that Fischli / Weiss create for their series *Fever*. c)

Indian fetishes and occult objects along with auto parts and everyday things merge into dream sequences and nocturnal scenes: esoterics, youth culture and riots distilled into a single concentrated whole. There is great appeal in the curiously compelling aesthetics of triviality that marks these outlandish, shrill still life configurations, seen shortly before everything threatens to break down and disappear in the maelstrom of history. In the sculpture *Fever,* it seems that the feverish sleep of reason has spawned an anthropophagous polar bear, keeping guard at the entrance to the underworld. A flight of stairs takes us deep down into the bowels of the unconscious.

Gefühle (Emotions), Melancholie (Melancholy), Solitude are among the eloquent titles in the *Fever* series. Here one finds all kinds of detritus from the deeper layers of the human psyche, assembled in Fischli / Weiss's inimitably associative manner. The ironic treatment of psychological terminology harks back to *Ordnung und Reinlichkeit (Order and Cleanliness)* [→ pp.202–5], the little publication issued to accompany *The Least Resistance* of 1980–1 [→ pp.185, 186, 197–201]. The film's protagonists Rat and Bear enlist a childlike signature in diagrams created to explain the meaning of life. Symbolising 'consciousness', a 'rubber wrap' holds together all assertions, views and insights. Lying inside is a layer of 'sleep', which in turn surrounds 'the unknown (gas?)'. Fischli / Weiss offer us an impression of an unknown world of sensations. The colours of the *Emotions* range from light red to bluish black; they are a pulsating mass of colour braced and choked by rampant black, ulcerous protuberances. The colours of melancholy – red and blue – ultimately symbolise the temperament of the quintessential artist, given a typically Fischli / Weiss-ian twist through the irony of their reflections on the heroic artist.

Literary references crop up in the *Fever* series as well, as in the case of the *Letzte Lockerung (Last Loosening)*. A suitcase is lying on a confusion of heavy iron chains, screws, furniture, stacks of dishes and mountains of

books. The assemblage is inspired by the dada manifesto of the same name written by Walter Serner (Seligmann) in 1918. Serner's *Letzte Lockerung: manifest dada* was published in 1920 as *Die gelösten Welträtsel* (*The Resolved Puzzles of the World*). In 'Paragraph 78°', Serner writes, 'Kick the cosmos! Long live Dada!!!', which could also apply to the work of Fischli/Weiss. [d] In the process of tracking down absurdity, the artists keep bumping into the 'big and small questions' of life, investing them with a humour that effectively parries their awareness of the likelihood of failure. The repertoire of motives in *Fever* explores the byways of philosophy: mysteries, gnosis, alchemy, parapsychology, psychology and esoterics. In contrast, the *Metaphysical Sculptures* would seem to deal with the traditional insights of philosophy, but visual obstacles and tricks of perception prevent them from keeping their promise. [e]

In the chaos of seeking meaning and dealing with the pressures of our daily lives, we are well advised to delight in the 'small idylls' of life, like the slumbering ducks in *Le repos des canards* [→ p.10] from the *Fever* series – or to escape our waking state by accepting the whimsical last loosening of a somnambulant feverish delirium. It is a state that has survived to this day in the 'dirty studio' of Fischli/Weiss.

a) Reference to Walter Serner, *Letzte Lockerung: manifest dada*, Hanover, 1920. English translation (*Last Loosening*) in Richard Huelsenbeck, Hugo Ball and Walter Serner, *Blago Bung, Blago Bung, Bosso Fatakal: First Texts of German Dada*, trans. Malcolm Green, London 1995.

b) Several parts were added to the original *Mad Max* installation, carved out of polyurethane. It was then called *Untitled* and later renamed *Raft*. At the same time, Fischli/Weiss worked on another project, *Das Geheimnis der Arbeit* (*The Secret of Work*). The *Raft* was shown for the first time in 1982 at the Klapperhof in Cologne, in the exhibition *Die Sonne bricht sich in den oberen Fenstern* (*The Sun Is Refracted in the Upper Windows*).

c) The *Fever* series was shown in 1983 at Monika Sprüth Gallery in Cologne and a year later at Crousel-Hussenot Gallery in Paris. A selection was also on view at the Kölnischer Kunstverein (1985) and at *Sonsbeek 86* in Arnheim, Holland.

d) Serner, *Letzte Lockerung*, 1920, reprinted Munich 1989, p.78.

e) The series *Metaphysical Sculptures* 1985/6 was shown at the Kunsthalle Basel in 1985 and a year later at Ileana Sonnabend Gallery in New York.

Group of 25 roughly carved, painted polyurethane sculptures
Forms of varying volume, generally 180 × 140 cm
1983/4

XVI

—

Frederic Tuten

—

—

Once upon a time a straw man lived in the mountains. Why he was there and how he came to be born is another story, one involving the mystery of the origin of puppets and dolls and other such figures humans create to give themselves power. Our straw man dwelled above cars and trams and homes and offices and smoky cafes, above hospitals, apart from every activity that bleeds life away from the day. That is to say, he lived happily, with no apparent desire or purpose, except to take each hour as it came, snow or shine.

Then, one day, three herdsmen, who had been tending their stock in isolation and were bored to death with their own company, found him lounging in a glade of sweet clover. They took him to their summer hut and sat him down at a table, where they had spent months playing poker and droning away until bedtime. A straw companion is better than no companion, one said, propping him up in an armless chair and dealing him cards of no consequence.

They enjoyed his presence, however mute, were pleased by his uncomplaining spirit. They, however, complained relentlessly, comparing

their present dull lives to the exciting ones they boasted of living in the towns below and to which they would one day return.

Lumpentiti – that was the name they had given him – was dazzled by the herdsmen's stories of town life, of the pleasures waiting there, and he imagined that his companions would take him with them, but at the first hint of snow they decamped, driving their cattle before them and leaving him behind.

He was made of straw but he was no dummy, and he soon realized that they would not return any time soon and that another dull winter alone awaited him. What once had passed for happiness now seemed provincial, an existence shared with rooks and their ignorant chatter. The glittering life below called to him more strongly each passing dull day, until, one morning, he rolled himself out of the cabin, rolled himself down the steep mountain slopes – and in the process shaking out of himself, whisk by whisk, all the straw that had once defined his body and his former life.

At last, when he was little more than an empty sack, he came to a flat rest at the edge of a seldom-travelled road. There he stayed, flapping about in the cold breeze and feeling sorry for himself. All he had wanted was a varied, exciting life – and now there was no excitement and little life, except for the clouds as they cavorted about him in the sky.

Then, one day, a speeding black car, just fresh from a robbery of a hundred vending machines, halted abruptly beside him. A man picked him up and tossed him in the rear, where thousands of coins lay about loosely in piles and in broken shopping bags. The man filled up the sack with coins and *Lumpentiti* was restored to his original shape, though he felt a strange metallic density.

Then they sped away, and through his back window *Lumpentiti* saw the wonders of tall buildings and squares and fountains, and believed that soon he would know the joys the herdsmen had spoken of in the hut, when he was just an boorish mountain dweller.

It was night when he was lifted from his seat and brought into a dark building and rushed into a basement's airless shaft, where he was propped up and left to sit like an unloved child. Now he sat in a darkened shaft whose illumination came not from the glorious mountain sky but from distant memories of artificial light. Now he had become a sack of coins so heavy with worldly value that he could not rise from the floor, but sat there immobile like a bag stuffed with sadness and self-delusion.

Rag doll stuffed with coins of different currencies, approx. 30 × 30 × 30 cm
1992
Created in conjunction with the 'Art in Architecture' commission for the new stock exchange
in Zurich

XVII

—

Beat Wyss

—

MELTING BEAUTY

—

The snowman lives dangerously. The seasonal warming of the sun threatens to undermine his icy stance. And that's not all. Any energetic little scamps who just happen to wander past are likely to see this upright white sculpture in the snowy landscape as a phallic challenge to be toppled immediately. And what is about their mothers? They let them get away with it. After all, their little princes should have to brook no other male rival, be it father, or milkman – or snowman. After the boys, along come the dogs, sprinkling yellow holes into what remains of the snowman's rump.

The snowman has many enemies. This silent, lonely figure with the bulbous nose of a heavy drinker seems to provoke a strange will to violence. Perhaps it is the obvious transience of its existence that appeals to the destructive urges of the masses. They cannot simply tolerate the inevitable decay of the snowman; they have to be the instruments of its demise themselves, as though, in this way, they might be able to counter the transience of their own lives. The destruction of the snowman is a countercharm – an antidote to the spell cast by death, to which we are all in thrall. Every year in spring, a huge

white figure is ceremoniously burned on the Bellevueplatz in Zurich as a sign that the people of the city have vanquished the dominion of winter.

But Fischli/Weiss have come up with the most brutal way yet of finishing off a snowman. They outdo the traditional Zurich custom known as *Sechseläuten* by stripping the ritual *Böögg-Verbränne* (burning the puppet) of its allegorical meaning. The artists rob the snowman of its transience by presenting the figure as an arbitrarily reproducible construct void of any deeper meaning.

The *Eislandschaft* (*Ice Landscape* 1989) photo series takes us into a laboratory for the artificial creation of snowmen. In the chilly concrete bunker, beneath the wan and milky glow of the lightbulbs, we might suspect this to be a place of torture. Indistinguishable figures stand around in the hazy room. In the middle, wooden pallets stacked in the half-light look like funeral pyres. Sheets are draped over the piles of wood, which are being hosed down by a man in a bobble-hat.

The droplets turn to sleet. Through the lens of the camera, an abstract sculpture emerges: a grainy, rugged surface fringed by stalactites of frozen water. And in the blink of an eye the parallels between the act of photography and the process of turning to ice become evident: just as water freezes to form snow and ice, so too does each object frozen into a photograph take on the stable aggregate state of aesthetic immediacy. The creative act consists in allowing art to happen – or perhaps I should say making art happen – in a lasting way. Well, art is probably both these things: a constant passive laissez-faire and an active drive – like a naughty boy pushing over a snowman.

Schneemann (*Snowman* 1990) wears the black bobble-hat of the hose-wielding figure in the cell. Are the snowman and the snow-maker really accomplices? The snowman, as I have said, has many enemies: naughty boys, dogs, people tired of winter. But the biggest enemy of all is the snowman himself. Made of nothing but snow-white crystals, he harbours the Freudian nirvana principle within his body, which dreams itself back into the lightness of a watery mist. Let us hold on to this happy end in the final image, where the *Snowman* meets a pleasant death by the warming fire.

And once again, photography returns as key witness, saving a fleeting moment for the eternal gaze of art.

———

Photographs
Ice Landscape 1989, *Snowman* 1990
Experiments for the unrealised project, *Ice Landscape*, in conjunction with a project for the Römerbrücke thermal power station in Saarbrücken. *Snowman* in a freezer. *Ice Landscape* realised as temporary installation in a cold store

XVIII

—

Stefan Zweifel

—

ISN'T IT FUNNY HOW A BEAR LIKES HONEY

—

The Poet's Courage and Stupidity

Hölderlin wanted to 'step naked into life', to be 'defenceless' as a child, immersing himself in the sounds of the hills and groves. When the poet steps barefoot into poetry itself, reaching for the clouds, listening to 'the silvery flood resounding afar' and gazing down into the valley where the vaporous waters of the river swirl ethereally, the water itself eventually becomes a cloud-spun mass to him, until above becomes below and he loses all sense of orientation, merging completely with nature and the gods – only to plummet dizzily into the abyss, his head smashed beside Orpheus's lute. Yet even in death he is protected by quiet simplicity. Such is the tone of Hölderlin's poems *Dichtermuth* and *Blödigkeit*, written around 1800. [a]

For more than 200 years, the courage of poets and artists has been marked by their daring to step naked into the realms of what Hölderlin calls *Blödigkeit*. This German word, in modern usage, means stupidity or idiocy. Yet at the time when Hölderlin wrote his poem, it was used in a rather different

sense – closer to stupefaction than stupidity; a kind of numbness, like the numbness that befalls a limb when it has gone to sleep. A foot numbed in this way seems rediscovered anew when it 'awakens' and, as the feeling gradually comes back, you notice with an idiotically vacant grin how it becomes a foot again. You become 'all foot' – a wholly barefoot idiot.

In this state of *Blödigkeit* that is akin to stupefaction, the artist is exposed helplessly and wordlessly to the impressions that rush at him from all sides, and to the deafening whirlwind of thoughts inside his head. Leaving the boundaries of reason behind, he strides out, like Lenz in the mountains. In the unrelenting glare of these impressions, he becomes a melting glacier, a mountain stream that gushes forth and tumbles down the mountainside. The heights of ecstasy and the depths of mindlessness converge in this one word: *Blödigkeit*.

There they sit, Rat and Bear, at the end of the film *Der rechte Weg* (*The Right Way* 1982–3). Like two 0s high above the sea of fog, 'with clouds and sky about them ringing'. Transposed into timeless distance, as distant as the diction of the Romantic poets, as distant as childhood. The rat swishes its tail and we hear, 'resounding from afar', the shrill screech that we, as children, once teased from brightly striped plastic pipes. Rat and Bear: they are not two, not 1+1, but as indefinable and as incalculable as 0. They elude the grasp of conceptual thought. They elude the urge to press opposites into a higher unity by the force of dialectical argument.

Instead of Hegel's circle of absolute knowledge, rounded and complete in itself, [b] the path bends to the endless spiral of Alfred Jarry's pataphysics. The fundamental truth of perceiving identity as A=A is transformed by Jarry's Dr Faustroll and his ape-like assistant Bosse-de-Nage into a 'HaHa!'[c] They cock a snook at all things scientific, with a cry of 'patati, patata!' For they are adherents of pataphysics, the 'science of imaginary solutions' in which the singular triumphs over the universal, and only the exception is the rule.

Rat and Bear thus find a space between concepts, between opposites – delving into the realms of childhood, on the highmoor of that pre-genital joy that prevails before the all-divisive gulf of gender difference. Sub-*ject* and ob-*ject* are no longer enemies on their shared tra-*jectory*[d] through the world. Time and again, they softly, softly touch the circles of knowledge, and flee into uncertainty.

Tip-Toe Upon a Little Hill

Just one more little dance; how nice it is to dance with your paws in the mossy heather, thinks the bear as he circles around his own axis, tilting gently like the earth. Oh, how lovely to feel the waters of the moor washing around my paws, highest and lowest converging! Here I am barefoot, paws in the mud, head in the sky, growing up and up beyond myself as in a dream, looking down at the trees, my head swaying like a crescent moon across the sky. Yes, I am like the moon that waxes and wanes – I am the *Über*-Bear.

Mm, thinks Rat, how warmly the pig grunts in my belly, how my brain becomes a whirling humming-top that spins in ever brighter colours through my mind. I have hunted down the pig, nurtured and cooked it. I am more than the sky – I am the universe in all its higher order and endless calm. I have turned the tree trunks heavenwards; their roots[e] are outlined against the sky like a lightning flash. And this root-flash begets the animals. I hold the formulae of the world in my hands and I draw them in the book. I am the laboratory rat[f] that has found a way out of the maze of conventional thought.

Yes, indeed, we have overcome the constraints of rational thought – those age-old opposites of rich and poor, up and down, front and back, large and small have all become one. The stark contrast between human and animal no longer prevails – all that remains is the subtle difference between Bear and Rat.

The whole world becomes a coursing river. They both leap into its maelstrom of vapour-clouds, hurtling through labyrinthine caves towards the waterfall. Sense is no longer pitched against nonsense, but against the sheer joy of senselessness. For where sense is dulled to senselessness, as in a semi-waking state, the world expands to admit perception. In our hunger for experience, we have only to gnaw at one little letter for the *vor*acity of our madness (*Wahnsinn*) to become the *ver*acity of our sense of truth (*Wahrsinn*).

Just one more little dance; a little dance to bring the rain and, with the rain, a little cloud. But every black cloud, as we know from that bear of little brain, Winnie the Pooh, is a buzzing swarm of bees in search of their honeycomb – and where there are bees, buzz-buzz-buzz, there is sure to be honey nearby.[g] We are, as Nietzsche said, 'honey-gatherers of the spirit'. And Nietzsche, that grumpy old bear,[h] knew full well that behind each cave there

is another cave, behind each mask another mask – the mask of the bear perhaps, or the mask of the rat. But we have not gathered all this knowledge in order to overthrow existing values. We have gathered it, buzz-buzz-buzz, in order to navigate between those values, charting the vanishing line of the free spirit.

The Radiance of the Neutral

Back and front, top and bottom, above and below, big and small, good and evil, subject and object. Armed with such terms, humankind has subjugated the natural world, casting it down: *sub-jectum*. But in doing so, humankind also subjected itself to a certain dual logic in which man is both the inmate and the guard of his own prison. Now, it is the 'ject', the free outpouring of sensuality, the casting of the dice – *alea jacta est* – that lures him. Now he wants to become the casting of the dice himself, just to see how many dots turn up. The dots of the dice are like eyes. Man gambles his very self with each new throw. [i]

This is an open field of play, and a hard-won field at that. It was conquered with great force. In the works of Georges Bataille, the human individual becomes the 'ject', the open wound that merges with other bodily fluids – blood, sperm, tears – in pure sensuality. The human individual becomes a wave among waves, surging with the oceanic desire of becoming. In order to break firmly established ways of seeing and thinking, to crack the I-carapace of the subject, Bataille created shocking photographs of big toes, of dead flies on sticky paper, the hacked-off hooves of slaughtered horses next to the legs of cancan dancers, the bulbous testicles of a bull thrust into a vagina, or the eye of a dead girlfriend peeping out through eyelashes of pubic hair, winking at Bataille unto death. [j]

But this heroic stance has had its day. The constant breaking of taboos has become a boringly predictable ritual of art. Of course, much depends on the opponent. It is not through the counter-concept of the anti-jectory that we become free, but through our own tra-jectory. By touching everything only fleetingly. By gliding through life like a boat on a river. Views and values are not inverted – merely tipped slightly out of kilter. The shock of the new has been ousted by the subversive power of the neutral.

'Ne-uter': that is to say *neither* Rat *nor* Bear, but the *neutrum* that cannot be grasped. In other words, the state of *Blödigkeit*. It is that state of

semi-wakening – before we quite realise where we are and who we are, adrift on the bed like a vapour-cloud, like cloud of infinite possibilities.

The Bear in his dream cloud at the start of the film *Der geringste Widerstand* (*The Least Resistance* 1980–1) wants to stay as formless as the cloud itself, but Rat phones up and startles him into the world, finding a new form for both of them – as artists, because, the argument runs, you can make a lot of money in a very short time as an artist. And indeed, Pop art triumphs: each picture is already a banknote, silkscreen-printed in many colours. You need neither intelligence, nor knowledge, nor ability. You need only make something. But what? A film, for instance.

Maybe a film like *Dominik Dachs und die Katzenpiraten* 2001. Dominik Dachs dreams of flying and wastes his days in a grump – until he borrows a boat and sails along the waterways with a chest of gold. That is how he meets Niki-Tiki the hedgehog. They share some sausages, save an apple for the following day and are glad to be 'alone together' at last. The water flows slowly, and the film moves slowly too: they fish, they clean a lamp. And so, as they drift along by the riverbank on their trajectory, they become figures onto which children can project their dreams. Rat and Bear have no gold on board with them, but they do have a box of books: *Ordnung und Reinlichkeit* (*Order and Cleanliness* 1981) [→ pp.202–5] are their titles, and at the end of this similiarly slow-moving film they all disappear together in a helicopter over Los Angeles.

In this, they have explained the world: the human individual in the diagrams [k] is really a cloud – sex, sleep and eating are the underlying constants, over which, depending on the individual, lies the occasional coil. Hölderlin is one such coil, but then again, so is Lenin, or LSD or Dior. These coils form the 'raincoat' of our consciousness. For athletes, it might be 'alcohol' and 'TV', for intellectuals, it might be 'travel' and 'museums'. And all of them are linked, in turn, with other clouds – by their work as colleagues, or by beds symbolizing 'sex', or by contented or broken hearts. Close to the cloud called Beatrice there is one called David and one called Peter. Could it be them – Fischli and Weiss?

They have seen through the world. The topology of Freud (Id – Ego – Superego) is dismantled here, unravelled as playfully as Lacan's Borromean knot. [l] Do we have to understand all that? The 'right way' leads out of stupidity and darkness into light, but it is easy to end up erring on the path that

is the 'asocial wrong way' (as 'pop musician' or 'charlatan') or erring on the path that is the 'normal wrong way' (as 'e-musician' or 'preacher'). Surely it would be better to stay close to the roots, to remain ensconced in a 'contented existence'. There, close to 'stupidity', live Rat and Bear. This where the idiot dwells.

The idiot is an individual entirely at one with himself, thinking his own thoughts. In classical Greek, the word *idios* means 'own, individual, unique to one'. But the idiots of the art world end in insanity, misunderstood by all: from Hölderlin, Nietzsche and Nijinski to Artaud, van Gogh and Baudelaire. Why? Because they remained alone. The idiot can only survive with a companion. Like Laurel and Hardy, Don Quixote and Sancho Panza, Bouvard and Pécuchet, [m)] Rat and Bear.

Bouvard and Pécuchet

Like Nietzsche, Gustave Flaubert often described himself as a 'bear in a den'. He rarely left his writing-den, or rather, his writing-'din' – for he would read his texts out loud at the top of his voice until he was as hoarse as a growling bear. In 1874 he left his den for the heights of Rigi in Switzerland. There, he felt like throwing his arms around three calves 'out of sheer brotherly love and a need to communicate'. The misanthropic Flaubert felt utterly alone, understood only by these dumb creatures. He once wrote that his ivory tower was battered by the waves of an ocean of shit and that he wanted to 'pour a bucket of shit' over the overweening mediocrity of bourgeois incompetence and fledgling mass democracy before he died. What he did pour out in the end was an inkwell full of hate: *Bouvard and Pécuchet.*

Bouvard and Pécuchet are two Parisian copy clerks who give up their day-jobs for a life in the country, where they promptly set about turning everything they try their hand at into a complete nightmare, while at the same time managing to transform the entire encyclopaedia of human knowledge into a labyrinthine maze of utter nonsense. They cut their hedges to a Baroque garden, discover Roman coins among the roots, plant seedlings and saplings, and analyse the bizarre fruits of their labours and the strange ways of the world in their chemistry lab in the cellar, where they themselves are like cockroaches scuttling around among the grey and mouldering knowledge of their time.

Flaubert spent seven years crafting this 'encyclopaedia of human stupidity' and began to suspect that he himself had been infected by the stupidity of his own protagonists. There were days when he felt his work had enfeebled him to the point of feeble-mindedness – 'just one step from idiocy – I now have a bowl of goldfish to keep me company at my meals'.

Flaubert himself becomes a goldfish, mouthing the stupid quotes from newspapers and books like so many air-bubbles, getting in touch with his inner idiot – his inner Bouvard. As a writer with the courage to look stupidity in the face, he becomes Bouvard and Pécuchet, just as he had once become 'a boatman on the Nile, a leno in Rome at the time of the Punic wars, then a Greek rhetorician in Subura where I was devoured by insects'.

This is what the artist is. A self unbounded by time and space. The artist gives us the courage to face up to our own stupidity. Instead of fearing our inner Bouvard, we should let ourselves delve mindlessly into our own dilettantism and try everything out afresh. Read everything again. Get those dusty old Greek books out of the attic and read Sophocles in the original – without understanding a word. Hire a piano – and get bogged down in Erik Satie. Or maybe just go fishing – practise with the fishing rod in the living room (like Bouvard and Pécuchet in a scene that was later abandoned).[11] The human being is a creature of boundless possibilities, capable of turning into anything and capable of erring endlessly.

Quiet Simplicty

In the end, Bouvard and Pécuchet copy advertising fliers they find on the street, instruction manuals, old books. And then, after hibernating for more than a hundred years, they re-emerge as Rat and Bear to discover a new domain: the domain of art. For this is indeed a place where old advertising flyers can be copied and coloured and marketed as readymades.

Dadada-dieda-duu-dadadadaa. That is the sound of the car horn playing the theme tune of *The Godfather* in the film *The Least Resistance.* Rat knows that art is mafioso. Being there is all that matters. They wander through a gallery and admire 'harmony and balance'. Can they really do that? A quick leaf through some art magazines, a Mondrian catalogue, a Klee book: 'Ah, Picasso.' And in a trice the grid patterns of Mondrian are dangling in the windscreen as they drive through the streets of LA. The music sounds like

Roxanne by The Police. Everything is plagiarism, clawed from elsewhere. And they have claws aplenty, Rat and Bear.

'Bad feelings between painter and viewer' have led to murder. Rat leaps out of a window – but he, too, is protected by quiet simplicity. By the quiet simplicity that acts as a shield against all the vagaries of interpretation. Rat and Bear thrive in an area that is beyond the grasp of thought: in neutrality. It is a placeless and ultimately wordless zone. Beyond male-female sexuality, beyond binary logic, beyond political jostling for position, the viewer is lured – not by indifference, but by the 'suspension of passionate tension' [n] – into a still unwritten, neutral territory, where he can constantly reinvent himself.

The avant-garde may have embraced the shock of the new, but it is the neutral that thwarts the paradigm. The neutral is neither true nor false. It says neither yes nor no. It loses itself in the infinitesimal dust of perception. 'Tip-toe upon a little hill', the highmoor takes on that same bewildering depth that Leibniz described in looking at a drop of water: in each drop of water you can discover a pond full of fish and on each scale of these fish are still more glistening droplets in which there are still more worlds and ponds. And so the mind-numbing multiplicity of the infinitesimal emerges out of simplicity. [o]

In the realm of rats and bears, then, it is not the posturing of taboo breaking that prevails, but the poetry of banality. Of course, the anal-neurotic compulsion of *Order* and *Cleanliness* cannot be entirely avoided. And indeed, they do look rather excremental, these unhardened clay figures that are meant to convey a sense of 'sudden insight' – while Rat and Bear peregrinate through this 'subjective encyclopaedia' [o] as salt and pepper shakers. But innuendo and underlying meanings are everywhere. They make us aware of our pre-genital desires, back at a time when the organs were still undefined and their function could change depending on the phantasma. Not unlike the body without organs propounded by Deleuze and Guattari. This is no Freudian rat – no rat-man. It has gnawed through the bars of the cage and released the bear behind it. But bears want to dance. In silent ecstasy.

Two circling 0s, then. Ethereal and cloud spun. Thus, Rat and Bear undertake their strange 'task' of casting the dice for us. Each dot on the dice is an eye. They cast new eyes for us. As nomads of the neutral.

Jean-Yves Jouannais, *L'idiotie: art, vie, politique, méthode*, Paris 2003.

Avital Ronell, *Stupidity*, Urbana / Chicago 2003.

Valérie Deshoulières, *Métamorphoses de l'idiot*, Paris 2005.

Clément Rosset, *Le Réel – traité de l'idiotie*, Paris 1977.

Georges Bataille, *Sur Nietzsche*, in *Georges Bataille, Oeuvres complètes,* vol. 6, Paris 1973.

Roland Barthes, *The Neutral: Lecture Course at the College de France (1977–1978)*, trans. Rosalind Krauss and Denis Hollier, New York 2005.

Maurice Blanchot, *L'Entretien infini*, Paris 1969.

Hans-Horst Henschen (ed.), *Gustave Flaubert, Universalenzyklopädie der menschlichen Dummheit*, Berlin 2004.

Gustave Flaubert, *Correspondance*, Paris 1956.

a) An English translation of these poems by Hölderlin can be found in *Friedrich Hölderlin. Poems and Fragments*, trans. Michael Hamburger, Vancouver 1994, and in *Friedrich Hölderlin. Selected Poems and Fragments*, trans. Michael Hamburger, London 1998. See also Walter Benjamin, 'Two Poems by Friedrich Hölderlin. The Poet's Courage and Timidity' (trans. Stanley Corngold), in *Walter Benjamin. Selected Writings 1913–1926*, vol.1, ed. Marcus Bullock and Michael W. Jennings, Cambridge/London 1996, pp.18–36, which contains English translations of both poems.

b) Georg Wilhelm Friedrich Hegel, *The Phenomenology of Mind* (1807), trans. J.B. Baillie, New York 1967, pp.787–808.

c) Alfred Jarry, *Gestes et opinions du docteur Faustroll – Pataphysicien,* in *Oeuvres complètes*, vol. I, Paris 1972; for instance after the encounter between the lobster and the can of corned beef (p.700). Raymond Roussel, whose novel *Impressions d'Afrique* is referred to in the sculpture of the same name by Fischli / Weiss, is also regarded as a pataphysical author.

d) On Buster Keaton's 'trajectory gag', see Gilles Deleuze, *Cinéma 1 – the movement-image*, trans. Hugh Tomlinson and Barbara Habberjam, London 1986, pp.173–7.

e) 'Rats are rhizomes', Deleuze / Guattari, *A Thousand Plateaus*, trans. Brian Massumi, London 1988, p.6.

f) See William Kotzwinkle's novel *Doctor Rat*, New York 1997.

g) As at the start of A.A. Milne's *Winnie the Pooh* ('Isn't it funny how a bear likes honey / buzz-buzz-buzz / I wonder why he does').

h) Friedrich Nietzsche, *On the Genealogy of Morals*, trans. Walter Kaufmann and R.J. Hollingdale, New York 1966, p.15. 'Shouldst thou however find honey therein, well! just lick it up, thou growling bear, and sweeten thy soul!' Friedrich Nietzsche, *Thus Spake Zarathustra* (chap.LXII), trans. Thomas Common, London 1932, p.237.

i) Georges Bataille, 'On Nietzsche: The Will to Chance', in *The Bataille Reader,* ed. Fred Botting and Scott Wilson, Oxford 1997, p.335. This English translation was originally published in *October* 36 (1986), pp.47–57.

j) Georges Bataille, *Story of the Eye*, trans. Joachim Neugroschel, San Francisco 1987.

k) Already introduced by David Weiss in *Wandlungen,* Zurich 1976.

l) A rather long and convoluted path leads from Sigmund Freud's schematic representation of the primary process of repression to Jacques Lacan's letter of 15 December 1977 to Pierre Soury (verso), in which he writes: 'topology resists / the discrepancy between psychoanalysis and topology / it is what it is / the edge / the encircling band / correspondence between topology and practice / the times'. Cited in *Die Erfindung der Gegenwart – daedalus*, Basel/Frankfurt 1990. Similarly, in his seminar of 21 November 1978 on 'La topologie et le temps', Lacan stated: 'Il y a une correspondance entre la topologie et la pratique. Cette correspondance consiste en les temps. La topologie résiste / c'est en cela que la correspondance existe.' (There is a correspondence between topology and [clinical] practice. The correspondence is made up of the times. Topology resists. It's with regard to that that the correspondence exists.)

m) First pointed out by Patrick Frey in his essay 'Ein ruheloses Universum', in *Das Geheimnis der Arbeit – Texte zum Werk von Peter Fischli & David Weiss*, Munich and Düsseldorf 1990.

n) Gustave Flaubert, *Bouvard et Pécuchet*, in *Gustave Flaubert, Oeuvres complètes*, vol. 10, Paris.

o) Fischli / Weiss in Robert Fleck, Beate Söntgen, Arthur C. Danto, *Peter Fischli David Weiss*, London 2005, p.8.

These are figures played by Fischli / Weiss in two films, and which also appear in other contexts
1980–1: *Der geringste Widerstand* (*The Least Resistance*) [–› pp.185, 186, 197–201], film, Super 8, colour, sound, 30 mins., camera: Jürg V. Walther, music: Stephan Wittwer
1981, in conjunction with the above: *Ordnung und Reinlichkeit* (*Order and Cleanliness*) [–› pp.202–5], photocopied brochure, published by the artists, Rat and Bear as salt and pepper set, painted and glazed fired clay
1982–3: *Der rechte Weg* (*The Right Way*) [–› pp.206/7, 210], film, 16mm, sound, 55 mins., camera: Pio Corradi, music: Stephan Wittwer
1981–2004: animal costumes in Perspex showcases [–› pp.208/9], 280 × 80 × 100 cm

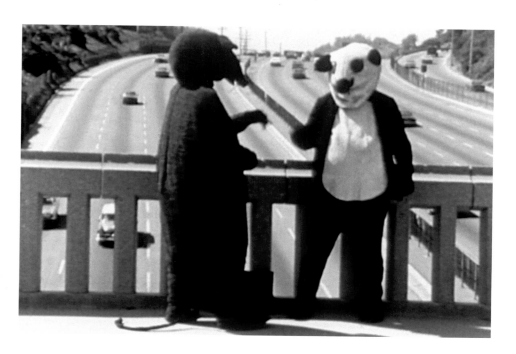

Grundtyp

versch
Typen, z.B.:

Sportler,
Aktivisten

FIG.6

z.B:
Kopf÷
mensch

etc.

Fig. 13

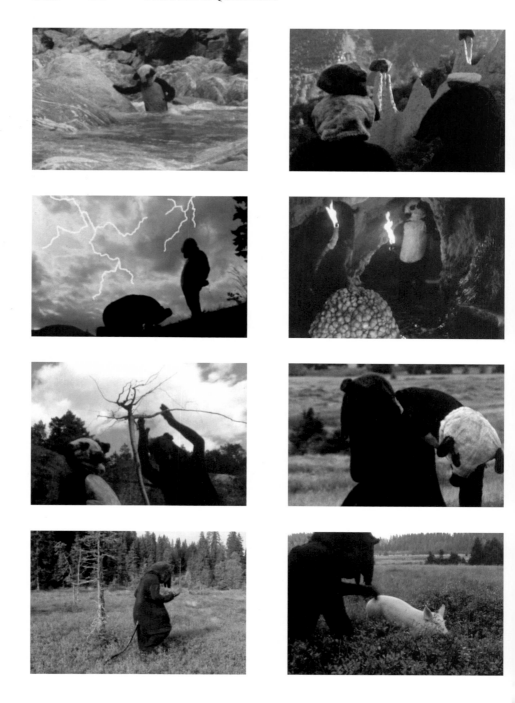

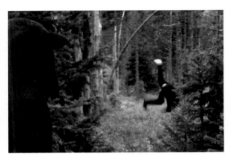
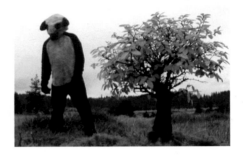

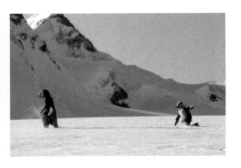
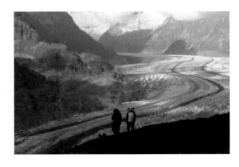

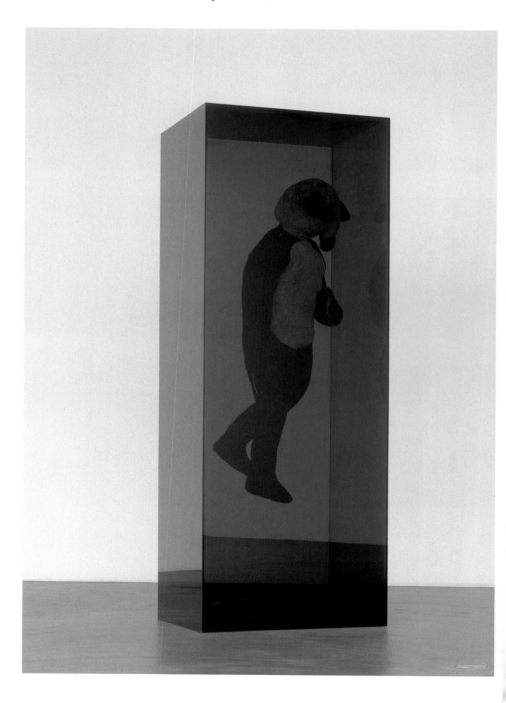

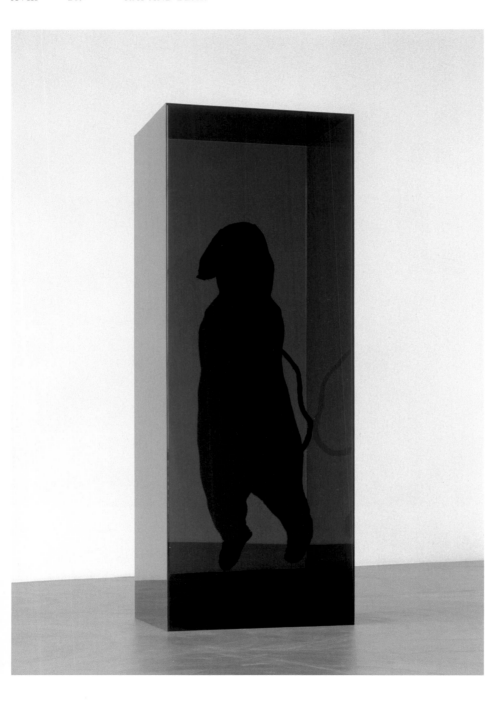

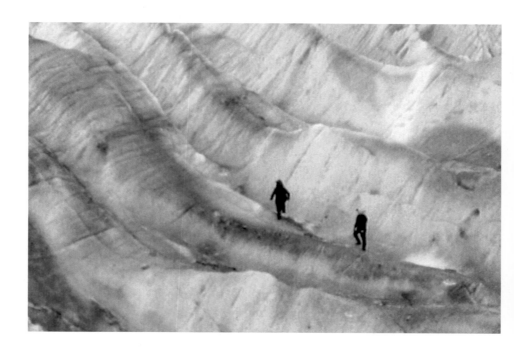

XIX

—

Arthur C. Danto

—

—

The Way Things Go (*Der Lauf der Dinge* 1986–7, which I would prefer to translate as *The Course of Things*), Fischli/Weiss's masterpiece and a result of the intervention of genius, is a film in which tyres and scuffed wooden chairs play a starring role.

The film consists of a number of events linked together in an improbable causal chain: a rotating garbage bag untwists the rope from which it hangs, moving closer and closer toward the floor as it does so until it touches a tyre positioned beneath it, which now takes up the action by rolling down an inclined plane and banging into a plank that gives it a further kick, which initiates a stepladder's awkward descent until it trips, which causes a further reaction … until, ultimately, some sort of inflammable foam goes up in smoke as it spills over the lip of a tray. Between start and finish, more tyres are set rolling, bottles are overturned, liquids spill, and things ignite, untwist, explode, rotate and roll on eccentric axes along dinky tracks.

As is often observed, the film has the deflected ingenuity of a cracked inventor such as Rube Goldberg, who drew such contraptions for his reader's

amusement a generation or so ago. But there is this difference: Goldberg's contrivances were madly complex devices, requiring an improbable assemblage of components for achieving tasks capable of being done by anyone simply and directly – like lighting cigars or rocking a baby or pouring coffee. They were caricatures of so-called Yankee ingenuity, expressing itself in 'laborsaving devices' that 'no home should be without'; but, rickety and crazy, these devices interposed so much mediating gear between agent and task that one always feared they would not be up to the homely demands made of them. The causal chain in *The Way Things Go*, on the other hand, has no function and no goal. But in concatenating slides, rolls, tumbles, spills, booms, bangs and spins, it vividly illustrates what Kant offers by way of characterisation of the work of art: it seems purposive while lacking any specific purpose. It does nothing, but it seems to embody, for viewers to whom I have shown it, meanings that touch on waste, violence, pollution, exhaustion and despair, all somehow reinforced by the overwhelming sense of suspense generated by the fact that it is a film: the individual episodes seem to happen one after another, smoothly and without interruption – the danger being that something will go wrong and break the chain.[a] It is, for all the triviality of its individual episodes, an epic of some kind, vastly transcending the connotations of play while retaining the spirit of innocent mischief in which boys at play egg one another on to higher and higher efforts which, taken collectively, seem to imply the pointless horror of unending war. Beginning with a Katzenjammer Kids mentality, Fischli/Weiss take their mischief to a distance so great that the resulting work becomes a postmodern classic with a rich art-historical pedigree ranging from Jean Tinguely, the fabricator of self-destroying machines, to Joseph Beuys, who made art of soap, old newspapers and whatever was, to echo Heidegger, 'at hand'.

The tremendous difference between the two photographic series, *Wurstserie* (*Sausage Photographs* 1979) [→ chap.XIV], and *Stiller Nachmittag* (*Quiet Afternoon* 1984/5) [→ chap.VIII] and *The Way Things Go*, is that this last, in Heideggerese, stresses the thingness of the things it uses and does not treat them as metaphors for something else. Ben Hur, for example, sees the possibility of chariotness in a plain cooking utensil. Part of the pleasure of the work consists in the way the pan continues to be just what it is and yet, for purposes of play, has become a chariot (just as the tape spools, remaining mere tape spools, have turned for purposes of play into wheels). The objects in *The

Way Things Go remain what they are throughout. In many cases, to be sure, they are deflected from the uses for which they were invented. The tyres do not cushion any vehicles or rim any wheels, and yet they do what enables them to serve their purposes when attached to vehicles: they roll. But they also get filled with liquid, like tyres left out in the rain. And, in at least one somewhat scary episode, they go up in flames, the way the tyres filled with gasoline and hung round the necks of suspected traitors as 'necklaces' do in acts of Third-World retaliation. Indeed, in the grunge and squalor of the space in which the causal chain is enacted, with all the flames, ropes, racks and tracks, treacherous slides and dripping water, there is something of the air of the interrogation space, where information and screams are pried out of victims by means of flames, ropes, racks and tracks, treacherous slides and dripping water. It is this analogy, perhaps, along with the suspense, that give the film its uneasiness and its moral edge.

And those hard wooden chairs! We have seen them in the scenes of torture by the painter Leon Golub in which victims, bound and blindfolded, are tormented with clubs and lighted cigarettes. (This validates the vocabulary of the *Sausage Photographs*, in which cigarette butts, all at once a symbol of cruelty, stand in for human beings.) And when Bruce Nauman inserted a straight chair into a piece of sculpture this, too, was widely read as a reference to torture. The chair tipping over in *The Way Things Go* seems at once comical and frightening, as it would be if someone were sitting in it tied up. Perhaps this is why viewers do not always laugh, are not sure whether this is funny, are uncertain what the response is supposed to be. If there is a moral, perhaps, it is that once detached from the wheels that give them their use and for which they were designed, tyres can find a range of deflected applications – from improvised hoops to cheap and convenient instruments of torture and incineration. And chairs can become the vehicles for torture. This is an argument for each thing having its place in a well-run society, which is the positive side of celebrating (if that is what it is) banality.

It is the world as everyone lives in it, the world of dailiness, the world of common experience, the dear, predictable world anyone who knows the world of *The Way Things Go* longs for. Such a person would give anything for a glass of fresh water, some dry socks, a warm meal, roads not potholed by mortar shells, gas stations where the pumps work. On the news last night, there was gas in the kitchens of Sarajevo for the first time in half a year. The

answer may not be metaphysically deep. But morally, humanly speaking, there is no answer deeper.

[Excerpt from 'Play/Things' first published in *Peter Fischli David Weiss: In a Restless World*, Walker Art Center, Minneapolis 1996]

a) In fact, the film is highly constructed (i.e., edited). It was filmed over a long period of time, after many trials and errors in producing the individual cause-and-effect sequences.

Film, 16mm, sound, 30 mins., camera: Pio Corradi
1986–7

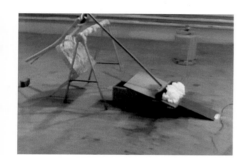

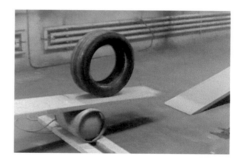

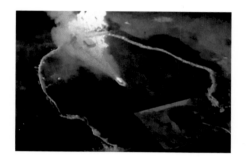

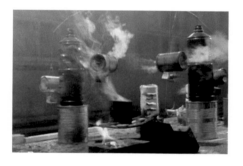

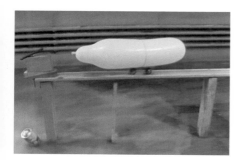

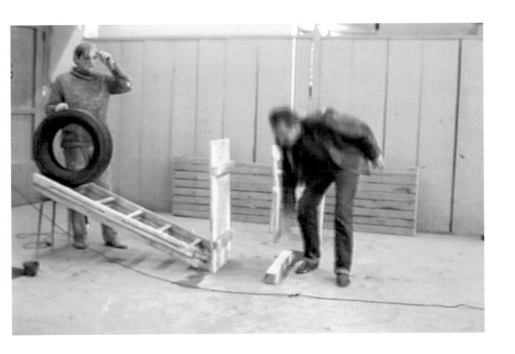

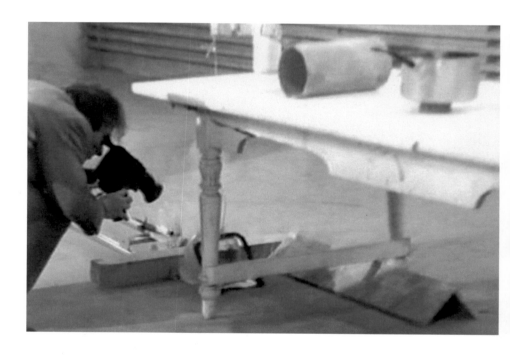

Now the thumb story mentioned above is a story, indeed an extraordinary one, but still completely plausible because improbable, but nevertheless functioning; word and causal chains can be formed effortlessly with language, in stories and with mysticism. Linguistically you can always somehow resolve it in a satisfactory manner!

However, the language structure must be right and when Kant in his *Critique of Pure Reason* attempts to explain the general principle of causality – as a category no less, for a priori and solely for the area of experience – as valid, then the chains of words and sentences themselves must also obey the constraints brought forth. Therefore, everything has to fit in carefully and be plausible.

That is not easy!

Indeed, nothing at all is easy with reality: I hit my thumb and the doctor doesn't travel to the Far East! It is quite difficult with things and objects; they are obstinate, composed, idiotic (Greek *idios*: strange, peculiar, capricious). The simple, tightly closed secret of things is presumably that they haven't got one at all – which makes things even worse! And so they just serenely stand around. The object says it itself: it stands, lethargic and stubborn, and is from the very beginning against being changed, moved or giving up its blessed as-is being. Strength and calculation are necessary in order to move it.

Consequently, we have to force weak, soft-limbed, presumptuous, but nevertheless industrious, people from one thing to another: hammers, pliers, nails, saws, all these tools have something violent about them, but violence alone does not achieve anything. The good, skilled manual worker needs patience, adroitness, sensitivity and cleverness. When all this bears fruit, he even succeeds in making something we call a *machine*.

Once many years ago, in 1987, I showed art students a film called *Der Lauf Der Dinge* (*The Way Things Go* 1986–7) [→ chap.XIX]. On top of that I invited a few friendly, skilled manual workers from next door, for whom I also considered the film reasonable. (Generally, workers don't like films made at art schools.)

Everyone, the students as well as the workers, succumbed immediately and absolutely to the charm of this film! Put more exactly: they stared in astonishment at the elegant proportions and well-structured

sequences between, so to speak, simple as well as pert and ready-for-action objects.

While the students were completely enthralled by the playfulness and the sensation of the presentation – *the show* – and wrongly-imagined computer or film manipulation, the skilled manual workers – two carpenters, one model builder and one stage technician – extolled the effort which must have gone into the making of the film in addition to the plain elegance and simplicity of means.

'Good heavens!', exclaimed one worker with great enthusiasm, 'That must have taken a lot of WORK!' – without any regard to all the effort and strain suspected. All four immediately and carefully conjectured as to how the whole thing could have been made.

We now know and can see as of recently how this film was made: at the beginning of 2006, Patrick Frey surprised his friends, the artists Peter Fischli and David Weiss, with two video cassettes, each three hours long. He had done a good job of forgetting them somewhere for 20 years, but nevertheless had also done a good job of saving them. The six hours show the production of the first sequence of things made in September 1985, which you could see as a three-minute super-8 film, the final work.

The Way Things Go is a film. I have to emphasise that here once again, since most viewers do not perceive it primarily as a film at all. All the same this film must be a film: the presentation of the piece requires enormous effort and nevertheless could still fail. The things also have to remain among themselves; the immediate presence of people would only be a disturbance. The film keeps us people at a safe distance, to its and our own advantage.

What I should also mention is that the completed film first consists of super-8 and then 16-mm film shots, not video shots. This has significant consequences: film material is expensive and every wasted roll of film hurts! When making a video film, unsuccessful takes are irrelevant. When making a real film everything depends on the one, the first attempt. The preparatory work requires great discipline and exactness, which is of visible benefit for the action, or put in a better way, for the happenings in the film.

I am sure that a recording of the approaches with video technology would have turned *The Way Things Go* into something entirely different.

Among the one hundred recording attempts there would then be a twisting and turning, wobbly course which would just about be a success. The demonstrable precision and completed elegance of the real film, however, are due to the work required for setting up and calibrating everything for that singular and necessary attempt.

On the other hand, Patrick Frey made a slightly negligent video film during the preparations for the real film, but it is also coherent: over the course of hours we see the artists, often Patrick Frey himself, too, and then an electrician from the neighbourhood on a factory floor, or outside because of the fireworks, tinkering with the sequences, sometimes like children, other times like engineers, in front of the video camera which is constantly running. In any event, the usual way of the world takes its sweet time – the duration, the tarrying, occasionally quite long.

Now and again the attempts do not succeed. We see rehearsals that are successful through many stages but in the end must fail. Everything has to be re-built all over again. We see innumerable attempts for that one perfect course of things. There is a lot of laughing going on. The failure and the missing submissiveness of the things are comical and burlesque. All the action is eccentric and farcical, but what pleasure, what inventive luck, arises when it succeeds! The men dance with each other and howl.

In conclusion, let us all together hit the thumbs of the advertising morons with a hammer since they once so deplorably rejected *The Way Things Go* for an inexpensive automobile commercial.

Now, everyone can find out and see who, with much effort and great patience, created such a magnificent piece.

———

Video with footage recorded by Patrick Frey on the occasion of the very first experiments and during the shooting for the 3-minute sketch (Super 8) of 1985, 68 mins., sound, edited 2006

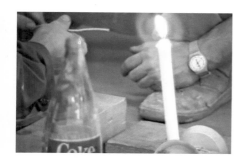

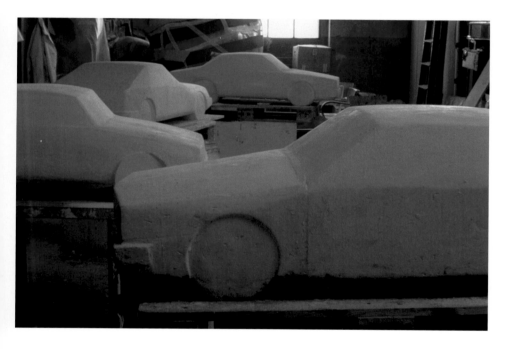

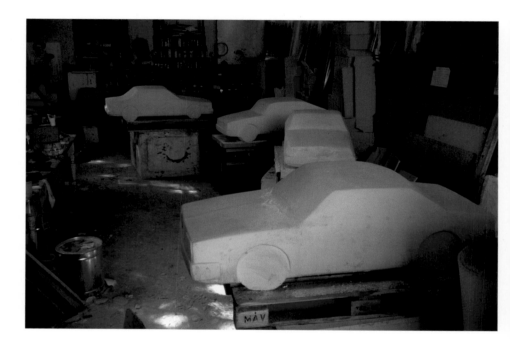

XXI

—

John Kelsey

—

—

The frequent flyer and the traffic jam are just two examples of the fact that, in our days, production and circulation are one and the same process. If we are moving we are probably working. If something produces value it is probably moving too, not just a thing but a transportation. 'Am I My Car?' is one of the big or small questions posed in the Fischli/Weiss's book *Will Happiness Find Me?* 2003. Big and small, these are the questions that works like *Autos* (*Cars*) and *Frauen* (*Women,* formerly entitled *Stewardesses* 1988) were already asking in the late 1980s, even if they were hidden behind other, more immediate ones, like 'is it too easy?' and 'is it good?'

 Cars and *Women* are works that have often appeared together, and one of the basic qualities they share is a ghostly, dry whiteness. Being made of plaster, this is a quality they both also happen to share with art galleries and museums. Cast in the same stuff, both sets of objects and the gallery walls that echo and contain them, have a way of undermining the old figure/ ground structure – being not exactly one or the other – and at the same time announce a sort of zone of indistinction between idea and surface, content

and packaging, information and format. Haunting the gallery and catalogue with their chalky blankness, these objects have a disconcertingly easy way of showing us what's so strange about the ordinariness of our world. This is an effect we know from other Fischli/Weiss works too, and one way they do it (when they're not busy animating static objects) is by stopping and freezing a thing that normally moves. Many works do it by robbing an ordinary thing or an image of its utility, and these do it with cast plaster.

A material so cheap and common seems perfectly and strangely adequate to forms as ordinary as cars and working women. Reduced and then immobilized in plaster, the perfectly normal desires these objects speak to – desires for mobility, independence, belonging, completeness, etc. – are made to stumble over themselves, over their own strangeness. Because *Cars* and *Women* are libidinal stumbling blocks. Some part of us is moving towards them only to be met by this dry, airy frozenness, and also this awkwardly reduced scale, and this is how a material as cheap and common as plaster shows us how strange we are in our wanting and recognising these things. They've also done it with clay and they've done it with acrylic and black rubber, but with plaster they do it cheaper and faster.

If I were Rosalind Krauss I might explain how the blank, white *Cars* and *Women* are also mothers and breasts, and that if they figure anything, it is their own absence.[a] Because what we encounter in them is in fact a repeating missed encounter with the real. Fischli/Weiss make sure we recognise these objects, and at the same time that we recognise our misrecognition of them, since they are nothing but substitutes for the images in our world. The plaster, causing a confusion between the blankness of the page and what appears on the page, reminds us that what we see is like an automatic ghost rising up in and even producing the gap in our seeing. And so we see that seeing is also not seeing.

The *Women* come in three sizes: small, medium and large (one metre tall). They come individually and in sets of four (cast in formation, along with the square of floor that supports them). The *Cars* are roughly one-third the actual size of a car. These off-scales give them the 'look' of art: Greek or neo-classical statuettes or Minimalist blocks presented on plinths, they occupy the place of art in a casual way, simply parked or posing here. They might be aesthetic stand-ins or sculptural surrogates. Even in heels, the *Women* mimic the relaxed beauty of classical *contrapposto* poses, one leg supporting the

body's weight, the other slightly bent. The alternating scales of these working women, when distributed in a gallery's expanse, produce optical illusions of depth perspective or odd fore-shortenings of rational, functional space. Standing next to a photograph, she is like a prop, a signifier of 'art' in a bourgeois salon. They are stewardesses and cars in the form of décor and vice versa. Returning us to the safety and comfort of a world whose values are always in order, they also haunt this place with their ordinariness and ease. They remind us that this space of inventory is always already filled, like a parking lot.

These aren't particular people, these women, and the cars too – parked in all their showroom obviousness – are approximations of the most average automobiles, as brandless as the women are anonymous. Examples of the normal, stripped of almost every identifying feature but the feature of being normal, they really are strange. We could say that anonymous, or whatever-art is that doesn't identify with itself, and that isn't non-art either, but that has a devious way of exemplifying and absorbing the art/non-art paradox that has haunted the aesthetic regime at least since Duchamp stripped a urinal of its use value in order to suddenly charge it with a disorienting exhibition value (in order to present exhibition value as such). *Cars* and *Women* are *examples* of readymades, and are in fact made that way by the artists, nonchalantly cast and cast into our midst as examples of automatic or mass-produced things. Have you ever seen a model kitchen, for example, displayed in a shop window? It is an abbreviation, life-like but smaller than life, and the faucets don't work. This could be something to cast in plaster too, an example of an installation.

The word automobile is close enough to automaton that a question like 'Am I My Car?' and the robotic look of the working women can be posed together, here in this gallery, in order to also ask the question of happiness in an automatic world. Ever more subtly calibrated to the production and circulation, to the moving-making of our post-Fordist economy and its value-producing transportations, are the processes by which we are at the same time subjectivised as individuals, as travellers, as workers, as consumers not only of an automatic world but of our own automation. Ever since the first readymade, modern art has attempted to match the automatic force of non-artistic, industrial processes, and not always in order to critique or sabotage these. Because there is still the promise of the joyride and the desiring machine. Automatic, familiar images such as *Cars* and *Women* are like

moulded blocs of late twentieth-century subjectivity laid out in plain view. They are our own whateverness. And in plaster as white as a gallery wall, they show how this whateverness is what links production and desire. Cast and frozen, but not in the glamorous permanence of marble or bronze, these static productions seem caught in the beams of oncoming traffic, of our own automobilised gaze.

a) Rosalind E. Krauss, *The Optical Unconscious*, Cambridge, Massachusetts
1994.

———

Cars: 4 different types, 45 × 150 × 70 cm
Women: sculptures in three different sizes: 40, 60 and 100 cm high
1988

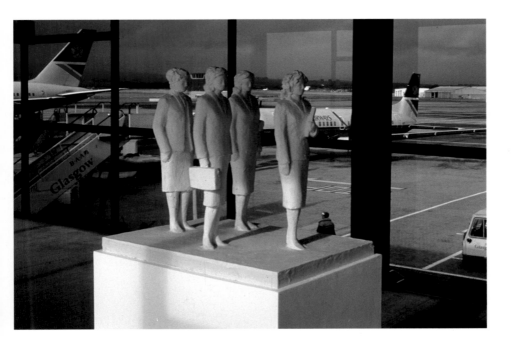

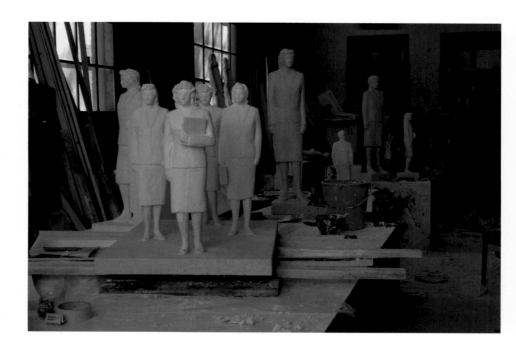

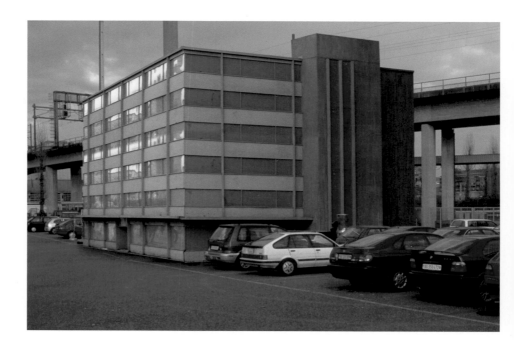

XXII

—

Hans Ulrich Obrist

—

THE FABRIC OF REALITY

—

Zurich, Sunday 18 December, 9 o'clock: I am in the wireless kitchen of the curator Beatrix Ruf. She and I have made a night-train journey from Paris to Zurich, having missed the last flight, and I am waiting for Peter Fischli to pick me up and drive me to the studio where David Weiss is waiting. I am very nervous; this interview has been planned ever since I met the artists for the first time in 1986, when they were just about to make their most famous work, the film *Der Lauf der Dinge* (*The Way Things Go* 1986–7) [–› chap. XIX]. The artists are reluctant to give interviews and have only granted a handful over the last decades, including a notable one with the artist Rirkrit Tiravanija for *Artforum*, when they all made a trip to the mountains together.

I especially want to ask them about their relationship to architecture and specifically their *Building in Münster*, the reduced-scale office block they built in a public space for *Skulptur.Projekte Münster* in 1987. As we start the interview, Fischli fetches the proposal they sent to Kasper König, curator of the Münster project. He reads it aloud:

'Proposal for *Building*, on the occasion of the exhibition *Skulptur. Projekte Münster*, 1987: our suggestion for the sculpture project is to build a structure on the scale of 1:5. It will resemble a building for a middle-sized company with four floors, and is designed in the modern international architectural style. Front: shops, offices and entrance. Back: hoist and loading ramp. Location: ideal would be a location close to the train station between the cinema and the snack bar. The building would match the atmosphere and architectural style there, and it would not, as in the city centre, stand in contrast to it.

Architectural style: common modernism, representing worthy mediocrity – a scaled-down example of middle-class self-representation. Construction: a wood construction, according to a drawing that we will hand in later, would be desirable. We would then add the facade, with all details, in about two weeks of work.'

He adds that there was an earlier version of *Building*: 'In 1984 we made a sculpture, which was about the size of a desk, 120 × 160 × 110 cm. That was an indoor sculpture.' Weiss explains how the idea for this sculpture, also of an office building for a small business, arose: 'Jean-Christophe Ammann had invited us to exhibit in the Kunsthalle Basel. We had to produce a lot of new works for this show. In this situation, we began to ask ourselves, "What are the general requirements for production?" There is the fabrication, the storage, the office … And I think one can say that the *Building* was a kind of a self-portrait of our studio.'

Before this, I had never considered this relationship between *Building* and the artists' studio. Studio visits are often revealing in this way. They constitute the best form of encounter with artists – all of a sudden language, explanations, behaviours, contexts and the work itself come together simultaneously. Although the studio we are now sitting in is no longer the same one, it too is situated in an industrial area, and is housed in the same kind of building, where the artists' neighbours are small companies such as a carpenter's workshop or a print shop, not a site where one would normally expect to find an artist's studio. However, the relation to the studio should not be taken too literally, objects Fischli: 'The initial idea was not to create a representation of our studio, but rather a representation of "work" in a more general sense. It was intended to refer not only to us but to the situation of small companies in general and to the people who work in these buildings

every day.' But, 'on the other hand', he notes, 'it was also about a demystification of the artist's studio. It brings the artist close to normal working people.'

Weiss states that the ordinary appearance of *The Building in Münster* was an important aspect of the work. It was intended to look as if it could have been found anywhere in Münster, or in any other middle-sized European city. He explains that architecture is important for the artists, primarily in terms of the role it plays in everyday life: 'Our aim was to find something that is representative for the living conditions of the many people who have to work in such a building every day.'

This idea of an 'everyday architecture' is reminiscent of the ethos adopted by the British architects Alison and Peter Smithson. In the late 1950s, in their studies of the everyday life of building sites, they introduced the notion of the 1:1 translation of materials 'as found' into their projects. It is interesting to remember how the Smithsons used the exhibition to test this idea. In the *Daily Mail Ideal Home Exhibition* show of 1955–6, for example, they exhibited their innovative *House of the Future*. Here, the exhibition was treated almost like a fair, where a prototype was presented like a stage set, using plywood, plaster and paint, but with real appliances. Peter Smithson drew my attention to the fact that Mies van der Rohe's Barcelona Pavilion of 1928–9 had adopted a similar artifice, being made up of only 60 percent of real materials, the remaining 40 percent being a wooden facsimile. The point about testing the 1:1 idea through exhibitions hasn't quite been resolved. Why is it interesting, in this context, that the *House of the Future* was presented like a stage set?

Paradoxically, while *Appliance Houses* such as the *House of the Future* constitute a very human form of modern architecture, with many analogies to life – acting like cells that can be linked to the more complex organic structures of cities – this style was to develop into Brutalism, which subsequently became an architectural cliché, and was viewed by many as the opposite of human architecture. As Peter Smithson explained to me in one of his last interviews, Brutalism as it evolved was not what the critic Reyner Banham had been talking about: 'The quality of a plaster ceiling is completely different from that of a concrete ceiling. With Brutalism it is not simply a question of rough materials, but the quality of the material itself – that is, what can it do? And by analogy there is a way of handling gold in a Brutalist way. This doesn't mean roughly and cheaply; it means asking what its

raw quality is. Brutalism is related to the ethos of Japanese construction. They say, "What is the quality of running water?" That is a Brutalist thought.'

For the Smithsons, it is the urban space between buildings that is most important, and they turned against the solitary character of modern architecture very early on, insisting on the collective, the space between the moment when all buildings are built as if they existed only in themselves.

Fischli has commented that in 2000 he attended a lecture given by Peter Smithson in Zurich, and very much admired his approach. He also refers to a relation with another architect: 'I read your interview with Robert Venturi. When you talked about his book *Learning from Las Vegas*, you asked him whether, if he would write the book today, he would still take Las Vegas as something to be "learning from"? And he gives this great answer, saying that one could take nearly everything as "learning from". I would say that building was a bit like "learning from the ordinary". All this mediocrity defines our urbanised landscape much more than the few so-called great achievements of contemporary architecture.'

The relation between everyday life and architecture is addressed in several of the artists' works, Weiss tells me, referring in particular to a photo series from 1993: 'Our photos *Siedlungen, Agglomeration* (*Settlements, Agglomeration*) [→ chap.X] deal a lot with this question. These are not the places of work but the places of living: the homes where the people who work in buildings such as the *Building* live. During our research, we observed that architecture plays a certain role. We photographed houses that were built between the late 1950s and the 1970s. We didn't want to include any photos of older houses. We were very much interested in architecture and other manifestations of so-called modern life. We wanted to see how "modern life" is constructed in contemporary Switzerland outside of Zurich.'

In general terms, he adds, the question is, 'What are the conditions in which we live?'

The artistic strategy adopted in *Building* in order to turn attention towards this normality is on the one hand a simple manipulation. Fischli notes: 'From a formal point of view, the exterior of the building is highly uninteresting. The only trick we use to direct attention to this building is the change of scale. One could say, "this building is just smaller" – but the perspective from the outside is also transfigured. Something small could also be seen as something that is far away: big buildings look small from a distance.

From this point of view one could say: "No, the building is actual size – you just see it from far away." By means of the change of scale, and at the same time the statement that the scale is still 1:1, we increased the distance between the spectator and the building artificially. In addition, objects that are far away have the ability to trigger many different types of imagination of what may be happening inside them.

'An important aspect of *Building* is to look at it as a narrative. There are many ways of inventing little stories around *Building*. For example, you can see the air-conditioning facilities, which we put on the third floor. You conclude that there are better conditions even on a social level. One could imagine a kind receptionist next to a gum tree in the entrance hall. Or one thinks of the furniture, the offices on the first and second floor, with the accountant or the pretty secretary …'

I always find this participation of the spectators' imagination very interesting. It's a bit like Duchamp's readymades, in which the spectator has to do at least 50 percent of the work.

Weiss remarks: 'One can easily feel melancholic while looking at the building, because it represents a fading time, a time when people had different hopes from today.'

I ask Fischli, whose father was at the Bauhaus, about his architectural background. He tells me that his father built the family house in the 1930s, and it was one of the first in the region to have a flat roof. When he was a child in the 1950s, he says, he could watch these avant-garde forms becoming the norm: 'During my childhood, we made excursions to see the avant-garde houses of the time. The houses that I saw on my way to school later all carried the notion of this particular point in architectural history, when the mediocre takes over from the extraordinary. Suddenly, the architecture means something completely different. These houses, like our *Building in Münster*, are no longer an avant-garde achievement, but just ordinary. And this moment has its own kind of beauty.'

Post scriptum

My final question concerns any unrealised projects that the artists might still wish to bring into being. Weiss answers this with reference to the third version of the *Building*, made in Zurich in 2001: 'The third *Building* exists only in virtual form [→ p.238]. It is a photographic version in which we

increased the size digitally to the scale of 1:2 from the outside, but inside it would be on a 1:1 scale. So a six-floor building from the outside has only three floors inside.' Fischli/Weiss sometimes talk about building this new version one day, and even giving it an interior.

———

1987: Model of an office/factory building, laminated, painted polyurethane, 120 × 160 × 110 cm [–› p.237]
As temporary outdoor sculpture made from wood, Perspex and paint on the occasion of the exhibition *Skulptur.Projekte Münster 1987*, 350 × 570 × 410 cm

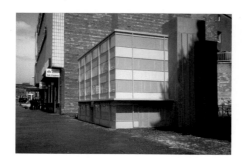

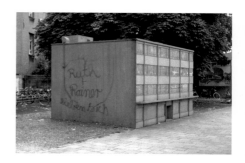

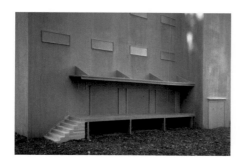

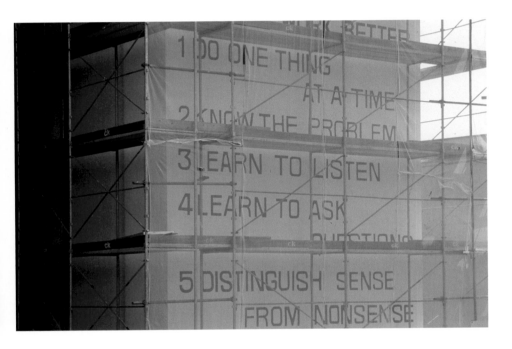

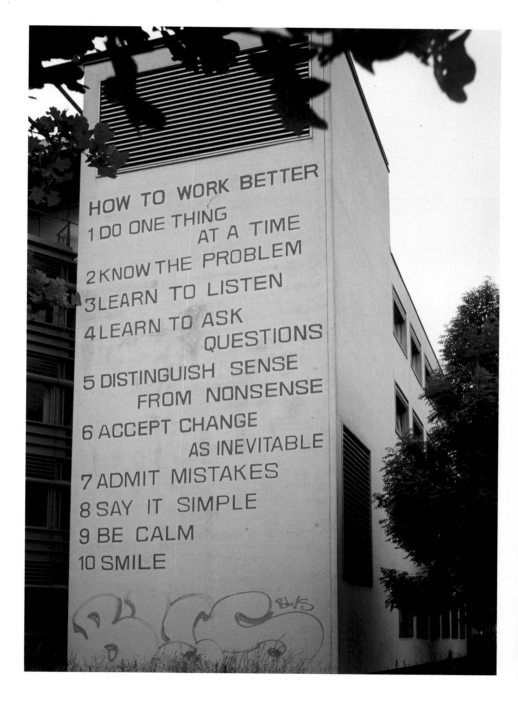

XXIII

—

Andres Lutz

—

—

Fischli/Weiss are good. Now let's talk about me. Me, myself and I. Actually it's rather interesting: I was dreaming out of the train window one morning about ten years ago, when my drowsy eyes lit on the façade of an office building that looked as though the good old Lord himself had used a great big potato stamp to stamp a set of rules on it, or instructions in ecumenical Weleda lettering – pastel mint coloured!

But he didn't threaten me with calamity like he did that lecher Belshazzar; he had good intentions for a change: the perfect Chinese sage, he gave me advice on how to improve my work.

My turn again: that sight out the window, it couldn't have been cleverer, being as I was in a pretty agitated phase of my life at the time, thinking I had to be burning a bunch of candles at both ends. The very first rule – 'Do one thing at a time' – was like balm for a soul torn every which way by so many musts and wants. I instantly projected that sentence onto the inside of my bony skullcap, right there above the sofa, a dainty, almost Zen Buddhist stratagem, and – lo and behold – I found solace!

Of course Mummy had already offered similar advice and so had Miss Brülisauer in kindergarten, but now art itself was gently leading the way to reason. You can't miss the mischief of writing art on a building like that. Rubbing it in, on the light grey wall of an office building, to increase the efficiency of all those docile clerks.

Fischli/Weiss are two bears, but they're two rats, too! Yes Lord, that's what's so nice about those ten maxims: you can take them seriously, as gentle directives, you can let them take effect as a meditative drip dripping into daily life, a positive effect no doubt, except that a New Age, a New Economy Satire is delivered along with them. Sitting there among them, cool as a cucumber. At least in the opinion of Yours truly, who has, as of now, turned art critic.

So, that's about it. Oh, there's still room on the page. Well, back to me again, for the last time, and to the essence of the number ten, rules, commandments, prohibitions, emerald panels and clever lists: for example, years later I'm squatting on the beautiful peak of the Rheinwaldhorn, with a panoramic view from Munot to Nanga Parbat, I'm on holiday, except that I still have to write this text and therefore go straight back to square one, because I'm up to my old tricks: leisure and work – so I'm hunkering up there in the desert of my freedom, thinking: God is dead, Nietzsche is dead, Zwingli gagged on his milk-and-bread soup,[a] only Fischli/Weiss are still at large and getting larger. What's to be done? I could for example be a little Faustian, out of spite, and wield 'power that would alone work evil but engenders good'. I could for example follow another dictum that I like just as much, Gottfried Benn's 'Build on your substance, not on your credo'. Maybe I'll go and spray it underneath the others one of these nights, for the sake of antithesis. Oh, come off it, no need to. It's not all that deadly serious. In terms of milieu and metaphor, our two friends have no doubt found succour of sorts in Huldrych Zwingli's milk-and-bread soup pot, taking a few bites of the Protestant work ethic, but without tugging their black gothic cap-it-alls as doggedly down their browbutts as grim Huldrych did. Instead they also look to Asia, Africa and America; so, as you can see, the diversity of possibilities, of truths is great on this grand and godly planet. They simply supply us with these ten handy little sayings to help us on our way – I've put them all above the sofa and keep practising the last one: smile.

a) In the early sixteenth century Zwingli wished to see the Protestant Reformation introduced throughout Switzerland, a policy which brought Zurich into conflict with the five catholic cantons. However, thanks to some reasonable leaders on both sides, a truce was agreed upon and the two opposing forces shared lunch. It is reported that the 'Innerschweizer' had milk while the 'Zürcher' had bread with them. Both parties agreed to share the food, now called 'Kappeler Milchsuppe' (milk-soup).

Screen print on paper in different colours, 70 × 50 cm; also as a mural on an office building in Zurich-Oerlikon
1991

HOW TO WORK BETTER.

1 DO ONE THING
 AT A TIME

2 KNOW THE PROBLEM

3 LEARN TO LISTEN

4 LEARN TO ASK
 QUESTIONS

5 DISTINGUISH SENSE
 FROM NONSENSE

6 ACCEPT CHANGE
 AS INEVITABLE

7 ADMIT MISTAKES

8 SAY IT SIMPLE

9 BE CALM

10 SMILE

XXIV

—

Patrick Frey

—

THE ART OF GENTLE REPULSION

—

Rubber in its natural form is the vulcanized resin of the rubber tree. Synthetic rubber is a polymer, an organic compound of high molecular weight. It becomes black through the addition of soot.

Mumyö and bonnö are both Buddhist terms 'for the sorrowful blindness connected with Being, mumyö meaning the darkness of imperfect knowledge and bonnö the darkness of passion and being entangled in it'.[a]

We have watched the material boundaries of art being exploded over the past twenty-five years, the material thresholds of, above all, disgust being transcended; we are no longer easy to shock. Whether felt, neon, fat, chocolate or manure, nowadays the idea will always at least come to mind that this may *also* be art, quite independent of whether one finds it good or bad and always assuming that one is at all concerned with the problem (which cannot be taken for granted).

But rubber? Rubber (in the case of these sculptures in synthetic rubber) is nothing new as a material, it probably even occurs in art here and there. Making sculptures out of it, casts of objects, as if it were bronze or wax, on the other hand – that, surprisingly enough, really is novel. The expression 'rubber sculpture', however, is not genuinely shocking, merely strangely irritating. The general (sculpture/art) and the specific (rubber) seem a perfect match, even appear magically to attract and repel each other. The irritation amuses, not so much because of the absurdity, impossibility or wrongness of the association as of the confusion of possible/impossible, this elastic back and forth between right and wrong. These rubber sculptures transport Fischli/Weiss's strategies with respect to right/wrong suitability of material, as we know them from the *Wurstserie* (*Sausage Photographs* 1979) [→ chap.XIV], and *Plötzlich diese Übersicht* (*Suddenly this Overview* 1981) [→ chap.XI], into an elastic dimension.

There is, after all, nothing absurd about the rubber cast of a stuffed crow; it is still black, and so it is still, as one might say, a black sheep and more – clever, thieving and capable of speech, an animal of nocturnal wisdom, witches' companion, whose hoarse call is like a primeval cry …

But what is the rubber crow in the context of the ensemble? 'Maybe a man, because he's a laid-back bird too', say Fischli/Weiss, [b)] and expand on their male fantasy: 'A man sees to it that he is well-groomed (*Mann Intim/Intimate Man*), then he gets into the car (*Auto*), chats up a woman (*Frau*), takes her to the house (*Haus*), and the *Vase* would be something like fulfilment.' That is *one* possible story, a story that leaves open the question not only of why a root (*Wurzel*) is also present, but why everything must be made of (black) rubber. Remembering David Weiss's laconic comment that if one could see pillows as mountains, one could also make roots out of rubber, I would like to devote the rest of this text to the material used to produce the art presented here.

When we think of rubber we probably think first of tyres, garden hoses, gaskets, shoe soles and other similar things; though they are in a certain respect decidedly important, they nonetheless have something inferior about them. They lack independence, exist less for themselves than for others, serving as intermediaries between actual things or parts of larger systems, and always doing so in accordance with their material properties: cushioning, resilient, insulating or protective. Rubber objects of this kind are thus

part of specific sorts of flexible intermediary relationships, for example between ground-water reservoir, water tap and rose bed, between cap and bottle or wheel rim and road. There is something in the design of these rubber objects that demands this relationship in two directions at once, for what is expressed in their innate dependence is a *dual* desire, not the simple one of the cap longing for the bottle, or the screw longing for the washer. Characteristically enough it is easier to grasp the design of a bottle-cap than of the gasket belonging to it. Alternatively, how would one describe an eraser, which, when new, can be almost any shape, but whose essence lies in its loss of material substance when used, allowing it to develop into a virtually indefinable non-shape?

Rubber may also bring totally different, ostensibly more independent things to mind, like balloons or inflatable rubber boats (and other variants of these thin receptacle-bodies which can be filled with air, liquid or something else). But unlike a wooden darning egg, for example, the balloon, too, lacks independence and is at the same time transitory, for it needs compressed air inside it to gain shape and, like an inflatable boat, become useful as an object. If we consider other objects, be they saucepans or Ming vases, we find that their usefulness lies in the emptiness contained in their interior; and this – not exclusively Taoistic – realisation must apply to balloons as well, but only when they are inflated. If the pneuma escapes, the balloon loses more than the air, it loses its soul (or spirit?); and we know the rude physical noise that accompanies this desoulification. Once the air is gone we can no longer see an empty space; no longer is there a clearly bounded Nothing making the usefulness of the receptacle formally visible, for this usefulness resides where there is now a miserable Something, in the genuinely formless, shrunken piece of rubber skin, which *itself* is now virtually nothing apart from a vague promise – or should one speak of a longing here too? – to expand once again (and again and again), acquiring size and shape.

When dealing with inflatedness, including everything organic, skinlike and bladderlike of which rubber is capable (in the new Fischli/Weiss film *Der Lauf der Dinge* (*The Way Things Go* 1986–7) [→ chap.XIX] this capability receives an impressive demonstration), in other words where rubber's valuable properties are allowed their full scope, the confusion of our feelings towards the material intensifies substantially. Admiration is aroused for its elastic-artistic achievements and the tenacious strength that ensures its

survival. But contempt too (quite in the sense of the fable of *The Oak and the Reed*) is aroused for *this* kind of survival, or perhaps it is even hate for rubber's undeserved claim to eternity – rubber, which seems as vulnerable as one's own skin and yet remains extremely durable. And – as opposed to hard plastic, for instance – in rubber material 'immortality' is allied with the aura of eternal 'youthful' elasticity and indestructability.

Contempt arises for the base and ignoble, for the characterlessness one believes one recognises in rubber's inexhaustible pliancy, its extreme, almost amoebic flexibility and adaptability. The ambivalence of one's feelings culminates in a sense of being confronted with a material strangely related to one's own flesh and yet alien, a material whose attractive 'warmth' and velvety softness are inhabited by something which is as gently as it is categorically *repellent*.

But this has the character of an objective realisation, for rubber is always and fundamentally of repellent gentleness, both psychologically and physically; and the way it repels varies so to speak with the hardness of the material. At the one end there is faint disgust at a rubber glove, with its skin-soft but nonetheless waterproof vulnerability; then follow a few objects with a relatively positive psychological aura, whose power of repellency can be used for erasing or playing with; and at the other end we come to the sombre realm of black vulcanite – the very material Fischli/Weiss use for their sculptures – where disgust no longer arises, but for that there is a dark uneasiness caused by the combination of gentleness *and* elasticity. Everything that absorbs heavy blows and knocks is made of matt black vulcanite, but so are rubber truncheons and bullets. The uneasiness is produced by 'that softness with which one can beat someone to death', as Bice Curiger recently commented. Naturally a brass paperweight can also be used as a murder weapon, but that requires a less muted, somehow more decisive act. With its repellent gentleness rubber cushions not only interobjective, but interpersonal, relationships as well: if it is soft, it creates contact without tangency; blows with harder rubber produce unconsciousness without completely killing. And when they do kill, then perhaps with very little injury. The rubber for its part is still less affected – if the word may be allowed here – even when tyres are slashed, surely the most profound vandalism of the twentieth century: though the tyre 'dies', the 'wound' closes immediately and can hardly be found. Rubber swallows virtually everything that is very loud, hard, sharp or aggressive, allows it to penetrate for a

moment and then repels it again; despite its natural elasticity there is a loss of energy, albeit only a very slight one, in fact that basic cushioning effect.

It is a – slight – loss of immediacy, of clarity about the reality of the world, no more, but no less either. What happens is best expressed by a term from media communications: moderation. As a TV moderator has to provide a buffer zone of understanding without allowing it to become too noticeable, rubber moderates dialogues of immediacy, creating tolerability and mediocrity where the genuinely real would be intolerable or excessive. In relationships between people, and between people and things (including all objects of desire) rubber also moderates truth (or its contrary) to a tolerable level, making it somewhat more flexible, forgiving small mistakes. While not falsifying, it softens rough edges just enough to render not only lack of truth (or its contrary) but also what has remained of it tolerable. Actually I have for some time now been talking not about rubber itself but specifically about Fischli/Weiss's rubber sculptures. It is an attempt at the (partly allegorical) description of a material, a description possible only because, in a variety of objects, the material has taken shape here in a manner that does it intense justice. These works are not simply sculptures made of rubber (for a change), but rather true object analogies of what could be described as rubbery. Or the reverse: perhaps this ensemble of sculptures is an endeavour to give form to the Great Rubberiness, to objectify rubber, understood as a material allegory of everything mediative, including that elusive thing called 'middle-of-the-road taste' – which fills and fulfils the unceasingly extending space of the Great Commonplace.

Let us look at this play of natural and scale-accurate proportions – forcing us to compare *and* confuse – out of which develops the perception of a moderate, medium size that in all its 'natural' rightness leaves behind a feeling of disharmony. Let us look at the settlement (*Siedlung*), where doors may not be slammed and the noise of nearby motorways must be excluded, above all at night, the same as here. In the house (*Haus*), the bungalow, 'modern' for twenty years now, things are not much different apart from there being fewer, but for that better insulated, doors. Maybe the original vase (*Vase*) and dog's dish (*Hundenapf*) are inside (dogs may still have been prohibited on the settlement (*Siedlung*), but they do not stand as close to each other here as in art: the delicacy with which Fischli/Weiss's objects are forced into comparison is remarkable. The similarity of the *Dog's Dish* and the *Vase* as receptacles appears stronger here than in reality. They *belong* together. But one thing

distinguishes them when they are made of rubber: a rubber dog's dish is perfect in *every* respect (apart from one's perhaps wishing one's dog a more cheerful colour). In comparison with the original, the *Vase* too lacks virtually nothing – except fragility; and this 'lack' renders the attractive vessel so practical as to make one slightly uncomfortable. The matt black rubber *Vase* is uncannily practical – even on the higher level of (male) fantasy. It is the embodiment of something like a *practical ideal*: it promises fulfilment of that longing for something of feminine beauty with which one can deal without risk, something which can even be thrown about. Rubber makes the *Vase* the fulfilment not only of form, but of wishes, gentler, more robust and more yielding than the brittle porcelain original. The process is comparable for the graceful female figure, in the transition from bronze to rubber.

But the flesh is dark and the sheen dull; this rubber is heavy and tenacious, impenetrably dense. The Moroccan hassock (*Marokkanischer Hocker*) with its firmly bulging, rubbery massiveness, an object Fischli/Weiss appreciate because 'it is beautiful the way it obtains an almost perfect balance between Morocco and Möbel Pfister, [c)] almost an equilibrium', speaks of the character *and* significance of this kind of moderated confrontation between home and abroad, the familiar and the foreign.

The soft black of these new Fischli/Weiss objects points to the fact that a cushioning of immediacy also means a shift into dullness or an increase in unconquered darkness. Rubber densifies the mystery around things and around the wishes and longings with which we imbue them. The mystery becomes elastic and resilient; the hassock too is a hassock at *night*, at rest, complacently content, filled to the bursting point with tenacious gloom.

It is dark where the sewer workers (*Kanalarbeiter*) lower their (rubber) hoses as well; what they bring up is viscous, base and concerns everyone – theirs is an unjustly disparaged profession. They participate intimately in man's culture and, like all modern housing estates and bungalows, are profoundly attached to a collective system. 'The sewer system is undoubtedly one of the very finest collective structural complexes apart from railways and motorways,' says David Weiss. 'And it is underground besides,' adds Peter Fischli. The sewer system is a system buried deep, enabling a high degree of order (and organisation?) because down there all that is individual and finely distinguished has been transformed into a single collective material. The *Kanalarbeiter* is an allegory of system seekers Fischli/Weiss, comparable to

the *Werkstatt des Alchemisten* (*Alchemist's Workshop*) in *Plötzlich diese Übersicht* (*Suddenly this Overview* 1981) [→ chap.XI] (where everything was still made of clay) or the *Bergwerk* (*Mine*) from the series of polyurethane sculptures [→ chap.I], but now drawn more strongly from ordinary life. 'It is no longer such an elevated task, less fairy-tale-like,' comments Fischli. But the alchemistic principle has not disappeared completely. Though the sewer workers may not be making gold out of sulphur, salt and quicksilver, they are trying to earn their money with collective shit. What they bring to light is the stuff of knowledge, the stuff of purity, pure melancholy if you will. This Fischli/Weiss allegory relates more than ever to a job that would be very difficult to accomplish without a pronounced sense of humour.

[First published in English in *Künstlerheft*, Biennale *Aperto*, Venice 1988]

a) Peter Pörtner, in *Japan und einige Aspekte des Nichts*, Konkursbuch 16/17, Tübingen 1987.
b) All quotations from a conversation with the artists, July 1987.
c) Translator's note: a popular chain of furniture stores in Switzerland.

———

Casts taken from everyday objects, life-size
1986–8
Further casts: *Grosse* und *Kleine Wurzel* (*Small* and *Big Root*), *Chinesischer Topf* (*Chinese Pot*), *Wurzeltisch* (*Root Table*)
2005/6

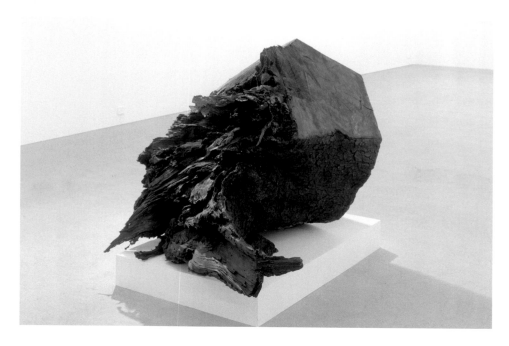

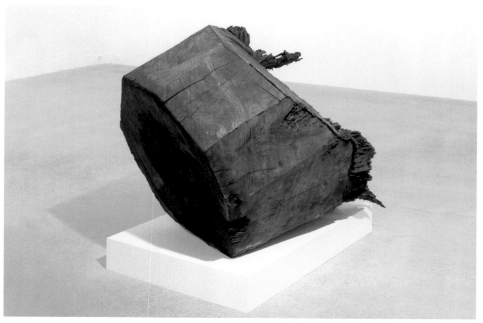

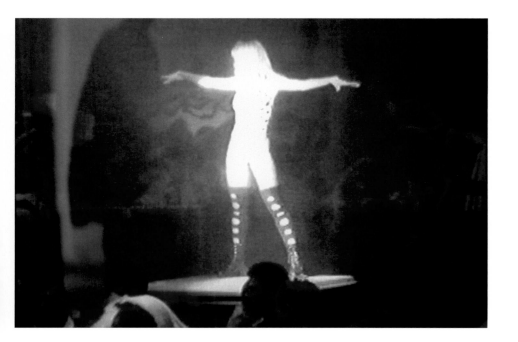

XXV

—

Bice Curiger

—

SUNDAY CHILDREN

—

We know that fortune smiles on Sunday children,[a)] but not with the extravagant windfalls of capricious good luck. Sunday children simply seem to divert a bit of the tranquillity that accompanies them when they make their first appearance on our planet, as a quiet reservoir that serves them to advantage for the rest of their days.

A predilection for the inconspicuous wonders of everyday life has guided the hands of the artists Peter Fischli and David Weiss in the Swiss pavilion at the Venice Biennale in 1995. As if through opening rifts and cracks, streams of images gush out of twelve monitors – solemn, serene and so inordinately ordinary that they are jarring, unsettling and seem vaguely out of place.

To be precise, it is not quite clear whether the stream is flowing towards us, or whether we are being sucked into a hypnotic maelstrom of images. The spell cast upon us might be called the 'magic of surfaces', for it is equally unclear whether this steady flow is fed by tributaries or whether it

is the 'main stream' of events. In other words: Are Fischli/Weiss concentrating on non-events or on proto-events?

Everything we see recorded here is obviously embedded in that powerful, giant web of all-embracing relations that unites our collective everyday lives. The easy accessibility of the images belies the fact that we watch the films as if discovering for the first time what we already know: a ride in an elevator, a plunge into a tunnel, waiting games, all those moments of suspended animation. We see a tank being washed in the sunset, a dog trembling after an operation, people dancing in a disco, an imposing snow-blower on its nightly rounds. The installation is governed by the diction and the world of those compositions schoolchildren produce when asked to describe a Sunday outing: ' … and then I had some ice cream and then it was time to go home'.

In all of the hours of video films that I watched, no-one tripped on a banana skin, no-one robbed a bank, no houses collapsed. The placid gaze, the undivided attention to all those significant nothings that have formed a tough, sugary crust in our collective semi-conscious minds, mesmerise us by the very absence of serviceability: no story, no instruction is the goal. There is no elucidating energy to lend meaning to the lack of significance, no clever narrative tricks and dramaturgical stays to keep us afloat on this modest, psychedelic river journey. With underhanded whimsy, Fischli/Weiss treat the dictum that art is without function in dead earnest. For, as we know, the power of representation always involves a compulsion to distort.

Films from the Pop era proudly celebrated the innovative intrusion of modern everyday life, with all its banalities, into the realm of art. But Fischli/Weiss's films are informed with that serene sense of wonder that Sunday children never lose when they go out into the world in unabashed, diligent and stubborn search of their rightful vein of gold. We workaday people with our foregone conclusions, our lowly wishes and compulsions have no choice but to grin and bear the unbearable lightness of their sunny affirmation.

[First published in English in Bice Curiger, Patrick Frey, Boris Groys, *Peter Fischli David Weiss, XLVI Biennale di Venezia 1995*, 1995, pp.35/6]

a) In Switzerland, it is considered a good omen to be born on a Sunday.

Installation in the Swiss Pavilion at the Venice Biennale, 12 screens, video, sound, 96 hrs, on the topics of everyday life, work, leisure, sport, excursions, travel
1994/5

XXVI

—

Mark Godfrey

—

—

One afternoon in New York City, I walked into the darkened space of the Matthew Marks gallery to find, stretching away from me, the largest table I had ever seen. It looked like an illuminated multicoloured blade slicing diagonally across the space, and approaching its near end I saw it was covered by a grid of transparencies. Because they were so small, I had to crouch over the table to see them properly. The very first photograph was taken from within a car on a lovely day, and though the camera caught the reflections of the passenger window, you could see quite clearly a rather plain field beyond the road. This shot established the theme of movement, and so the journey began.

The next few images showed Stockholm at various hours of the day, and then pastoral scenes of horses and sheep. I moved along, the grid before me filling with orangey sunsets, autumnal forests, and craggy alpine heights. Though the grid unified and equalised all the images, there were sudden jolts, as when the scene shifted from a glacier to the interior of an Egyptian taxi with no indication of the journey from one to the other. For the most part, the photographs just kept me moving over the surface of the table as none

demanded prolonged attention, but then I would recognise a place I'd been to and pause, or come across a view I wish I had seen. There were hardly any photographs of people and absolutely none of whoever owned the camera; some photographs were of classic views, others were far more mundane, some places seemed 'exotic', others totally ordinary. Soon my mind began to fill with questions: Were the photographs arranged in the order they were made? Over what period of time did these journeys take place? Were the photographs all taken by the artists? I carried forward, peering over Thailand, Milan, the Scottish Highlands, Mount Fuji ... and then my back began to ache and I looked up. Beyond me, like a road, the table stretched far ahead, the perspective lines rushing together. There were still hundreds of photographs to see. I had been crouched over for half an hour: my journey was nowhere near done.

Sichtbare Welt (*Visible World*) appeared in this format in 2001. [a] Answering most of the questions I had is pretty easy: Fischli/Weiss did take all the photographs themselves, but did not arrange them in the order they were taken. Instead, they placed groups of images according to how they looked when set down next to other groups in the sequence. The trips were made between 1987 and 2001, and for the most part they were not undertaken especially for the purposes of the eventual work; rather, the artists found themselves in the various cities across the world after exhibition invitations. For instance, the Cairo photographs were taken when they showed their *Equilibres – Stiller Nachmittag* (*Equilibres – Quiet Afternoon* 1984/5) [→ chap. VIII] series in the city in 1989.

Thinking about the relation between *Visible World* and the artists' other works, this series is a good place to begin. In *Equilibres – Quiet Afternoon*, the artists balanced everyday objects that would topple and crash after the click of the camera. The precarious sculptures were presented only as photographs, but in *Visible World* the relation of photography and sculpture is reversed: the photographs are presented in a sculptural situation, shown on and by a table of a specific height, placed importantly at an angle to the walls of the gallery, setting up a particular encounter for the mobile viewer. [b] The use of the table as a presentational and sculptural device also recalls *Tisch*

(*Table*) from 1992 [→ pp.19, 20/1, 26/7], a long table on which the artists arranged hundreds of their painted polyurethane replicas of run-of-the-mill objects. The support in *Visible World* also alludes to light-box tables in newspaper editing rooms. Such tables are used by journalists to scrutinise and select images for publication: Fischli/Weiss invoke this function only to disregard it, for no editing seems to have taken place, nothing cast away.

This last point connects *Visible World* to other works using neither photography nor tables. In 1993, the pair presented *Raum unter der Treppe* (*Room Under the Stairs*) [→ pp.12, 28], an installation at the Museum für Moderne Kunst in Frankfurt for which they fabricated, in polyurethane, the kind of cleaning, maintenance and storage objects commonly found in institutional broom cupboards. Jean-Christophe Ammann wrote about the way the artists aimed to achieve 'an exemplary form of dehierarchisation[c] by making visible these things that we pass by without seeing; just so, a principle of dehierarchisation governs *Visible World* where a photograph of the Sydney Opera House might be flanked by a shot of the nearby docks. A similar principle also operated in the 1995 video installation of twelve TV monitors in the Swiss Pavilion in Venice [→ chap.XXV]. Whereas video artists usually condense or elongate gathered information, Fischli/Weiss showed over eighty hours of 'unabridged' footage. Boris Groys suggested that while the artists simulated 'the readymade sense of television time',[d] viewers crowding the pavilion would realise that they could only see a fragment of what the artists presented. Thus viewers would intuit the difference between their hurried encounter with the work and the artists' relaxed mode of filming the footage. Just so, looking at the photographs of *Visible World*, you sense how divergent are the times you take with the work, and the times the artists spent on their travels. This might even induce jealousy. As has been written many times, Fischli/Weiss 'abuse time', but their viewers rarely have the pleasure.

We can also chart the relationship of *Visible World* to the artists' previous photographic projects. The first grouping of the artists' 'travel' photographs appeared in *Parkett* no. 17 (1988), before being published as the book *Photographs* 1989. These images showed iconic subjects such as Stonehenge and the Pyramids, and while *Visible World* would eventually feature many more mundane images that had been taken during these trips, it also cast aside some of these first-published views. Another group of photographs

were gathered into the book *Bilder, Ansichten* (*Pictures, Views* 1991). When, the next year, Fischli/Weiss were asked to make work for an office space, they offered some of this group, frustrating the commissioners' aspirations to acquire 'high art' by supplying images mimicking tourist photographs.[e] Again, *Visible World* includes some, but not all, of this collection. Rather than functioning as a compendium of earlier projects, *Visible World* gathers some of the photographs already presented, discards others, and introduces for the first time many more, and just as these previous works in some ways spawned *Visible World*, in its turn, the 2001 work has been generative: the slide piece *Eine unerledigte Arbeit* (*An Unsettled Work* 2000–6) [→ chap. XXVIII] gathers and superimposes underexposed shots from the travels that were not included in *Visible World*; the collection called *Fotografías* 2004/5 [→ chap.XXIX] stemmed from the desire to look under the surface that *Visible World* had tracked. In this way, just as *Visible World* charts a series of journeys, one followed by the next, so the work itself is not a terminus, but one 'station' along the artists' photographic production line.

It is also productive to consider the work within the recent history of artists' use of photography and within the functions of photography in the wider culture in general. The most obvious comparison for *Visible World* is Gerhard Richter's *Atlas* 1962–ongoing. [f] Indeed, if you juxtaposed a grid of Alpine photographs from the later panels of *Atlas* (for instance, panel 467 from 1988) with a number of similar (and contemporaneous) images from *Visible World*, you would be hard put to tell to whose project such photographs belonged. Yet the exercise would be misleading. In the earlier parts of his work, Richter had brought together family snapshots, advertising images, and documentary photographs; *Visible World* is by no means an investigation of the multifarious registers and functions of photography in post-war culture; but then *Atlas* is by no means a continued meditation on travel photography. But nonetheless, the comparison is important, for both works at times illustrate the banality of the medium. Richter does this through his juxtapositions of different kinds of images; Fischli/Weiss suggest (and emphasise with their title) that photography will only ever present the superficial world as it is available to sight. 'We were interested in the uppermost layer of reality, how it offers us only the

visible, the surface', said Fischli in a particularly Warholian moment. Weiss followed, 'On the jacket of the book there's a hippopotamus whose head is peeking out slightly above the surface of the water, but the rest of this large, beautiful animal is invisible, below the surface.' [g]

One could imagine another art historical comparison, this time between a gathering of sunset photographs from *Visible World* and Hans-Peter Feldmann's *Untitled (Sunsets)* from 1994. This would introduce the idea of de-skilling in artists' photography, the 'deadpan anonymous amateurish approach' to the medium associated with Feldman, as well as with artists such as Ed Ruscha. In Benjamin Buchloh's analysis, Ruscha deployed 'a particularly laconic type of photography, one that situated itself as explicitly outside of all conventions of art photography as much as outside of the conventions of the venerable tradition of documentary photography'. [h] It is important to specify exactly what kind of a de-skilling takes place in *Visible World*. The de-skilled photographs appearing in the work of Ruscha, Feldmann, etcetera were sometimes non-centred and blurry: by contrast, Fischli/Weiss's de-skilled shots actually mimic the 'well-taken' amateur photograph where everything is nicely (and very conventionally) composed, and rendered sharply in focus. 'The resistance to releasing the shutter', Weiss has said, 'is low'. [i] The distinction between their photographs and Feldmann's is helpfully clarified by a project of the latter's. One day, Feldman asked Fischli/Weiss 'to send him photographs that were not considered good enough to use in their work, but that they had not thrown away'. [j] They obliged with twenty-eight photographs close to ones shown in *Visible World*, but none quite as bright or crisp.

The comparison with Feldmann's *Sunsets* also raises the key matter of tourist photography, and the relation of *Visible World* to this genre. Not only do Fischli/Weiss mimic the form of amateur tourist photography (balanced compositions, etcetera) but also the subject matter. Just as in their polyurethane sculptures the artists re-created everyday objects, so in *Visible World* for the most part they replicate well known views. As Fischli explained, 'During our first journey there was an intention to find pictures that already exist as such, that are broadly distributed and enjoy tremendous popularity.' [k] This replication might be seen as a critical activity. If the tourist prides himself or herself when taking a 'good' shot, Fischli/Weiss deflate this notion of quality by achieving the 'well-made' photograph thousands of times. By

finding 'pictures that already exist' the artists also manage to expose the very condition of tourist photography. Peter Osborne has written that 'much tourist photography is quotation – a reprising of the contents of consequence of photography. Tourist photography is more a process of confirmation than of discovery.' [1] With their photographs of the pyramids, or of the New York skyline, Fischli/Weiss quote what is already a quotation, and in so doing, the artists lay bare the artifice and banality of tourist photography. Unlike the amateur whom they mimic, the artists understand the construction of the tourist gaze, the pre-determination of the urge to capture picturesque sights on film.

Reading *Visible World* in this way, we could suggest other comparisons with similarly critical and deflationary projects. For *Variable Piece 48 1971*, Douglas Huebler travelled from Massachusetts to New York City taking a photograph along the motorway towards the horizon, then another when he reached that point, and so on until he got to his gallery. In all he took some 650 photographs en route, and finally asked a third party to chose from these extremely dull views the most 'aesthetic' – a ludicrous task. The comparisons with Huebler's works are helpful, because though we can detect in Fischli/Weiss's work the same critical position towards tourist photography we find in Huebler's, so we can also begin to see how different is the Swiss artists' outlook.

While Huebler criticised tourist photography through works that offer deliberately dull black and white images, Fischli/Weiss do the same while presenting an extremely generous range of rich, diverse and compellingly beautiful photographs. While they reveal the construction of the tourist gaze, they cause us to fall in love with the photographs they offer: the work is as much a celebration as a dissection of the photography it presents. This double-edged quality is the work's its major achievement, and is typical of the artists' works. As Elizabeth Armstrong wrote, 'if there is an element of parody in [Fischli/Weiss's] works, it is commingled with an undeniable spirit of exploration and wonder'. [m] Fischli himself has indicated that *Visible World* poses a question later included in the 2003 book *Findet mich das Glück? (Will Happiness Find Me?)*: 'Can I re-establish my innocence?' That is, can an artist look at the world with amazement without denying the critical force of 1970s art? *Visible World* is so compelling because this 'wonder' continues to be palpable and is every bit as important as the work's emphasis on the

superficiality and familiarity of its images. 'It's OK to be schizophrenic,' Fischli has commented, 'it's the only solution that we have'.[n]

Realising this we might disregard photographic precedents and think about *Visible World* alongside a completely different-looking body of work. As to its identity, there's a clue in the final three photographs taken in Rome that appear about a quarter of the way along the table. These show the church of Santa Maria in Trastevere, and seem to have been taken from a window in the building across the piazza from the church. Alighiero Boetti lived and worked in this very building, and the spirit of his work seems very close to Fischli/Weiss's. In particular I am thinking about the series of embroideries from the 1980s called *Tutto*. Boetti selected images from a vast range of sources, cutting out pictures and pencilling around them on a canvas, filling this canvas with different outlines. The canvases would then be sent away to Pakistan to be embroidered in hundreds of colours, and returned to Boetti in Rome. Just like *Visible World*, these embroideries offer 'everything' to sight; every shape, and every colour, and every kind of object. Just like *Visible World*, the embroideries provide an extremely pleasurable visual experience. But just like *Visible World*, the *Tutto* works present the world only as surface.

Both works seem to come from the artists' desires to embrace the whole world with their work, but both works dramatise the futility of this desire (in this respect, both look back to Manzoni's *Socle du Monde* 1961). Rather than assuming a totalising view, the works present the whole world only as fragments. And it is with this in mind that I want to circle back to the light-box table. For the final effect of the table is to dramatise the impossibility of the work's attempt to show the whole world. As much as it is a mode of display (allowing the transparencies to be visible), the table *denies* this presentation. Unlike the artists' slide shows (which display multiple images to the stationary viewer), the table stretches the photographs out along its 90-foot surface. Leaning, walking, bending over, moving along, the viewer becomes wearied, and the total view of the world is withheld.

a) The work exists in three formats: as a light-box table, as a three-monitor video installation and as a book. I am particularly interested in the first format.
b) One precedent for the table is Mel Bochner's 1966 installation *Working Drawings And Other Visible Things On Paper Not Necessarily Meant To Be Viewed As Art*. Bochner

placed four ring-bound files on plinths causing the viewer to lean over to see the contents. Another is Dan Flavin's diagonal barrier sculptures.

c) Jean-Christophe Ammann, 'A workroom under the staircase', in Jean-Christophe Ammann, Rolf Lauter (ed.), *Peter Fischli / David Weiss, Raum unter der Treppe*, Frankfurt 1995, p.29.

d) Boris Groys, 'The Speed of Art', in Bice Curiger, Patrick Frey, Boris Groys, *Peter Fischli David Weiss, XLVI Biennale di Venezia 1995*, 1995, pp.60 and 56.

e) Robert Fleck, Beate Söntgen, Arthur C. Danto, *Peter Fischli and David Weiss*, London 2005, p.133.

f) Ibid., p.31.

g) Ibid., p.29.

h) Benjamin H.D. Buchloh, 'From the Aesthetic of Administration to Institutional Critique (Some aspects of Conceptual Art 1962–1969)', in *L'art conceptual, une perspective*, Musée d'art moderne de la Ville de Paris 1989, p.46.

i) Fleck et al., p.30.

j) See *Hans-Peter Feldmann: 272 Pages*, Fundació Antoni Tàpies, Barcelona 2001, p.160.

k) Fleck et al., p.29.

l) Peter D. Osborne, *Travelling light: photography, travel and visual culture*, Manchester 2000, p.79.

m) Elizabeth Armstrong, 'Everyday Sublime', in *Peter Fischli David Weiss*, Walker Art Centre, Minneapolis 1996, p.88. Bice Curiger has also described the artists' 'serene sense of wonder' before the world. Bice Curiger, 'Sunday Children', in Bice Curiger, Patrick Frey, Boris Groys, *Peter Fischli David Weiss, XLVI Biennale di Venezia 1995*, 1995, p.36, reprinted in this volume, p.268.

n) Conversation with the artist, 22 March 2006.

———

Video: 8 hrs, with cross-fading between 2800 pictures

Table: 15 light tables with a total of 3000 pictures from the slide archive on various journeys started in 1987, from which *Airports* [–› chap.II], *Garten (Garden)* [–› chap.XXX], *Siedlungen, Agglomeration (Settlements, Agglomeration)* [–› chap.X] have evolved, at Matthew Marks Gallery, New York, in 2002; 13 light tables at ARC, Musée d'art moderne de la Ville de Paris, in 1999

XXVII

—

Vincent Pécoil

—

—

For their solo exhibition at the Musée d'art moderne de la Ville de Paris, Fischli/Weiss chose to show only *Blumen* (*Flowers* 1997/8); the catalogue accompanying the exhibition was a collection of plates reproducing overlays of the images of flowers that could be seen at the exhibition. This choice may have been partly inspired by the same reasons that led Warhol to show only his *Flowers* for his first exhibition in the French capital. 'In France they weren't interested in new art; they'd gone back to liking the Impressionists mostly. That's what made me decide to send them the *Flowers*; I figured they'd like that.'[a] Judging by my recent visit to the Musée de l'Orangerie (devoted to Claude Monet), it tends to be mainly American citizens who admire Impressionist flowers these days. Never mind: French people are thought to like flowers, French artists in particular. And in fact Edouard Manet once said that 'fruit, flowers and clouds' are all a real painter needs to say everything that has to be said. And really this comparative diversion is useful to us mainly in understanding what Fischli/Weiss's *Flowers* are *not*. Manet painted skilfully composed still lifes, while Fischli/Weiss photograph

disorganised living nature, populated by ants, flies, snails and butterflies moving amid a chaos of flowers, berries, mushrooms and weeds overlaid on top of one another.

Traditionally the flower in painting has been regarded as a symbol of mortal fragility, and the insects alongside it as another metaphor for the ephemeral nature of life. And certainly in the successive fading of the slides of *Flowers* we can sense a sort of visual meditation on the futility of earthly beauty. But here the beauty of the flowers is not metaphorical, it is simply commonplace. Why would we deprive ourselves of the pleasure of the beauty of ordinary things? Too much colour, too much beauty – too easy? This ordinariness is troubling, for the works produced by art and the crafts that take art as a model are thought to be extraordinary. If I look through the window of my flat, on the other side of the road, just opposite, I can see the signboard of a florist proclaiming: 'Florist of quality.' The implicit commercial suggestion is that there are, by way of contrast, florists without quality (just as Robert Musil spoke of a man without qualities). Might Fischli/Weiss be among those? Abjuring any hint of floral arrangement, they seem to allow themselves to be impressed (in the double meaning of the word: psychologically and photographically) by the natural environment they photograph. The overlays of images are of course a form of composition, but these are the result of chance (one of the artists shoots a film, then hands it over to the other who in turn takes an equal number of shots on the same spool, with no prior consultation between the two). The relationships of things to each other are here constructed without the intervention of a responsible consciousness. And when they embark on the design of a garden, as they did in Münster in 1997, it is a completely ordinary garden they choose to make, no more and no less anodyne than their sculptures which are replicas of things of no value, so common that they run the risk of remaining invisible.

What is more, photographs of flowers conjure up one of the favourite practices in the world of amateur photography, namely macro photography. Perhaps the persistent prejudice shown in despising the amateur photograph originates in the former categorisation of pictures of flowers and animals as subordinate, incidental, and hence as belonging to a lower genre. Both prints and slide shows, the two forms in which the series is presented, have that 'amateur' dimension. The colour prints and the slide show evoke a domestic setting, pictures intended to embellish a flat, or the private projection of slides

for friends or family. As for the catalogue of the Musée d'art moderne de la
Ville de Paris, it consists of a series of unbound plates. The most natural way
to read it is to separate the double pages and place them edge to edge. Thus
reading it more or less reconstitutes the double projection of the 162 slides
forming the exhibit. The loose plates folded in two also suggest that they are
replicas of the Ektachromes (i.e. that they are like posters) and that we could
in turn put them up on the wall, as if the exhibition had simply been turned in
on itself for a time.

Projektion 1 (H) (Flowers) consists of the double projection of
slides that are themselves double exposed. The carousels are programmed to
make the images follow one another by cross dissolves. The arrangement
produced by means of double and quadruple overlays gives us the impres-
sion that we are seeing a profusion of hitherto unknown details in nature.
This estranging effect is partly due to the overlays that create an impression
of unreality; the berries seem to be coming out of the mushroom, the wide-
shot landscapes are mixed up with macro views, and some forms, attenuated
by the overlays, are transformed into shadows. The projection creates an
endless loop effect, with the pictures of flowers following one another in an
illusion of movement created by the dissolves, without anything whatsoever
happening. Henry Miller says somewhere that artists are people busy polish-
ing lenses ready for an event that never happens, that one day the lens will be
perfect; and that day we will clearly perceive the stupefying, extraordinary
beauty of this world. b) The excess of overlays and the quantity of the images
give the idea of a profusion that cannot possibly be inventoried, taking us
further away from that hypothetical day.

A similar feeling is also provoked by Sichtbare Welt (Visible World
1987–2000) [→ chap.XXVI], especially when it was shown on television. This
accumulation of landscapes following one another in cross dissolves with the
same very fluid transition between the images as in Flowers, was broadcast on
the Franco-German TV channel Arte. Every evening, at the end of the day's
programming, a relatively long sequence from Fischli/Weiss's work (at least
long in the context of television, where the absence of events is obviously a
drawback) was shown, accompanied by soft, very beautiful, slightly melan-
choly music. It is hard to describe the feeling that certainly many insomniac
viewers and I myself experienced many times, confronted by this show reduced
to its simplest expression. Gliding would perhaps be the most accurate word.

The presentation of the same cross dissolves in a museum can give only a diminished impression of those moments of late-night solitude, during which the diaphanous surface of the world passed slowly by before the television viewer's eyes.

One of the indirect effects of this work is to revive awareness of the feeling of passivity inherent in the fact of watching television. Watching television is never referred to in everyday language as an 'activity', as that presupposes a complete alertness of the senses. It seems to me that what arouses this dawning awareness in the work of Fischli/Weiss is its symmetrically passive conception. This cannot be regarded as a defect, for the propensity to passivity which is required of the person watching television can also be that of the artist, who can be expected to have a great capacity to be affected by things. The activity is precisely that experienced by Robert Walser's walker in *Der Spaziergang (The Stroll* 1917), an ode to love applied to all perceptible phenomena; the two artists chose to reproduce an extract from Walser's famous book in the monograph on them published by Phaidon Press. The extract in question advises us to look at and consider all things, the humblest as well as the most beautiful, as having equal value, the same attractiveness, the same beauty: 'With the utmost love and attention the man who walks must study and observe every smallest living thing, be it a child, a dog, a fly, a butterfly, a sparrow, a worm, a flower, a man, a house, a tree, a hedge, a snail, a mouse, a cloud, a hill, a leaf, or no more than a poor discarded scrap of paper ... ' [c] On their walks Fischli/Weiss photograph the indifference of the world, but if we did not experience the world through our senses we would be nothing, and without that experience we would be dead. The spectacle exists only because we are there, just before going off to sleep. Directly we close our eyes, the world ceases to exist, it vanishes. *Flowers* serves to remind us that life depends only on the fluttering of an eyelid. Close your eyes, and 'the visible world', the world of flowers, insects and our world too, disappears, as it did a few years ago at the end of the television programme, as a prelude to sleep.

a) Andy Warhol & Pat Hackett, *Popism; The Warhol Sixties*, San Diego, New York, London 1980, reprinted 1990, p.112.
b) Henry Miller, quoted by Gilles Deleuze in *Spinoza. Philosophie pratique*, Paris 1981, p.24.
c) Robert Walser, *Der Spaziergang*, 1917, quoted in Robert Fleck, Beate Söntgen, Arthur C. Danto, *Peter Fischli David Weiss*, London 2005, p.125. (Höchst aufmerksam und liebevoll muss der, der spaziert, jedes kleinste lebendige Ding, sei es ein Kind, ein Hund, eine Mücke, ein Schmetterling, ein Spatz, ein Wurm, eine Blume, ein Mann, ein Haus, ein Baum,

eine Hecke, eine Schnecke, eine Maus, eine Wolke, ein Berg, ein Blatt oder auch nur ein
ärmliches, weggeworfenes Fetzchen Schreibpapier, auf das vielleicht ein liebes, gutes Schul-
kind seine ersten, ungefügten Buchstaben hingeschrieben hat, studieren und betrachten.)

———

Double exposures created in the camera: 111 flower motifs and 40 mushroom motifs as inkjet
prints, 74 × 107 cm, as well as 16 motifs as Cibachrome, 120 × 180 cm
1997/8
4 slide projections: *Sommer (Summer), Herbst (Autumn), Pilze (Mushrooms), Fantasy*, with
cross fading, 2 projectors each, 162 slides each
2001

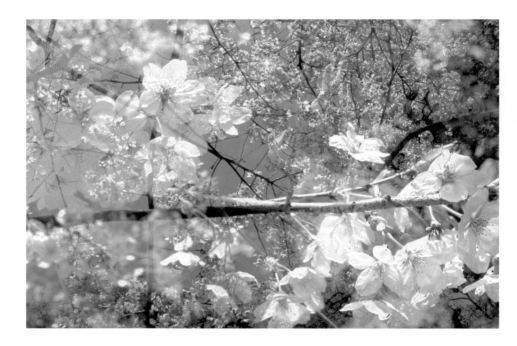

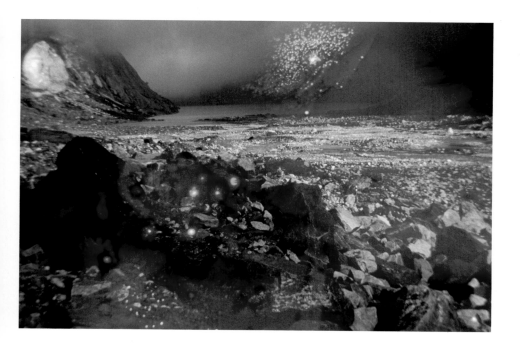

XXVIII

—

Valentin Groebner

—

A NIGHT-TIME DRIVE

—

Eine unerledigte Arbeit (*An Unsettled Work* 2000–6) is picture jello. *An Unsettled Work* is a ghost train. Damp snake scales and zombie teeth against a motorway at night, a nostril in a cow's flank, piggies in octopus gravy, dolls and Christmas decorations. Just the right thing for a slide show, *An Unsettled Work* is an uninterrupted, inescapable sunset, colours included. Which – please forgive – looks a little kitsch to me.

'Yes, too much of a bad thing,' says Peter and laughs. What was that lovely 1970s buzzword? Psychedelic. 'It's just a little illness we had to go through, a fever,' says David. Three quarters of the photographs were not taken for the work itself; they're just chance snapshots. Both: 'After *Der Lauf der Dinge* (*The Way Things Go*) [→ chap.XIX], we were so tired of having to create the world ourselves, really exhausted. We just started driving around to give the consequences of the Big Bang a chance to settle down. The pictures are the residue of this archive; they're just the photographs that we didn't throw away. We buttered our bread, and now we have to eat it.'

An Unsettled Work is pictures swarming in a darkness made luminous. But pictures are luminous anyway – at least that's what the scholars of antiquity thought. How can pictures move, amuse or frighten their viewers? And why are pictures so good at generating new pictures (along with the relevant stories), even at a distance, even in dimly lit caverns? The ancients found an elegant solution to the conundrum: because pictures send little particles into the eyes of those who look at them. Tiny little splinters, a thin membrane, a kind of skin – *eidola*, as they were called in ancient and medieval tracts – of the same shape and colour as the objects themselves, but only as surface, subtly diluted – so that the pictures could penetrate the eyes of those who looked at them. And even more disturbing, enter their heads too: clinging there forever. The powerful pictures of the ancients were made of glistening gold- and silver-plated metal, studded with crystals and precious stones. It was dark in those temples, caverns and churches, and candles illuminated the pictures, which reflected their flickering light. They were genuine because they glittered.

We've had something in our eye ever since. Because the luminosity penetrates the eye of the beholder whether he likes it or not. Luminosity is a local blinding. Where there is light, it looks at us, Jacques Lacan wrote. And it is only thanks to that light, he added, that something is recorded on the ground of the beholding eye, not an object, but the trickling of a surface that is not designed a priori for distance and recognition; a screen, a picture screen, a game of impenetrability and devotion. One can also put it differently. 'You can't hardly look that fast,' as Markus Binder of the Attwenger dance-floor duo croons in Austrian dialect. Was that blinking light, that picture, meant for me? Once I drove through the night on the motorway from Genoa to La Spezia, where all the tunnels (and there are lots of tunnels) have names. One of them is called *L'Apparizione*: the apparition.

That's why all those doll's heads and wineglasses, wax figures and skulls glitter in *An Unsettled Work*. There are shining candles, corals and wax figures, winter mountains and window decorations in close-up ('at Christmas we went the length of Bahnhofstrasse, Zurich's Fifth Avenue, with two tripods, diligently taking pictures of all the crazy displays.') There are shiny eyes and teeth morphing into each other, and highlights glistening on the scales of reptiles. It begins to dawn on viewers that horror glitters, too – even nasty Santa Claus, Chronos, time incarnate, a child eater.

Still more set pieces for stories: firefighters ('All for real, the carpentry workshop across the street was on fire!'), a white dog in the snow, recurring as in a dream, sometimes standing on its head, and the legs of the friendly lady in the peep show spread wide. It makes one wonder: That's not an allegory, is it? But then come the astronauts from Tenochtitlán in Interlaken, and behind the Mystery Park, there's a dentist's office in aspic. It turns on a film in my own viewer's head. 'He's just a crazy dentist!' a frightened witness screams when Bruce Willis breaks his own teeth in Terry Gilliam's *Twelve Monkeys*. They had put a tiny bug in them in order to track his movements. Needless to say, his persecutors come from the future. As in art.

But while I am remembering, the pictures have already driven on, around four or five more curves, past snakes, cows and dolls' heads, and what the devil do they have to do with the dentist's office? In films as well as slide shows, meaning is generated by sequences, by pictures following one after the other. But in the image tunnel of *An Unsettled Work*, that happens so often that the accumulation of signs bagged by the diligent eye collapses under its own weight. 'It's like a piece of bread with tons of butter,' says Peter. And we, the impatient visual animals that we are, gobble it all up. Because our own instruments of perception ignite sensations of delight when radiant images keep morphing slowly and steadily into new fodder for the retina. 'It's the dirt that makes things genuine,' says David.

The recognition of patterns is the one program that the human brain perched behind the eyes cannot switch off at will. And looking is driving – pictures transport us to someplace else, whether we are watching an exciting car chase in a film or slides fading into each other during a lecture. But this time it's not me being set in motion; instead my eyeballs have been grabbed and drawn into the pictures. That's why it feels as if my own eyes have rushed ahead and ventured off on their own. There's nothing for it but to scuttle after them, helplessly. *An Unsettled Work* is a lavish night-time drive into that vast empire of refulgence that has been steadily spreading for the past two-and-a-half thousand years since antiquity. Welcome to the passenger seat! We can't look away even though we're always limping along behind. And all this rampant radiance swallows us up, sucks us into promiscuous and alarming happiness: everything is related to everything else, oh lordy be. Luckily, we're not in charge.

———

Slide projection with cross fading, 2 projectors, 162 slides
2000–6
Originally developed from 1987 onwards on the basis of the series *Sichtbare Welt* (*Visible World*) [–› chap.XXVI], dark slides, shown as slide projection in various versions, under the title *Freakshow, Monsters* (MACBA Barcelona 2000)
Subsequently developed further

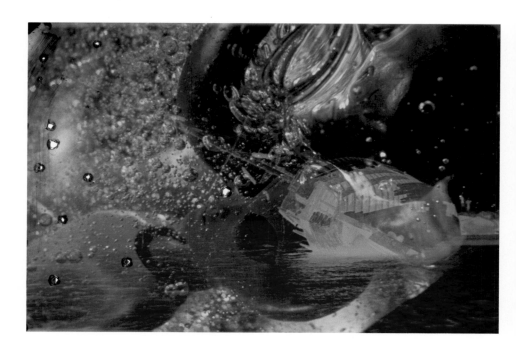

XXIX

—

Jörg Heiser

—

—

Eighteen groups, each with six photographs. All 4 × 6 inch prints (the usual size for snapshots). All black and white, unframed but behind glass, hung in a row. All, without exception, showing painted genre scenes from the realms of fantasy, fairytale, exotica, urban and popular myths, horror, science fiction, romantic nature. A coach, sea anemones, a dragon, a clown, the Wolf and the Seven Little Kids, Jimi Hendrix, a snowy landscape, a sounder of wild boar, a steam engine at night, a mysterious lady with gleaming eyes, cosmic mist, a suspension bridge and skyscrapers, a rat, a ghost ship.

I shall attempt to demonstrate that the *Fotografías* 2004/5 are the perfect key to the 'Fischli/Weiss method', which the said artists have explored and refined over the last few decades – without wanting to suggest that this work serves merely to exemplify. But in Fischli/Weiss's case, talk of a key is a bit tricky; you feel a bit like the inept raconteur who bungles a joke and laboriously explains the punch line ('you see, the joke, hee hee, is that the chicken crosses the road, because all it wants to do is get to the other side, hee hee, there's no other reason'). But that's not really the point. Because, in the

first place, *Fotografías* isn't side-splittingly funny (nor does it need to be). And, in the second place Fischli/Weiss are not a joke; there are witty moments in their work, but not always, and if there are moments of wit, then not because this is all there is to their work. So I'll gaily set to work with my key, happily explaining everything to death, splitting hairs – neatly, one by one – as I interpret away, starting with what I first learnt about this work (on the invitation card in late summer 2005): its title.

As a title, *Fotografías* – apart from the striking, somehow ceremonial resonance it has for non-Spanish ears (I imagine it with good, strong consonants, a rolled 'r' and powerful open 'a' sounds) – tells us nothing whatsoever about the subject matter. So painted images have been photographed; we might have guessed as much. But at the same time the title is also intentionally lopsidedly tautologous: okay, the objects have titles that tell us what they technically are – photographs – but they are also pictures of painted pictures. So the fact that they are not called *pinturas* directs my attention away from the subject matter to the way it is presented.

My information-hunger is further frustrated by the absence of any kind of accompanying texts. There is not even any background in the literal sense: the painted scenarios are presented frontally and without surroundings. Not a hint of a concrete spatial or temporal context … although, wait a minute, in some of the pictures you can see riveted metal plates as bases, facings, and in one – in the picture of a spider – there is something that looks like a door hinge. In some of the pictures bright reflections (possibly caused by a flash-bulb?) suggest a painted metal surface or multiple layers of thick gloss paint on a wall. The motifs must have something to do with functional or amateur outdoor paintwork: most likely at a fairground (ghost train, fun rides etc.) or on lorries, engine bonnets, sales stands and so on.

The images on booths and carousels are brightly coloured and promise their target audience (predominantly children and young people) temporary immersion in a highly stimulating fantasy world, or better still, they are already part of this immersion process themselves. At the same time, they also reveal the fantasies of the jobbing painters or their clients – or their misapprehension (leading to strange outcomes) as to which images and motifs would serve the cause of entertainment or amusement. But in *Fotografías* I am not confronted with fairground painting in all its brash glory but small and silent in black and white, further muted by the narrow range of tonal contrasts and a

graphite-like saturation (not unlike solarisation, without being that), as though emerging from a shadowy dream-veil (when I ask Fischli/Weiss, I learn that they achieve this effect using black-and-white Agfa slide film underexposed by two to three aperture points and printed on coloured photographic paper).

It's as though the energy of the at times larger-than-life originals – fuelled by all kinds of intentions and needs – has been sucked into a black hole measuring 4 × 6 inches. Yet it also seems that through this process that same energy appears compressed and intensified. We see before us a staunchly restrained presentation of nothing more than 109 small-format black-and-white images with motifs that are highly susceptible to accusations – stemming from a suspicion spawned by nineteenth-century industrialisation – of being nothing more than kitsch, the suspicion being that these might merely be calculated, stereotypical, commercialised, uninspired 'wishful imaging'. This is, of course, not the place to embark on an in-depth discussion of the concept of kitsch, so, in a nutshell: faced with critiques of kitsch (Adorno, Greenberg etc.), cultural historians (Eco, Cultural Studies etc.) and artists alike (Warhol, Koons) have determinedly championed supposedly 'uninspired', hence uninteresting wishful imaging as most definitely interesting, above all by virtue of the feelings invested in it.

In the 1920s the Germanist Hans Naumann spoke of 'sunken cultural goods', suggesting that the lower classes were mimicking the culture of the higher echelons of society; he regarded this as a kind of natural division of labour between the giving, creative intellectual aristocracy and the receiving, reproducing lower classes. However crude this construction, it still persists as the historical basis of the stubbornly lingering notion that it suffices to describe the relationship of the cultural elite to the broad masses in terms of 'sinking' and 'rising'. An apt commentary on this is provided by a small clay sculpture from 1981, part of the series *Beliebte Gegensätze* (*Popular Opposites*) which is itself a sub-series of *Plötzlich diese Übersicht* (*Suddenly this Overview*) [→ chap.XI]: in this piece the difference is reduced to that between a dachshund standing on all fours and another sitting up and begging. So far the artists Fischli/Weiss have not precisely been noted for their Adornoesque rigour regarding vernacular cultural practices. Yet – unlike large swathes of the Pop-art scene – they do not merely appropriate the *images and themes* of the big wide world of mass and pop culture, they also notably appropriate its *practices* (as in the sculpting of dachshunds).

Nevertheless, as I contemplate Fischli/Weiss's *Fotografías*, the words 'sunken cultural goods' instantly spring to mind. Although the reason for this is not in fact the imitation of high-culture romantic landscape paintings in the fairground decorations (Caspar David Friedrich's *Wanderer über dem Nebelmeer* [*Wanderer Above the Sea of Fog* 1818] is reborn as Heidi's grandfather with a knotted walking stick, a knapsack and a wide-brimmed hat). The real reason is that the concept of something 'sunken' is not only about evaluation and devaluation, but also has something to do with the archaeology of historical sedimentation: the pictures have the air of remnants of a lost culture that has been discovered lying in some stagnant water. So the decision to present them as Fischli/Weiss have done – colourful, large, painted motifs now in the shape of small-format, black-and-white photographs – is clearly not merely the result of the ironic appropriation of 'low level' cultural artefacts, nor is it about scornful arrogance. On the contrary, the reduction to small, black-and-white images distils the motifs so that the viewer feels close to them and gains a new insight into them: we suddenly recognise not so much drained stereotypes as emotionally charged icons.

As I wander along pictures hung in a single row, it's as though I were walking along a film; but when I stand still and concentrate on a particular image, it's more as though I were standing at the 4 × 6 inch entrance to someone else's psycho-mind-grotto, or even to my own: there they are, strangely durable fragments of past and present longings (meeting an unknown woman on a South Sea beach at night) and fears (meeting an unknown woman on a South Sea beach at night), vague hopes (not to be like the embarrassing clown) and clear certainties (being like the embarrassing clown).

In *Fotografías* I discern four methods that seem central to Fischli/Weiss's work. Firstly: their encyclopaedic, *Wunderkammer*-like collecting that stems more from fragmentary memories and chances than from meticulous research, more from images than facts (Fischli/Weiss collected the fairground images over the years in Switzerland and its neighbouring countries without necessarily adhering to some empirical system of collection). Secondly: ignoring or attacking hierarchies or exclusions/inclusions that normally go hand-in-hand with collecting (as a feature of artistic, art-historical or scientific praxis) – by dint of the sheer amount accumulated, by their handling of existing media (big, colourful, painted images presented as small black-and-white photographs), by equalising items (all the pictures treated

the same) or inversion (what once was important becomes unimportant, and so on). Thirdly: extending, compressing or 'wasting' time by laboriously creating works that are 'quickly' absorbed by the eye (series of photographs, replicas), or vice versa by exhibiting real time (as in the video installation lasting around 100 hours in total at the 1995 Venice Biennale) [–› chap.XXV]. Fourthly: the slapstickish undermining, exposing and exaggeration of these first three methods – talking of *Popular Opposites* or *Suddenly this Overview*, letting obviously level-headed procedures collide with obviously neurotic ennui, combining banal anonymity with idiosyncratic wilfulness, deliberately incorporating errors or incongruities, for instance presenting *Fotografías* as eighteen groups of six pictures each which should add up to 108 – but which actually amounts to 109 pictures. Which picture is 'remainder one', left over from the rest? I should ask the artists, but I like the idea of it being a puzzle that I might one day even solve myself.

———

109 colour prints from black-and-white slides, photographs of paintings
10 × 15 cm
2004/5

XXX

Veit Loers

—

—

Even within the many-facetted oeuvre of Peter Fischli and David Weiss, the *Garten (Garden)* is something of an exception. Had it not been created specifically for an exhibition of public sculpture in Münster in 1997, it might well have been remembered as a temporary garden bearing no relationship whatsoever to art, documented only in a few photographs and a small, illustrated booklet.

When Kasper König and Klaus Bussmann invited Fischli/Weiss in 1997 to take part in the *Skulptur.Projekte Münster* for the second time, the artists planned a garden as art project. [a] Ten years previously, they had created a building for the Münster sculpture exhibition. It was a modern commercial structure, a building on a scale of 1:5 – too big to be a model and too small to be a house – located 'near the railway station, between snack bar and cinema'. [b] This time, they went to the outskirts of town to create a garden. They chose the site of the former city moat between the Westerholtscher Meadow, the Lipper Wall and the River Aa. This site by the old city wall was privately owned and had evidently been a garden in earlier times. Indeed, it had even

been a garden with a certain artistic ambition, as indicated by some photos in an old album showing a geometric hedge with animal figures cut into it. The remains of this artwork was left by the artists in its overgrown state, as it was a country garden. Such a garden has little in common with the art of garden design as practiced in the Baroque era, nor with the landscaped park, nor even with the Romantic notion of the rambling garden, let alone the allotment. [c)] It is also a far cry from the suburban gardens of today, the backyard party gardens with their manicured lawns, swimming pools, evergreens and cypresses that have since mutated into misconstrued ecological oases with ponds and native vegetation. Instead, this is a garden in the ancient tradition of the enclosed kitchen garden behind or near the village house, where vegetables, salad, flowers and herbs were grown for the household, fenced in to protect them against damage or even destruction by wildlife. Such gardens once provided a constant source of food for the domestic kitchen, intended for immediate use, as opposed to the crops of the field.

The kitchen garden has to do with private ownership. It was primarily tilled and tended by the women of the house. Throughout the Communist states of the Cold War era, as in impoverished Central Europe of the post-war years, it provided a minimum of nutritious proteins and vitamins – a staple diet of potatoes, cabbage, beans and salad. As we know, it was a source of nourishment for those who lived under government systems of planned economy and large-scale collective agriculture. Gardens were not seized by the state, for fear of setting the comrades who owned them against the ruling classes.

So what does all this have to do with the *Garden* of Peter Fischli and David Weiss? Does the cultivation of food have a role to play in contemporary art, or is it that the Romantic notion of the garden has also extended to the vegetable patch? Before considering this fundamental question as to the aesthetic findings of the artist duo, we have to reflect on their own aims and the creative design process itself. Both these factors are addressed in their September 1996 concept, which calls for a 'high degree of intimacy and privacy for the imagined keeper of the garden'. The imagined keeper of the garden is represented 'by the degree of order and chaos, work and leisure, nurture and nature' and acts as both benefactor and beneficiary of the idyll. [d)] For Peter Fischli and David Weiss, the creation of the garden becomes a dialectical process in which the role of the gardener as the active agent constantly correlates with the role of the observer as passive onlooker.

The country garden, too, has always had its observers: neighbours, passers-by, friends, enemies. They tend to judge the garden in terms of its effectiveness – in other words, in terms of its cleanliness (i.e. how well it is kept clear of weeds), the geometry of its pathways, the state of its salads and tomatoes and the seasonal blooming of its flowers. These things have never been achieved without the use of dung and other fertilizers or without spraying them against blight, greenfly and other plant pests. Gardens were regarded as beautiful if they radiated productivity – not in the sense of a Dutch greenhouse packed full of hybrid tomato plants, but in the sense of a microcosm in which cabbage grows alongside lettuce, spinach and anemones. Peter Fischli and David Weiss looked at country gardens like those in Alsace and documented them in photographs before embarking on their project in Münster. In these photographs, we can see the plastic sheeting that has replaced the glass-covered seed-trays, vegetable beds lying fallow after harvesting, others that have been recently dug over and still others full of vegetables in their prime. e) We also see how a snowy garden looks in winter when work has ceased. There is an array of tools that includes watering can, hosepipe, water barrel, wheelbarrow and ladder, compost heap and implement shed. A real garden is never perfectly tidy. The imagined keeper cannot be far away and is likely to return at any moment to continue the work in hand.

For all its air of improvisation, the artists prepared the project carefully and in good time. In the autumn of the previous year, a gardener versed in environmentally friendly mixed cultivation began preparing the beds and sowing the seeds of certain winter-hardy vegetables and flowers in accordance with the artists' plans. In order to access the garden, a little wooden bridge was built over the watercourse of the Aa. The *Garden* itself was to take up only a small part of the existing meadow with its mature fruit trees. The turf covering this area had been professionally cut, rolled up and stored, so that it could be replaced after the temporary garden phase. The remaining meadow was to be flower-strewn, with two fields of maize and potatoes to the side of the garden beds. The aim was to create a garden capable of feeding a family of twelve. From sowing seeds in seed-trays and planting out in drills, from setting up the wooden supports for the runner beans to cultivating the leeks, savoy cabbage, onions, Brussels sprouts, red cabbage, lettuce, carrots etc., as well as herbs such as parsley, chives, chervil, dill, sorrel and mint, and flowers such as anemones, sunflowers, gladioli, larkspur, dahlias and zinnias,

the process took months of hard work and patience. By the time of its official opening on 20 June 1997, the artists wanted the *Garden* to 'exude a certain cornucopian richness'.

The moment a country garden becomes an artwork and part of an exhibition, complete with vernissage, it is no longer a garden. For a garden is normally a seasonally determined process of order, beauty and functionality. Trying to make a garden comply with the rules of an art installation or a kind of Land art project, let alone fulfil the criteria of the sublime, with all the *morbidezza* of its heady scents and gently rambling wildness, puts on the pressure. Peter Fischli and David Weiss relate how they were planting big, juicy heads of lettuce just two days before the opening. What is more, they pursued the process of 'naturalness' in much the same way as casting a film. It was an approach redolent of their seemingly random arrangement of painstakingly recreated objects in the *Raum unter der Treppe* (*Room under the Stairs* 1993) [→ pp.12, 28]. The implement shed took the form of a rough lean-to structure cobbled together with a roof of plastic sheeting, beneath which there was a table consisting of a panel on legs and three plastic chairs from a DIY store, deliberately chosen in green. On the table there were a few tools and, of course, a transistor radio. To round off the effect, a large and rather ugly-looking scrunched-up ball of foil with some peat or earth in it was lying in front of the structure as though it had simply been forgotten.

But the two artists were interested in showing something else that cannot normally be portrayed: the gardener's struggle against pests and weeds. For the beauty of the garden comes at a price. Many weeds, such as quickweed, chickweed, couchgrass, and goutweed, and countless pests, from caterpillars and greenfly to fungi and mole crickets, not to mention all the starlings, slugs and moles, are all lurking around ready to devour the garden as it grows, or at least to wreak enough havoc for it to look a little worse for wear. As a symbol of nature's very own guerrilla war, the artists installed a showcase at the Westfälisches Landesmuseum containing all manner of pesticides and weed killers from the rich arsenal with which the chemical industry arms the gardener. In this way, the *Garden* as art environment was echoed, at some remove, by the countercharm of the poison cabinet that had been promoted to the status of art installation by its presence in a museum setting.

It is at this point, if not before, that the observer and ideal user is, as it were, led up the garden path. For this *Garden* is no fake. It really is a private

paradise on which we would not normally be allowed to trespass because a country garden is private property. Building a wooden bridge was a positive incitement to break that taboo. In this respect, the idea that *Garden* represents is a far cry from that of Tobias Rehberger's vegetable patch at *Manifesta* 1998 in Luxembourg, where the notion of the private garden was played out against the notion of the public park. But just as we begin to enter into the spirit of the *Garden* as such, the temptation of paradise is undermined by all manner of real things and invisible stratagems. The situative image becomes even more ephemeral when we realise that the *Garden* is just a Potemkin village, temporary and transient; that no matter how much we wish to believe in a garden of paradise, it is just another commissioned piece, like a display at a horticultural show, designed to make a momentary impression. These factors will not be lost on the astute visitor who wonders how a garden by Peter Fischli and David Weiss might look: on the one hand the beauty of nature tamed, on the other the visitor's inability to deal with it. And then there is the rather malicious way the artists allow the visitors to walk right into the situation as though stepping into a stage set of such deliberate artifice that it seems like a trap.[f)]

It is only logical to compare the garden in Münster with the photographs of *Blumen* (*Flowers* 1997/8) [→ chap.XXVII] that were created, by no means coincidentally, in the following years: large C-prints and slide installations in which the individual images of flowers merge in double exposures. While the flower photos themselves, like the photos of airports and landscapes, are dreamy orgies of colour in the manner of picture-postcard beauty – a beauty that renders even the most practised art observer helpless – the slide series whisks us away into nebulously surreal realms whose phantasmagoria lead us from the greenhouse and the prettiness of snowdrops and primroses into an incomprehensible web of time and space.[g)] We are led out of the 'Visible World', which, according to the artists, is a conceptually defined and outlined world of names, into an unnameable, fantastic, in-between world – an 'Invisible World' that reaches from the theosophical, ethereal realms of Helena Blavatsky to the scientific world of the scanning microscope and even to the *Shadow Divers* of Ridley Scott's latest film project.

The *Garden* in Münster has both. It is the tangible illustration of its title – a place where the art-tourist is abducted into the perfect, but also culturally anchored, world of the garden whose natural props are not just for show. And it is the example set to frustrate the observer who cannot help

wondering why the *Garden* is art and not just an arrangement of natural props. Thus, we have three principles of perception: the persuasiveness of the beauty of the picturesque English landscaped garden of the eighteenth century, [h] irony as a problem of knowledge and, finally, an insight into a world of questions of the kind posed by Peter Fischli and David Weiss, such as: what would constitute the *Garden* if we could not see it, or how functionality might evolve into beauty. In this respect, both in its literal sense as an oasis of fertility, and in the sense of its exclusion from the conventional norms of an art project, it is not so very far removed from Jeff Koons' floral *Puppy* 1992 at Schloss Arolsen, where the unexpected picture-postcard beauty of the sculpture culminated in the artist's own mischievous definition of its appeal as a 'contemporary Sacred Heart of Jesus'.

All that is left of Peter Fischli and David Weiss's *Garden* in Münster is a handful of photos and an idea. Anyone can make their own garden and ally themselves with the artists by saying it has something to do with art, even if they are not quite sure where to start and how to channel their feelings.

a) Patrick Frey, 'Es wächst. Bemerkungen zum *Garten* von Peter Fischli und David Weiss', *Skulptur.Projekte in Münster 1997*, ed. Klaus Bussmann, Kasper König, Florian Matzner, Ostfildern 1997, pp.151–7.

b) *Skulptur.Projekte in Münster 1987*, ed. Klaus Bussmann, Kasper König, Cologne 1987, pp.87.

c) Telephone conversation with Peter Fischli and David Weiss, March 2006.

d) Unpublished paper, September 1996.

e) Photographic documentation of such gardens over a period of ten years in *Peter Fischli & David Weiss – Gärten*, ed. Florian Matzner, Cologne 1997.

f) Robert Fleck, 'Adventures close to home: Peter Fischli and David Weiss', in Robert Fleck, Beate Söntgen, Arthur C. Danto, *Peter Fischli David Weiss*, London 2005, pp.83.

g) Boris Groys, 'Bilder im Übergang', in *Peter Fischli, David Weiss*, exh. cat., Musée d'art moderne de la Ville de Paris, Cologne 1999; see also the views expressed by the artists in an interview with Beate Söntgen (see note f), p.3: 'maybe it's a bit of a surprise attack'.

h) On this subject and on *Garden* by Peter Fischli and David Weiss in terms of how it relates aesthetically to other artists' gardens, see Brigitte Franzen, *Die Vierte Natur, Gärten in der zeitgenössischen Kunst*, Cologne 2000, pp.189. On playing with aesthetics, see Brigitte Franzen, 'Working Green: Artists in Relation to Schreber Gardens', in *Down the Garden Path: The Artists Garden after Modernism*, exh. cat., Queens Museum of Art, ed. Valerie Smith, Domenick Amirati, Jennifer Liese, New York 2005, p.135.

Private, accessible vegetable and flower garden planted specifically as a contribution to the exhibition *Skulptur.Projekte Münster 1997*
1997

XXXI

—

Max Wechsler

—

—

Animals have been integrated into Peter Fischli and David Weiss's world ever since the duo began making art: the bear, the rat, the piglet and the hedgehog, dogs, mice, the mighty hippopotamus, bugs and, of course, cats, to which I shall devote the bulk of my attention. It is not surprising to find the two artists playing the roles of rat and bear for the first time in one of their earliest joint projects, the film *Der Geringste Widerstand* (*The Least Resistance* 1980–1) [→ pp. 185, 186, 197–201]. And we must not forget the individual works made by each of them that same year for the exhibition *Bilder* (*Pictures*). Fischli created as an improbable panopticon showing a model world between hard work and Eldorado, populated with mice, guinea pigs and goldfish; Weiss responded next door with nothing more and nothing less than a *Planetarium*, in which he appeared as a holographic homunculus, a demiurge perhaps, or even an animal of the future. And finally we have *Tier* (*Animal*) of 1986, with its enigmatic, hollow, see-through body from the series of *Metaphysical Sculptures*. Nonetheless, one cannot claim that animals are a

major and conspicuous motif in the work of the two artists, but then what do 'major' and 'conspicuous' mean when confronted with such masterful discretion and sensational banality.

But now, to address the issue of cats, it must be said that they essentially need no justification: their appearance and conduct are self-explanatory. Significantly, they do not ordinarily figure in fables; their lifestyle, character and appearance do not provide the stuff of a moral tale. Their anarchic nature slips through the mesh of most systems of order. Nonetheless, they, too, are the subject of highly contradictory projections, covering the entire spectrum from the cutthroat, diabolical cat of horror stories to the cute little playful domestic pet. The medieval scholar and philosopher St. Albertus Magnus is said to have shown great appreciation of cats despite their bad reputation, even ascribing a sense of beauty to these sensitive creatures. Most people are probably still of the same mind today, undeterred by the inscrutability or the mystical character of the cat.

A cat is not simply a 'sack of fur' with 'two holes where the eyes are', as Georg Christoph Lichtenberg once remarked. 'Most certainly not!' declared the ill-fated Louis-Ferdinand Céline, who virtually went through hell with his cat Bébert. 'A cat is enchantment personified, undulating finesse ... Pure purring, eloquent purring ... Bébert actually chatted when purring ...'[a]

Cats are magical creatures with an intense aura and an unrelentingly persistent faculty for communication. As such, they make ideal companions for artists. Even when they are not playing author themselves, like E.T.A. Hoffmann's tomcat Murr, they enjoy keeping company with poets and writers at their lonely task, often bringing them back down to earth with a natural innocence and charm that elude the grasp of the intellect. Imagine how cold the heart and feet of St. Hieronymus would be, were not the lion at his side in his study. Fischli/Weiss's quotation of a passage from Robert Walser's *Der Spaziergang* (*The Stroll* 1917) is remarkable in this context. Walser had a very special affinity to all things feline, as demonstrated by his natural kinship with the poet as vagabond, and writing that often seemed to emerge as if in sleepwalking. He describes, in a prose text, that not only the 'girls' pub' and liquor, but also a cat, stood by him when he was writing his novel *Geschwister Tanner* (*The Tanner Siblings* 1907): ' ... she always lay down on what I had already written and blinked at me so whimsically, so

quizzically with her unfathomable yellow eyes … In fact, the more I became involved in writing, the more I felt that a benevolent being was watching over me.' b)

 Although they tend to appear only sporadically, the presence of cats in the work of Fischli/Weiss cannot be ignored. In the early days, it was Puss in Boots or a moulded 1950s knickknack in *Plötzlich diese Übersicht* (*Suddenly this Overview* 1981) [–> chap.XI], a project that is also a send-up of the age-old topic 'man + animal': two figures are shown wearing the costume of a pantomime horse, a situation that used to devolve into comic catastrophe in the cinema and at the circus. Then we find a gawky, utterly enchanting calico kitten in *Bilder, Ansichten* (*Pictures, Views* 1991), or a cat gazing at us from the packaging of cat food standing *Tisch* (*Table* 1992). On this *Table* and in various other ensembles of fictional workplaces, one almost always finds traces of animal food alongside cigarette butts, medication, sweets and other little promises of happiness. These periodical appearances culminated in a droll portrait on the cover of *Parkett* no.17 (1988). We are confronted with a motley black-and-white cat, with a fantastic mask of a face, sitting on its haunches, its front paws in the air, for all the world as if it were voluntarily posing for the photographer. To me, this feline specimen, a magnificent thing in itself and then in such a pose to boot, shows an earnestness, a casual normality that definitively transcends all conventional feline adoration.

 The allegorical cats reclining at Eve's feet in all the renditions of Adam and Eve are negligible, as is even Broodthaers's *La souris écrit rat* (*Mouse Writes Rat* 1974), a shadow cat projected onto the wall like the imposing figure seen from the back in the spiritual universe of Friedrich's *Wanderer über dem Nebelmeer (Wanderer Above the Sea of Fog* 1818). The involvement with cats and kitties begins to deepen in the context of *Sichtbare Welt* (*Visible World* 1987–2000), a vast accumulation of photographs about our planet and its appearance, an involvement that becomes still more intense in the artists' video project for the Venice Biennale (1995). Having spent a great deal of time in their studio during which they also completed *Der Lauf der Dinge* (*The Way Things Go* 1986–7) [–> chap.XIX], Fischli/Weiss began hankering for fresh air. Like the poet Walser, they sallied outdoors to let the wind of the world flutter about their ears. Opening their arms to the things and creatures that crossed their path, they indulged their notorious penchant for encyclopaedic compilations. Their immense store of films boasts one very special item,

in which the artists join a native cat roaming through the streets of Venice. Keeping her company and stopping where she stops, they offer us an unanticipated bonus: sightseeing of a very different order at a vast remove from all the hopelessly hackneyed views of Venice.

Another product of their peregrinations is the video loop *Büsi* (*Kitty*), made in spring 2001 for the *The 59th Minute Project* at the invitation of Creative Time. At the top of every hour, a brief artistic interlude interrupted the commercial program on the NBC Astrovision Panasonic screen on New York's Times Square. *Büsi* shows a domestic cat lapping up milk with exquisite diligence. She stops just long enough to raise her head and look straight ahead, quite casually, before turning away from the world again and devoting herself with renewed concentration to the pleasurable task at hand. Thus, for a brief moment she gazes into the camera and through the on-screen projection at Times Square: the cat looks directly out into the world, she glances down at the witch's cauldron of Broadway and 7th Avenue, where they intersect and lead on to uptown New York.

The self-contained animal is at peace in the navel of the metropolis, in the midst of a mighty ruckus of running text and moving pictures, in the midst of an immense array of flickering lights and colours above a constant, never-ending din. We encounter a kind of apotheosis of normality in this creature casually confronting a deluge of communication so staggering that it paradoxically acquires almost autistic traits. One cannot help thinking of Werner Herzog's film *The Enigma of Kaspar Hauser* 1974. I hear little Agnes trying to teach Kaspar Hauser a ditty: 'Good morrow kitty white / I should also like a bite. / Behave and I'll be fair, / you drink here and I'll drink there. / Slurp, slurp, slurp / the milk is good / slurp, slurp, slurp / what lovely food.' The disparity between wanting to learn and the ability to learn produces such extremes between joy and desperation that Kaspar is almost torn apart. Later, under the influence of his own transformation from feral to human, he zealously tries to teach the kitten to eat with its paws and walk on its hind legs, an objective that inevitably leads to unpleasant scratches and mutual misunderstanding.

a) Céline, *Féerie pour une autre fois I, Romans, IV,* Paris 1993, p.19.
b) 'Geschwister Tanner', in Robert Walser, *Das Gesamtwerk*, vol.2, Geneva and Hamburg 1971, p.128.

———

DVD, 6 mins., silent
Outtake from *Videos for Venice* [–› chap.XXV]
1994
Edited as a one-minute contribution for a project for the Public Art Fund on Times Square in
New York, where it was shown once an hour on a giant screen in 2001 [–› p.334]

10
› *Le repos des canards* 1984
Unpainted polyurethane
Artists' studio

12
› *Room Under the Stairs* 1993
Carved and painted polyurethane
objects
Museum für Moderne Kunst, Frankfurt

19, 20/1
› Objects for *Table* 1992
Carved and painted polyurethane
Still lifes in artists' studio

22/3
› Objects for *Untitled (Tate)* 1992–2000
Carved and painted polyurethane
Still lifes in artists' studio

26/7
› *Table* 1992
Carved and painted polyurethane
Still lifes in artists' studio

28
› *Room Under the Stairs* 1993
Carved and painted polyurethane
Museum für Moderne Kunst, Frankfurt

29, 30, and 35–40
› *Airport*, 1987–ongoing
Cibachrome photographs

45
› *Concrete Landscape* 1997
Concrete, stones
Messe Leipzig

46
› *Concrete Landscape*s in progress
Concrete, stones

50
› *Concrete Landscape*s in the studio
Concrete, stones

51
› *Findet mich das Glück?* 2002
German edition of the publication
› *Will Happiness Find Me?* 2003
Inkjet print
26.5 × 20 cm

52
› *Questions* 1980–2002
Small slide projection 2000

62/3
› *Questions* 1980–2003
Large slide projection
Installation view: Venice Biennale,
2003

64
› Drafts for *Questions*

65
› *Surrli* 1989
Slide projection

66
› Surrli machine
Metal, wood, lamps, wires and batteries

70–4
› *Surrli* 1989
Slide projection

75
› *Tube* 1985 (from *Grey Sculptures*)
Polyurethane, cloth, paint
40 × 177 × 70 cm

76
› *Organ of Equilibrium* 1986 (from
Grey Sculptures)
Polyurethane, cloth, paint
53 × 73 × 42 cm
Photograph: Heinz Keller

79
› *Small Question Pot* 1986 (from *Grey
Sculptures*)
Polyurethane, cloth, paint
100 × 100 × 80 cm
› *Furnished Apartment* 1985 (from *Grey
Sculptures*)
Polyurethane, cloth, paint
30 × 120 × 140 cm

80/1
› *Factory* 1986 (from *Grey Sculptures*)
Polyurethane, cloth, paint
90 × 130 × 100 cm

82
› *Animal* 1986 (from *Grey Sculptures*)
Polyurethane, cloth, paint
55 × 100 × 52 cm

83, 84 and 89–94
› *Kanalvideo* 1992
Video stills

95
› *International Style* 1984 (from *Quiet
Afternoon*)
Photograph

96
› *Reclining Figure* 1984 (from *Quiet
Afternoon*)
Photograph
› *Artificial Intelligence* 1984 (from
Quiet Afternoon)
Photograph

101
› *The Egoist* 1984 (from *Quiet
Afternoon*)
Photograph

102
› *Shine and Work* 1984 (from *Quiet
Afternoon*)
Photograph

› *Flirtation, Love etc.* 1984 (from *Quiet
Afternoon*)
Photograph

103
› *A Day's Work* 1984 (from *Quiet
Afternoon*)
Photograph
› *Tenderness* 1984 (from *Quiet
Afternoon*)
Photograph

104
› *The Sedative* 1984 (from *Quiet
Afternoon*)
Photograph
› *Expanding Universe* 1984 (from *Quiet
Afternoon*)
Photograph

105
› *Mr and Mrs Pear with their New Dog*
1984 (from *Quiet Afternoon*)
Photograph
› *The Hare-Woman* 1984 (from *Quiet
Afternoon*)
Photograph

106
› *The Invention* 1984 (from *Quiet
Afternoon*)
Photograph

107, 108 and 112
› *Son et lumière – Le rayon vert* 1990
Flashlight, turntable, plastic cup, tape

113, 114 and 117–20
› *Settlements, Agglomeration* 1993
Photographs

121
› *Suddenly this Overview* 1981
250 unfired clay sculptures
Exhibition view: Galerie Pablo Stähli,
Zurich

122
(from left to right and top to bottom)

› *In the Cellar*
› *Alchemist*
› *Strangers in the Night Exchanging Glances*
› *Woman in Bathroom*
› *Milieu*
› *From Far Away the Hunter Hears Little Red Ridinghood's Grandmother Snoring Alarmingly Loud*
› *Gotthard Breakthrough*
› *Mick Jagger and Brian Jones Going Home Satisfied After Composing 'I Can't Get No Satisfaction'*

all from *Suddenly this Overview* 1981
Unfired clay

130
› *Under the Ground* 1981 (from *Suddenly this Overview*)
Unfired clay

131
(from left to right and top to bottom)

› *Popular Opposites: Sweet and Sour*
› *Popular Opposites: Funny and Silly*
› *Popular Opposites: Front and Back*
› *Popular Opposites: Man and Beast*
› *Popular Opposites: Small and Big*
› *Popular Opposites: Theory and Practice*
› *Popular Opposites: Inside and Outside*
› *Popular Opposites: Possible and Impossible*

all from *Suddenly this Overview* 1981
Unfired clay

132
(from left to right and top to bottom)

› *Lex Barker Hits Marcello Mastroianni in La Dolce Vita Because He's Been Driving Around in Rome All Night Long With Anita Ekberg*

› *Baby*
› *Bread*
› *Waiting for the Elevator*
› *Swiss Freeway*
› *Disc Jockey*
› *Birth and Death*
› *Junkyard*

all from *Suddenly this Overview* 1981
Unfired clay

133
› *Modern Development* 1981 (from *Suddenly this Overview*)
Unfired clay

134
› *Mausi's Pissed* 1981 (from *Suddenly this Overview*)
Unfired clay

135, 136 and 141–4
› *Objects From the Raft* 1982
Carved and painted polyurethane objects

145, 146 and 151, 152
› *The Room in Cham* 1991
Carved and painted polyurethane objects

153
› *Moonraker* 1979 (from *The Sausage Photographs*)
Photograph

154
› *Fashion Show* 1979 (from *The Sausage Photographs*)
Photograph

157
› *In the Mountains* 1979 (from *The Sausage Photographs*)
Photograph

158/9
› *At the Carpet Shop* 1979 (from *The Sausage Photographs*)
Photograph

160
› *The Accident* 1979 (from *The Sausage Photographs*)
Photograph

161
› *Pavesi* 1979 (from *The Sausage Photographs*)
Photograph

162
› *The Fire of Uster* 1979 (from *The Sausage Photographs*)
Photograph

163
› *Boite de nuit* 1984 (from *Fever*)
Carved, painted polyurethane
180 × 130 × 130 cm

164 and 168/9
› Sculptures in the studio 1983/4 (from *Fever*)
Carved, unpainted polyurethane

170
› *Monument* 1983/4 (from *Fever*)
Unpainted polyurethane
Artists' studio

171
› *Skull* 1984 (from *Fever*)
Carved, painted polyurethane
100 × 120 × 120 cm

172
› *Hunger* 1984 (from *Fever*)
Carved, painted polyurethane
220 × 220 × 170 cm

173/4 and 178
› *Lumpentiti* 1992
Doll stuffed with coins
SWX Swiss Exchange, Zurich

179
› *Ice Landscape* 1989
Model for an unrealised project

180
› *Snowman* 1990
Photograph
Study for Kunstprojekte Heizkraftwerk Römerbrücke, Saarbrücken

184
› *Ice Landscape* 1989
Model for an unrealised project

185, 186 and 197–201
› *The Least Resistance* 1980–1
Film stills
Camera: Jürg V. Walther

202–5
› *Order and Cleanliness* 1981
15 photocopies based on the publication
released on the occasion of the film *The
Least Resistance*

206/7
› *The Right Way* 1982–3
Film stills
Camera: Pio Corradi

208/9
› Costumes of the protagonists of the
Rat and Bear films in Perspex cases
2004
Photographs: Stefan Altenburger

210
› *The Right Way* 1982–3
Film stills
Camera: Pio Corradi

211, 212 and 217–20
› *The Way Things Go* 1986–7
Film stills
Camera: Pio Corradi

221, 222 and 227, 228
› *Making Things Go* 1985/2006
Film stills
Camera: Patrick Frey

229, 230
› *Cars* 1988
Plaster sculptures
Artists' studio

235
› *Women, Stewardesses* 1988
Plaster sculptures
Glasgow Airport

236
› *Women, Stewardesses* 1988
Plaster sculptures
Artists' studio

237
› *Building* 1984
Painted polyurethane model of a
three-storey office building
120 × 160 × 110 cm

238
› *Building – Factory*
Photograph
Unrealised project for the city of
Zurich

245, 246
› *Building – Factory* 1987
Perspex, wood, paint
350 × 570 × 410 cm
Views of the temporarily realised
project for *Skulptur.Projekte Münster
1987*

247
› *How to Work Better* 1991
Mural under construction
Zurich-Oerlikon

248
› *How to Work Better* 1991
Mural
Zurich-Oerlikon

252
› *How to Work Better* 1992
Silkscreen

253
› *Record* 1988
Cast rubber ø 30 cm
Parkett Edition, Zurich

254
› *Small Root* 1987
Cast rubber
46.5 × 57 × 37 cm

262
› *Divider* 1987
Cast rubber
5 × 34 × 26 cm
› *Small Cupboard* 1987
Cast rubber
36 × 63.5 × 55 cm

263
› *Ottoman* 1987
Cast rubber
58 × 58 × 32 cm
› *Drawer* 1987
Cast rubber
48 × 43 × 14 cm

264
› *Big Root* 2005
Cast rubber
105 × 165 × 114 cm

265, 266 and 270–2
› *Videos for Venice* 1995
Video stills

273, 274 and 283–6
› *Visible World* 1987–2000 (selection)
3000 slides

287
› *Flowers* 1997/8
C-print

288
› *Mushrooms* 1997/8
C-print
294–6
› *Flowers* 1997/8
C-print

297
› *Mushrooms* 1997/8
C-print

298
› *Flowers* 1997/8
C-print

299, 300 and 305–8
› *An Unsettled Work* 2000–6
Slide projection

309, 310 and 316–8
› *Fotografías* 2004/5 (selection)
109 photographs mounted on white
paper

319
› *Gardens* 1987–97
Photograph

320
› *Garden Münster* 1997
Domestic garden created for
Skulptur.Projekte Münster 1997

327–9
› *Gardens* 1987–97
Photographs

330
› *Garden Münster* 1997
Domestic garden created for
Skulptur.Projekte Münster 1997

331
› *Gardens* 1987–97
Photograph

332
› *Garden Münster* 1997
Domestic garden created for
Skulptur.Projekte Münster 1997

333
› *Büsi* 2001
Video still

334
› *Büsi* 2001
'The 59th Minute: Video Art on the
Times Square Astrovision', Creative
Time, New York

340
› *Büsi* 2001
Video still

PETER FISCHLI

1952	› born in Zurich
1975–6	› Accademia di Belle Arti, Urbino
1976–7	› Accademia di Belle Arti, Bologna
1978	› Group exhibition at the Accademia, Bologna
1979	› Start of collaboration with David Weiss
1980	› *Bilder*, Kunstmuseum Winterthur
	› lives and works in Zurich

DAVID WEISS

1946	› born in Zurich
1963–4	› Preparatory course, Kunstgewerbeschule, Zurich
1964–5	› Kunstgewerbeschule (sculpture), Basel working as sculptor with Alfred Gruder (Basel) and Jacqueline Stieger (UK)
1970	› *Sketches*, Edition Toni Gerber (with Urs Lüthi, text: Jean-Christophe Ammann)
1974	*Drei Geschichten,* Edition Stähli, Zurich
1975	› *Up and Down Town*, Edition Stähli, Zurich
	› *The Desert is Across the Street*, Galerie Stähli, Zurich, and De Appel, Amsterdam (with Urs Lüthi and Elke Kilga)
1976	› Galerie Stähli, Zurich
1979	› Galerie Gugu Ernesto, Cologne
	› Galerie T'Venster, Rotterdam
1979	› Start of collaboration with Peter Fischli
1980	› *Bilder*, Kunstmuseum Winterthur
	› lives and works in Zurich

SOLO EXHIBITIONS

2007	› *Fragen & Blumen*, Kunsthaus Zürich/Deichtorhallen, Hamburg
2006	› *Flowers & Questions*, Tate Modern, London
	› *Rat and Bear, Fotografías*, Matthew Marks Gallery, New York
2005	› *Fotografías*, Galerie Eva Presenhuber, Zurich/Galerie Sprüth Magers, Cologne
	› Museo Tamayo, Mexico
2004	› *An Unsettled Work*, Kestner Gesellschaft, Hanover
2003	› Museum Boijmans Van Beuningen, Rotterdam
	› *Hunde (Dogs)*, Matthew Marks Gallery, New York
	› Galerie Barbara Wien, Berlin
	› Galerie Sprüth Magers, Cologne
	› Sprüth Magers Lee, London
2002	› *Fragen, Projektionen*, Museum Ludwig, Cologne
	› Matthew Marks Gallery, New York

2001	› *Büsi (Kitty),* Times Square Project, Public Art Fund, New York
	› *Fischli & Weiss. Mundo visível*, Museu de Arte Contemporânea de Serralves, Porto
	› *Peter Fischli David Weiss. Airports*, Galerie Sprüth Magers, Munich
2000	› *El mon visible (Visible World, Sichtbare Welt),* Museu d'Art Contemporani de Barcelona
	› Leopold-Hoesch-Museum, Düren
	› El Museo de las Artes, Universidad de Guadalajara, Mexico
	› Sammlung Goetz, Munich
	› *Sichtbare Welt, Plötzlich diese Übersicht, Grosse Fragen – Kleine Fragen*, Museum für Gegenwartskunst, Basel
1999	› Matthew Marks Gallery, New York
	› ARC, Musée d'art moderne de la Ville de Paris
	› Kunsthalle Bielefeld
1998	› *Flughäfen 1988–98*, Galerie Monika Sprüth, Cologne
	› *Arbeiten im Dunkeln*, Kunstmuseum Wolfsburg
	› Galerie Hauser & Wirth & Presenhuber, Zurich
	› White Cube, London
1997	› Wexner Center for the Arts, Columbus
	› San Francisco Museum of Modern Art
	› Institute of Contemporary Art, Boston
	› Centre pour l'image contemporaine, Saint-Gervais, Geneva
1996	› *In A Restless World*, Walker Art Center, Minneapolis
	› Institute of Contemporary Art, University of Pennsylvania, Philadelphia
	› *Arbeiten im Dunkeln*, Kunsthaus Zürich
	› Serpentine Gallery, London
	› Nationalgalerie im Hamburger Bahnhof, Museum für Gegenwart, Berlin
1995	› Venice Biennale, Swiss Pavilion
	› Galerie Monika Sprüth, Cologne
1994	› Sonnabend Gallery, New York
1993	› Kunsthalle Zürich
	› Le Case d'Arte, Milan
	› Musée d'art et d'histoire, Geneva
1992	› Musée national d'art moderne, Centre Georges Pompidou, Paris
	› Galerie Walcheturm, Zurich
	› Galleria Locus Solus, Genoa
	› Galerie Francesca Pia, Bern
	› Börse, Zurich
1991	› Kunstverein für die Rheinlande und Westfalen, Düsseldorf
	› Wiener Secession, Vienna
	› Galerie Achenbach, Frankfurt am Main
	› Galleria Bonomo, Rome

1990
> Galerie Hussenot, Paris
> Instituto Valencia de Arte Moderno
> Kunstverein München, Munich
> Galerie Marga Paz, Madrid

1989
> University of South Florida Art
Museum, Tampa
> Sonnabend Gallery, New York
> *Skulpturen und Fotografien*, Galerie
Monika Sprüth, Cologne
> Le Case d'Arte, Milan
> Galerie Susan Wyss, Zurich
> Akhnaton Gallery, Cairo

1988
> Institute for Art and Urban Resources,
P.S.1, New York
> Museum of Contemporary Art, Los
Angeles
> Dallas Museum of Art, Dallas
> University Art Museum, Berkeley
> Institute of Contemporary Arts, London
> Third Eye Centre, Glasgow
> Musée de Grenoble
> Le Case d'Arte, Milan
> Interim Art, London
> Museum für Gegenwartskunst, Basel
> Portikus, Frankfurt am Main
> Centre d'Art Contemporain, Geneva

1987
> Le Case d'Arte, Milan
> Galerie Monika Sprüth, Cologne
> Gallery Hewlett, Carnegie-Mellon
University, Pittsburgh
> List Visual Arts Center, The
Massachusetts Institute of Technology,
Boston
> The Renaissance Society at the
University of Chicago

1986
> Sonnabend Gallery, New York
> The Corridor, Reykjavik

1985
> *Peter Fischli/David Weiss*, Kunsthalle
Basel
> Groninger Museum, Groningen
> *Stiller Nachmittag*, Galerie Monika
Sprüth, Cologne
> Centre Culturel Suisse, Paris
> Produzentengalerie, Hamburg
> Kölnischer Kunstverein, Cologne

1984
> Galerie Crousel-Hussenot, Paris

1983
> *Fieber*, Galerie Monika Sprüth, Cologne

1982
> St. Galerie, St. Gallen

1981
> *Plötzlich diese Übersicht*, Galerie
Stähli, Zurich
> Galerie Balkon, Geneva

GROUP EXHIBITIONS

2006
> The Studio, Dublin City Gallery
> Kunstmuseum Luzern, Projektion,
Lucerne
> *Franz West without Franz West + Der
Ficker*, Centre d'Art Santa Monica,

Barcelona/Centro Atlántico de Arte
Moderno, Las Palmas
> *Emanuel Hoffmann-Stiftung. Werkgruppen und Installationen*, Museum für
Gegenwartskunst, Basel
> *ALLER / RETOUR 2*, Centre Culturel
Suisse, Paris
> *Wrong*, Galerie Klosterfelde, Berlin
> *Infinite Painting*, Villa Manin – Centro
d'arte contemporanea, Codroipo
> *Faites vos jeux!*, Museum für
Gegenwartskunst, Siegen

2005
> *Universal Experience: Art, Life, and the
Tourist's Eye*, Museum of Contemporary
Art Chicago
> *Artgames*, Ludwig Forum, Aachen
> *Lichtkunst aus Kunstlicht*, Zentrum für
Kunst und Medientechnologie ZKM,
Karlsruhe
> *Flashback*, Museum für Gegenwartskunst, Basel
> *Ma Non Al Sud*, Gallerie Civica d'arte
contemporanea di Siracusa, Syracuse
> Cobra Museum of Modern Art,
Amsterdam
> *REALIT;-)T*, Kulturzentrum Seedamm,
Pfäffikon
> *hoch hinaus*, Kunstmuseum Thun
> *Menschensgladbach*, Städtisches
Museum Abteiberg, Mönchengladbach
> Reykjavik Art Museum
> *Feeling strangely fine*, Galeria Estrany,
Barcelona
> *Atlantic & Bukarest*, Kunstmuseum Basel

2004
> *Ritardi e Rivoluzioni*, Venice Biennale,
Palermo
> *Hard Light*, P.S.1 Contemporary Art
Center, New York
> *Skulptur – Prekärer Realismus
zwischen Melancholie und Komik*,
Kunsthalle Wien, Vienna
> Triennale Fellbach
> *Artists' favourites act II*, Institute of
Contemporary Arts, London
> *Memory and Landscape*, La Casa
Encedida, Barcelona
> *Before the End*, Le Consortium, Dijon
> *natürlich gebaut*, Helmhaus, Zurich
> *Sculpture:* Matthew Marks Gallery,
New York
> *Defying Gravity: Contemporary Art
and Flight*, North Carolina Museum of
Art, Raleigh
> *Stacked*, D'Amelio Terras, New York
> *Unreal Estate Opportunities*, pkm
gallery, Seoul
> *Travelling: Towards the Border*, The
National Museum of Modern Art, Tokyo

› *Multiple!/Multiple!*, Contemporary Collectors Gallery, Roslyn Harbor, New York
› *Extra: How Many Extra Layers Can We Graft on to Reality Before it Collapses?*, Swiss Institute, New York
› *fast forward*, Zentrum für Kunst und Medientechnologie ZKM, Karlsruhe
› *The Last Picture Show: Artists Using Photography 1960–1982*, Walker Art Center, Minneapolis
› *Happiness*, Mori Art Museum, Tokyo
› *Ritardi e Rivoluzioni*, Venice Biennale
› *Utopia Station*, Venice Biennale
› *Purloined Nature*, Kawamura Memorial Museum, Chiba
› *20th Anniversary Show*, Galerie Monika Sprüth Philomene Magers, Cologne
› *Looking in – Looking out. Positionen zeitgenössischer Kunst*, Kunstmuseum Basel
› *Grotesk! 130 Jahre der Frechheit*, Schirn Kunsthalle Frankfurt / Haus der Kunst, Munich

2002
› *Subréel*, MAC, Galeries Contemporaines des Musées de Marseille
› *Wallflowers. Grosse Fotografien*, Kunsthaus Zürich
› *Moving Pictures*, Solomon R. Guggenheim Museum, New York
› *It's a wild party and we're having a great time*, Paul Morris Gallery, New York
› Galerie Yvon Lambert, Paris
› *The House of Fiction*, Sammlung Hauser & Wirth, St. Gallen
› El Museu d'Art Contemporani de Barcelona, Collecio Macba, Barcelona
› *En Route*, Serpentine Gallery, London

2001
› *Tenth Anniversary Exhibition – 100 Drawings and Photographs*, Matthew Marks Gallery, New York
› *Analogue Dialogue*, Kunstmuseum Solothurn
› *The Dark*, Kunstmuseum Wolfsburg *Szenenwechsel XX*, Museum für Moderne Kunst, Frankfurt
› *Bildarchive*, Kunst-Werke, Berlin
› *Ein gut plazierter Helm ist wie ein beruhigender Blick*, Kunsthalle Nürnberg, Nuremberg
› *Ohne Zögern-Without Hesitation. Blicke in die Sammlung Olbricht*, Neues Museum Weserburg, Bremen
› *Vom Eindruck zum Ausdruck – Grässlin Collection*, Deichtorhallen, Hamburg
› The Vision Art Exhibitions, Malmö

› *makeshift*, University of Brighton Gallery
› *Moving Pictures*, Solomon R. Guggenheim Museum, New York

2000
› *Minding*, Le Garage, Geneva
› *Fest der Flüsse*, Wienfluss U4 Stadtpark, Vienna
› *Europeans*, Zwirner & Wirth, New York
› *Pero mira como* (with Gabriel Orozco and Richard Wentworth), Centro de la Imagen, Universidad de Guadalajara, Mexico
› Sammlung Goetz, (with Mike Kelley), Munich
› *Inventional,* Angles Gallery, Santa Monica
› *as it is*, Ikon Gallery, Birmingham
› *Eiszeit,* Kunstmuseum Bern
› *La prima idea. Aktuelle Malerei auf Papier*, Graphische Sammlung der ETH Zürich
› *voilà – le monde dans la tête*, Musée d'art moderne de la Ville de Paris
› *Staged*, Bonakdar Jancou Gallery, New York
› *fleurs*, Museum zu Allerheiligen, Kunstverein Schaffhausen
› Museo d'Arte Contemporanea, Castello di Rivoli, Turin
› Massachusetts Museum of Contemporary Art
› Tate Gallery, London
› *Orbis Terrarum – Ways of Worldmaking. Cartography and Contemporary Art*, Museum Plantin Moretus, Antwerp
› *L'Opéra. Un chant d'étoiles*, Opéra National, Brussels
› *Cable Factory, Some Parts of This World. Helsinki Photography Festival 2000*, The Finnish Museum of Photography, Helsinki
› *Moment*, Dundee Contemporary Arts
› *Staged. Constructions of Reality in Contemporary Photography*, Bankadar Jancou Gallery, New York
› *Hausschau. Das Haus in der Kunst*, Deichtorhallen, Hamburg

1999
› *Trailer,* Galerie Kampl im Kunstforum, Munich
› *Contemporary Swiss Art*, Ludwig Museum – Museum of Contemporary Art, Budapest
› *Maisons / Häuser. Carsten Höller. Rosemarie Trockel. Peter Fischli & David Weiss*, Musée d'art moderne de la Ville de Paris
› *Real Stories II*, Friedrich Petzel Gallery / Marianne Boesky Gallery, New York
› *Looselipssinkships. Projections vidéos*,

Galerie Erna Hécey, Luxembourg
> *h:min:sec. Eine Ausstellung zur Zeit*,
Kunstraum Innsbruck
> *Un musée en appartement. Une
exposition de toutes les gravures,
multiples et photopraphies, publiés par
Parkett*, Centre d'Art Contemporain,
Geneva

1998
> Matthew Marks Gallery, New York
> *Mai 98*, Kunsthalle Cologne
> Kunsthalle Zürich
> 11th Biennale of Sydney
> *Kunstausstellung Holderbank*,
Holderbank
> *Freie Sicht aufs Mittelmeer*, Kunsthaus
Zürich
> *Eight people from Europe*, The
Museum of Modern Art, Gunma
> *Alpenblick. Die zeitgenössische Kunst
und das Alpine*, Kunsthalle Wien, Vienna
> *I shop therefore I am*, Kunstverein
Hamburg

1997
> *Skulptur.Projekte Münster 1997*,
Münster
> Documenta X, Kassel
> *Transit. Fotografia degli anni '90*,
Centro d'Arte Contemporanea Ticino,
Bellinzona
> *Airport*, The Photographers' Gallery,
London
> *Von den Dingen. Gegenstände in der
zeitgenössischen Kunst*, Museum zu
Allerheiligen, Kunstverein Schaffhausen

1996
> *Non! Pas comme ça*, Centre d'Art
Neuchâtel
> *Nowhere*. Louisiana Museum of
Modern Art, Humlebaek
> *Mit dem Blick der 90er Jahre*, Museum
Schloss Burgk, Burgk/Saale, Ehemaliges
Umspannwerk
> *Fast nichts. Almost invisible*, Singen

1995
> *Zeichen und Wunder*, Kunsthaus Zürich
> Mai de la Photo, Reims
> *Micromegas*, American Center, Paris
> Venice Biennale

1994
> *Cloaca Maxima*, Museum der
Stadtentwässerung Zürich

1993
> *Double Take*, Kunsthalle Wien, Vienna
> *Post Human*, Deichtorhallen, Hamburg
> *Equilibre*, Aargauer Kunsthaus, Aarau
> *Passing Through*, Galerie Walcheturm,
Zurich

1992
> *Post Human*, Castello di Rivoli, Turin /
Asher Edelman Foundation, Pully/
Lausanne
> *Double Take*, Hayward Gallery, London /
Deste Foundation for Contemporary Art,
Athens
> *Platzverführung*, Schorndorf/Stuttgart

> *Swiss Pavillon*, Expo 1992, Seville
> *Oh cet echo*, Centre Culturel Suisse,
Paris
> *Sonderfall Schweiz*, Schweizer
Landesmuseum, Zurich
> *Projekt Schweiz*, Kunsthalle Basel

1991
> Galerie Walcheturm, Zurich
> *Chamer Räume – Kunst an Ort*, Cham
> *Metropolis*, Martin-Gropius-Bau, Berlin
> *Schwerelos*, Grosse Orangerie –
Schloss Charlottenburg, Berlin

1990
> Villa Arson, Nice
> Biennale, Sydney

1989
> Bienal, São Paulo
> Rooseum, Malmö
> Sonnabend Gallery, New York

1988
> *Aperto*, Venice Biennale
> Carnegie International, Pittsburgh

1987
Skulptur.Projekte Münster 1987,
Münster
> Documenta 8, Kassel
> *Offenes Ende – Junge Schweizer Kunst*,
Institut für Moderne Kunst Nürnberg/
Institut für Moderne Kunst Erlangen
> *Comic Iconoclasm*, Institute of
Contemporary Arts, London
> *The Sonnabend Collection*, Reina
Sofía, Madrid
> *Stiller Nachmittag*, Kunsthaus Zürich

1986
> *Auf dem Rücken des Tigers*, Shedhalle
Zürich
> *Swiss Pralines*, Forum Stadtpark, Graz
> Sonsbeck 86, Arnheim
> *Swiss Selection*, Galerie Beyeler, Basel

1985
> *Cross Currents in Swiss Art*, Serpentine
Gallery, London
> Nouvelle Biennale de Paris

1984
> *Zwischen Plastik und Malerei*,
> Kunstverein Hannover
> Haus am Waldsee, Berlin
> *An International Survey of Recent
Painting and Sculpture*, The Museum of
Modern Art, New York

1983
> *aktuell 83*, Lenbachhaus, Munich

1982
> *Neue Skulptur*, Galerie nächst St.
Stephan, Vienna

1981
> *30 Künstler aus der Schweiz*, Galerie
Krinzinger, Innsbruck/Galerie nächst St.
Stephan, Vienna/Frankfurter Kunstver-
ein, Frankfurt/Kunstmuseum Zug

1980
> *Saus und Braus*, Städtische Galerie
zum Strauhof, Zurich

CATALOGUES AND ARTISTS' BOOKS

2006
› *Equilibres*, Verlag der Buchhandlung Walther König, Cologne
› Renate Goldmann, *Peter Fischli, David Weiss*: *Ausflüge, Arbeiten, Ausstellungen*, Verlag der Buchandlung Walther König, Cologne

2005
› *Peter Fischli David Weiss*, with texts by Robert Fleck, Beate Söntgen, Arthur C. Danto, Phaidon Press, London
› *Fotografías*, Verlag der Buchhandlung Walther König, Cologne
› *Fotografías*, exh.cat., Museo Tamayo Arte Contemporaneo, Mexico City

2003
› Peter Fischli and David Weiss, *Will Happiness Find Me?*, Verlag der Buchhandlung Walther König, Cologne, and Alberta Press, London

2002
› Peter Fischli and David Weiss, *Findet mich das Glück?*, Verlag der Buchhandlung Walther König, Cologne
› *AC: Peter Fischli, David Weiss, Fragen Projektion*, exh.cat., Museum Ludwig, Cologne 2002–3

2000
› *Sichtbare Welt*, exh.cat., Museo d'Art Contemporani de Barcelona

1999
› *Peter Fischli, David Weiss* (with a text by Boris Groys and a foreword by Laurence Bossé), exh.cat., Musée d'art moderne de la Ville de Paris, Verlag der Buchhandlung Walther König, Cologne, and Paris-Musées, Paris (English version: Matthew Marks Gallery, New York 2000)

1998
› *Gärten*, exh.cat., Skulptur.Projekte Münster 1997, Oktagon Verlag, Cologne

1997
› *Arbeiten im Dunkeln*, exh.cat., Kunstmuseum Wolfsburg 1998, Hatje Cantz Verlag, Ostfildern (expanded German edition of *In A Restless World*, Minneapolis 1996)

1996
› *In A Restless World*, exh.cat., Walker Art Center, Minneapolis

1995
› *Peter Fischli, David Weiss*, with texts by Bice Curiger, Patrick Frey, Boris Groys, exh.cat., XLVI Biennale di Venezia 1995, Lars Müller Publishers, Baden
› Peter Fischli, David Weiss, *Raum unter der Treppe*, Hatje Cantz Verlag, Ostfildern
› *Peter Fischli, David Weiss, Bericht über den künstlerischen Schmuck im Neubau der Börse Zürich*, exh.cat., Börse Zürich 1992, Oktagon Verlag, Cologne

1993
› *Siedlungen, Agglomeration*, exh.cat., Kunsthalle Zürich, Edition Patrick Frey, Zurich, and Kunsthalle Zürich

1992
› *Peter Fischli David Weiss*, exh.cat., Musée national d'art moderne, Centre Georges Pompidou, Galeries Contemporaines, Paris

1991
› *Bilder, Ansichten, Die Sichtbare Welt*, exh. cat., Wiener Secession, Edition Patrick Frey, Zurich, and Wiener Secession, Vienna

1990
› *Airports*, exh.cat., Instituto Valenciano de Arte Moderno, Valencia, Edition Patrick Frey, Zurich
› *Das Geheimnis der Arbeit, Texte zum Werk von Peter Fischli & David Weiss*, exh.cat., Kunstverein München, Munich

1989
› *Quiet Afternoon*, exh.cat., Akhnaton Gallery, Cairo
› *Photographs*, exh.cat., 20th São Paolo International Biennial, Edition Patrick Frey, Zurich, and Swiss Federal Office of Culture, Zurich

1988
› *Peter Fischli David Weiss*, exh.cat., Portikus, Frankfurt

1987
› *In a Restless World*, exh.cat., List Visual Center, The Massachusetts Institute of Technology, Boston

1985
› *Stiller Nachmittag / Equilibres*, Eigenverlag, Zurich
› *Stiller Nachmittag, Ein ruheloses Universum*, exh.cat., Kunsthalle Basel

1982
› *Plötzlich diese Übersicht*, exh.cat., Galerie Stähli 1981–2, Edition Stähli, Zurich

1981
› *Ordnung und Reinlichkeit, Publikation zum Film Der geringste Widerstand*, published by the artists, Zurich

FILMS AND VIDEOS

2006
› *Lauf der Dinge: In der Werkstatt*, video, recorded during the filming of *Skizze zu Der Lauf der Dinge* from 1985, camera: Patrick Frey, edited in 2006

2003
› *Hunde*, video, loop, 30 mins.

2001
› *Büsi*, video, 6 mins.

1997
› *Sichtbare Welt*, video, 8 hrs, cross-fading of 2800 images, 3 screens

1995
› *Videos für Venedig*, video, 96 hrs, 12 screens

1994
› *Bus to the Station and Back*, video, 60 mins.

1992
› *Kanalvideo*, video, 60 mins.

1987
› *Der Lauf der Dinge*, 16mm, 55 mins. camera: Pio Corradi

1985
› *Skizze zu* Der Lauf der Dinge, 8mm, 3 mins., camera: Rainer M. Trinkler

1983
› *Der rechte Weg*, 16mm, 55 mins., camera: Pio Corradi, music: Stephan Wittwer

1981 › *Der geringste Widerstand*, 16mm,
 30 mins., camera: Jürg V. Walther,
 music: Stephan Wittwer

AWARDS AND PRIZES

2006 › Roswitha Haftmann Preis, Zurich
2003 › Leone d'Oro (Golden Lion),
 Venice Biennale
2000 › Günther-Peill-Preis, Leopold-Hoesch-
 Museum, Düren
1994 › Kunstpreis der Stadt Zürich
 (Art Award of the City of Zurich)
1989 › Prix Caran d'Ache, Geneva

Daniel Birnbaum is Rector of the Städelschule and Director of the Portikus in Frankfurt am Main. A contributing editor of *Artforum*, he was co-curator of the 50th Venice Biennale 2003 and of the first Moscow Biennale 2005. His most recent publication is *Chronology* 2005.

Claire Bishop is Leverhulme Research Fellow in the Curating Contemporary Art department at the Royal College of Art. She is the author of *Installation Art: A Critical History* 2005, and 'Antagonism and Relational Aesthetics', *October* no.110, 2004, and contributes regularly to *Artforum*.

Iwona Blazwick is Director of the Whitechapel Gallery. She is a curator and author of numerous texts on contemporary artists and on exhibition histories as well as commissioning the *Contemporary Artists Monographs* series for Phaidon Press.

Francesco Bonami is Manilow Senior Curator at Large, Museum of Contemporary Art Chicago, and the artistic director of Centro Arte Contemporanea Villa Manin, Fondazione Pitti Immagine Discovery and Fondazione Sandretto Re Rebaudengo. He is a contributor to the Italian daily *Il Riformista* and *Vanity Fair Italia*. His new book *106 memos × 1 Triennium* will be published in Spring 2007.

Lynne Cooke has been Curator at Dia Art Foundation since 1991. She has curated exhibitions in North America, Europe and elsewhere. In addition to teaching at Columbia University in the Graduate Fine Arts Department, she is on the faculty for Curatorial Studies at Bard College. Among her numerous publications are recent essays on the work of Rodney Graham, Jorge Pardo, Diana Thater, and Agnes Martin.

Bice Curiger is Curator at the Kunsthaus Zürich and Editor in Chief of the *Parkett* book series published in Zurich and New York in collaboration with contemporary artists, as well as Editorial Director of the magazine *Tate Etc.* She is the author of a monograph on Meret Oppenheim, *Defiance in the Face of Freedom* 1989. She recently curated *The Expanded Eye* at Kunsthaus Zürich. A collection of her texts was published under the title of *Kunst expansiv* 2002.

Arthur C. Danto is art critic for *The Nation*, and Johnsonian Professor Emeritus of Philosophy at Columbia University. His major work is a trilogy – *The Transfiguration of the Commonplace* 1981, *After the End of Art* 1997, *The Abuse of Beauty* 2003.

Tacita Dean is an artist and curator, born in Canterbury and now living in Berlin. She studied Fine Art at Falmouth School of Art in Cornwall and later followed a postgraduate course at The Slade School of Fine Art in London. There was a retrospective exhibition of her work at Schaulager, Basel, in 2006. She curated *An Aside*, a touring exhibition for the Hayward Gallery in collaboration with Camden Arts Centre, London 2005.

Robert Fleck (*1957 in Vienna) lived in France from 1981 to 2003 and has been director of Deichtorhallen Hamburg since 2004. He is the author of an essay in the Phaidon monograph *Peter Fischli David Weiss* 2005. His most recent book is *Marie Raymond, Yves Klein* 2006.

Patrick Frey is an author, comedian and publisher based in Zurich.

Alison M. Gingeras is an adjunct curator at the Guggenheim Museum, and a critic. In Spring 2006 she curated *Where Are We Going? Selections from the François Pinault Collection* – the inaugural exhibition at Palazzo Grassi, Venice. She frequently contributes to publications such as *Artforum* and *Tate, Etc.*, and has authored two forthcoming monographs, *Guy Bourdin* 2006 and *John Currin* 2006.

Mark Godfrey is lecturer in History and Theory of Art at the Slade School of Fine Art, University College London. He is an art historian, critic and curator, and has recently written on artists such as Tacita Dean, Sharon Lockhart, Anri Sala and Matthew Buckingham. His forthcoming book, *Abstraction and the Holocaust*, will be published by Yale University Press.

Renate Goldmann (*1967) is an art historian, publicist and curator, working inter alia for the Institut für Auslandsbeziehungen (ifa) since 2000. Publications among others: *Dirk Skreber, It Rocks us so Hard* 2004, *Michael Krebber, Ausserirdische Zwitterwesen* 2005 and *Peter Fischli David Weiss. Ausflüge, Arbeiten, Ausstellungen. Ein offener Index* 2006.

Dominique Gonzalez-Foerster (*1965) lives in Paris and Rio de Janeiro. She is a visual artist also involved in film, architecture and music. She has exhibited in museums, biennals, and documenta 11. www.dgf5.com.

Valentin Groebner teaches Medieval and Renaissance history at the university of Lucerne. He has written on images of violence (*Defaced* 2004) and on the history of passports and identity papers (*Who Are You?*, forthcoming from Zone Books in 2006). He never drives alone at night.

Boris Groys is Professor of Philosophy and Media Theory at the Staatliche Hochschule für Gestaltung in Karlsruhe. His latest publications include: *Topologie der Kunst* 2005 and *Ilya Kabakov. The Man Who Flew into Space from his Apartment* 2006.

Jörg Heiser (*1968) lives in Berlin, is co-editor of *frieze* magazine, a frequent contributor to German newspaper *Süddeutsche Zeitung*, a writer on art and culture (recent essays on Susan Hiller, Glenn Brown, Bas Jan Ader) and an occasional freelance curator. Shows include *Funky*

Lessons (BüroFriedrich Berlin and BAWAG Foundation Vienna 2004–5) and *Romantic Conceptualism* (Kunsthalle Nürnberg, and other venues 2007–8).

Thomas Kapielski (*1951 in Berlin) studied physical geography and philology. He is an artist, author and lecturer. Recent publications: *Weltgunst* 2004, *Anblasen*, *Texte zur Kunst* 2006 and *Emolumente. Sammler zeigen ihre Kapielskis*, 2006.

John Kelsey lives in New York. He is a member of Bernadette Corporation, co-director of Reena Spaulings Fine Art and a frequent contributor to *Artforum*.

Max Küng (*1969) is a reporter with DAS MAGAZIN, Zurich. He has just brought out his first book, *Einfälle kennen keine Tageszeit*, published by Edition Patrick Frey, Zurich. He is a keen hiker. Otherwise, he is quite okay.

Christy Lange is a writer based in Berlin. She works in the Berlin office of *frieze* magazine, to which she is a regular contributor.

Veit Loers is an author and curator and lives in the Veneto region of Italy. He was director of the Abteiberg Mönchengladbach Museum to 2003. Publications include *Painting on the Roof* 2003, *Franz West* 2006 and *Künstlerbiographie der Christian Friedrich Flick Collection* 2006.

Andres Lutz (*1968) is an artist and lives in Zurich. He is part of the artist duo Lutz / Guggisberg.

Hans Ulrich Obrist (*1968 in Zurich) lives and works in London and Paris. He is Co-Director of Exhibitions and Director of International Projects at the Serpentine Gallery in London. He is also Inviato Speciale of *Domus* Magazine and Editor in Chief of *Point d'Ironie* (published by agnes b). Obrist has edited more than sixty books, most recently *Interviews with Rem Koolhaas* published by Walther König, Cologne.

Vincent Pécoil (*1971) lives in Dijon. He published *Prières américaines* 2002 and wrote several monographs, recently including *John Tremblay* 2005 and *Saâdane Afif, Lyrics*, Palais de Tokyo, Paris 2005. He is currently working on an essay on art and the cultural industries (*Culture Is Their Business*, to be published in 2007). He also works as a curator and contributes regularly to various publications, including *Art Monthly, Contemporary, Flash Art, Frog, Parkett* and *Tate Etc.*

Nancy Spector is Curator of Contemporary Art and Director of Curatorial Affairs at the Guggenheim Museum in New York. In 2002 she published *Matthew Barney, The Cremaster Cycle*, Guggenheim Museum New York.

Frederic Tuten's widely translated novels include *Tintin in the New World, Tallien: A Brief Romance, Van Gogh's Bad Café, The Adventures of Mao on the Long March*, and his most recent, *The Green Hour*. He writes on film and art, and lives in New York City.

John Waters is a film director, screenwriter and photographer who lives and works in Baltimore, Maryland.

Max Wechsler (*1943) is an art critic and translator living in Lucerne. He studied English, German and the history of art at Zurich University. In addition to his work as university lecturer he publishes his reviews and essays in international journals and art catalogues. Most recent publications include *Augenzeugnis – Ausgewählte Texte zur Kunst* 2006, *Günther Förg: Fotografie/Photography*, Kunsthalle Bremen, Cologne 2006.

Beat Wyss is Professor of Art History at the Staatliche Hochschule für Gestaltung in Karlsruhe. He is the author of *Hegel's Art History and the Critique of Modernity* 1999.

Stefan Zweifel (*1967) wrote his dissertation on *Pornosophie & Imachination: Sade – Hegel – La Mettrie* and lives as a writer and critic in Zurich.

Room beside
Cafeteria

Visible World 1987–2000
Video, 8 hrs.
Tate. Purchased 2002

Room 1

Büsi 2001
Video, 6 mins.
Exh. copy

Dogs 2003
Video, looped, 30 mins.
Exh. copy

In the Studio 2004
Carved and painted polyurethane
51 × 100 × 60 cm
Private Collection, New York

Lamp 1992
Carved and painted polyurethane
ø 38 cm, height 65 cm
Musée Barbier-Müller, Geneva

Cupboard 1987
Carved and painted polyurethane
60 × 45 × 40 cm

Peanuts 1981 (from *Suddenly this Overview*)
Unfired clay
Life-size, dish ø 11 cm

Sewer Workers 1987
Cast rubber
26.5 × 47.5 × 19 cm

Room 2

Flowers, Mushrooms 1997/8
Approx. 40 c-prints
74 × 107 cm
Exh. copies

Airports 1987–2006
12 Cibachrome photographs
160 × 225 cm

Room 3

Suddenly this Overview 1981 and 2006
40 sculptures, unfired clay
Between 6 × 7 × 5 cm and 82 × 83 × 5 cm
Exh. copies

Because the original sculptures are so fragile, the artists have decided
to make replicas and several new sculptures in the spirit of *Suddenly
this Overview* for the Tate exhibition. The majority of the sculptures
from *Suddenly this Overview* are preserved in the Emanuel Hoffmann
Foundation, on permanent loan to the Öffentliche Kunstsammlung
Basel.

The Sausage Photographs 1979
10 photographs
24 × 36 cm
Exh. copies
Walker Art Center, Minneapolis; Clinton and
Della Walker Acquisition Fund, 1993

Room 4

An Unsettled Work 2004
DVD
Collection Thomas and Cristina Bechtler, Switzerland

Boîte de nuit 1984 (from *Fever*)
Carved and painted polyurethane
180 × 130 × 130 cm

Room 5 *Quiet Afternoon* 1984/5
Approx. 30 photographs
30 × 40 cm
Exh. copies
Kunsthaus Zürich

Lumpentiti 1992
Doll stuffed with coins
30 × 15 × 15 cm
SWX Swiss Exchange

Beetle 1986/7
Aluminium water-jug mounted with wires on roller skate,
bundles of wire, coal
28 × 23 × 23 cm
Alfred Richterich Collection

Room 6 *Son et lumière – Le rayon vert* 1990
Flashlight, turntable, plastic cup, tape
25 × 40 ×16 cm
Exh. copy
Goetz Collection, Munich

The Way Things Go 1986–7
16 mm film, 30 mins.

Making Things Go 1985/2006
Video, 68 mins.

Building 1987
Polyurethane, wood, steel, cloth, paint, glue
120 × 160 × 110 cm
Friedrich Christian Flick Collection

Room 7 *Questions* 2002–3
1,215 slides, 15 slide-projectors, 15 lenses, 8 dissolve units

Exh. copy
Friedrich Christian Flick Collection

Room 8

Question Pot (*Big*) 1986 (from *Grey Sculptures*)
Polyurethane, cloth, paint
ø 200 cm, height 134 cm
Grässlin Collection, St. Georgen, Germany

Bean 1986 (from *Grey Sculptures*)
Polyurethane, cloth, paint
ø 50 cm, height 140 cm
Hauser & Wirth Collection, Henau, Switzerland

Animal 1986 (from *Grey Sculptures*)
Polyurethane, cloth, paint
85 × 45 × 50 cm

Ear 1986 (from *Grey Sculptures*)
Polyurethane, cloth, paint
60 × 45 × 35 cm

Apartment 1985 (from *Grey Sculptures*)
Polyurethane, cloth, paint
30 × 120 × 140 cm

Tube 1985 (from *Grey Sculptures*)
Polyurethane, cloth, paint
40 × 177 × 70 cm

Egg 2006 (from *Grey Sculptures*)
Polyurethane, cloth, paint
ø 100 cm, length 127 cm

Kanalvideo 1992
Video, 60 mins.
Exh. copy

Carnegie Museum of Art, Pittsburgh; A.W. Mellon
Acquisition Endowment Fund, 2005.54

Room 9

Cupboard 1987
Cast rubber
210 × 100 × 60 cm
Purchased from the artists, 2001. Centre Pompidou, Paris.
Musée national d'art moderne / Centre de création
industrielle

Wall 1987
Cast rubber
42 × 92 × 34 cm
Purchased from the artists. Centre Pompidou, Paris.
Musée national d'art moderne / Centre de création
industrielle

Ottoman 1987
Cast rubber
58 × 58 × 32 cm
Purchased from the artists. Centre Pompidou, Paris.
Musée national d'art moderne / Centre de création
industrielle

Dog's Dish 1986/7
Cast rubber
⌀ 26.5 cm, height 8.5 cm
Purchased from the artists, 2001. Centre Pompidou, Paris.
Musée national d'art moderne / Centre de création
industrielle

Candle 1986/7
Cast rubber
⌀ 27 cm, height 15.5 cm
Gift of the artists, 2001. Centre Pompidou, Paris. Musée
national d'art moderne / Centre de création industrielle

Divider 1987
Cast rubber
5 × 34 × 26 cm
Purchased from the artists. Centre Pompidou, Paris.
Musée national d'art moderne / Centre de création
industrielle

Big Root 2005
Cast rubber
140 × 114 × 100 cm
Exh. copy
Emanuel Hoffmann Foundation, Basel, on permanent loan
to the Öffentliche Kunstsammlung Basel

Small Root 1986/7
Cast rubber
46.5 × 57 × 18 cm
Purchased from the artists, 2001. Centre Pompidou, Paris.
Musée national d'art moderne / Centre de création
industrielle

Chinese Pot 1986
Cast rubber
ø 21 cm, height 21 cm

Fotografías 2004/5
18 groups of 6 black and white photographs
Each 10 × 15 cm
Exh. copies
Emanuel Hoffmann Foundation, Basel, on permanent loan
to the Öffentliche Kunstsammlung Basel

Room 10

Untitled (Rotterdam) 2000–4
Carved and painted polyurethane
Dimensions variable

Untitled (Tate) 1992–2000
Carved and painted polyurethane
Dimensions variable

Untitled (Pallets) 2000-4
Carved and painted polyurethane
200 × 160 × 120 cm
Ringier Collection, Switzerland

Room 11 Rat and Bear Costumes 1980/2004
Cotton and Perspex
280 × 100 × 80 cm
Courtesy Matthew Marks Gallery, New York

The Right Way 1982–3
16 mm film, 50 mins.

Order and Cleanliness 1981
15 photocopies
Exh. copy
Ringier Collection, Switzerland

—

Unless otherwise credited, all works courtesy
Peter Fischli / David Weiss